MARK
WALLINGER

TABLE OF CONTENTS

INHALTSVERZEICHNIS

FOREWORD

Madeleine Schuppli and Janneke de Vries

Some exhibitions simply happen at the right time, but that can hardly be planned in advance. If we are lucky, a lot of factors coincide and lead to a thoroughly satisfactory end result. This has been the case with the exhibitions of Mark Wallinger's work at the Kunstverein Braunschweig and the Aargauer Kunsthaus, as well as this catalogue. Both presentations are taking place at a time when the artist has received a lot of publicity because of important major projects such as *State Britain* (first shown at Tate Britain in London in 2007) and *Zone* (for the Sculpture Projects Muenster 07). *State Britain* eventually led to Mark Wallinger's nomination for the Turner Prize, which he was subsequently awarded. At present the London artist is in discussions regarding his proposal for another fascinating project: *The White Horse* is a gigantic sculpture of a thoroughbred which would stand near Ebbsfleet Eurostar train station in south east England. The picture on the jacket of this book gives some idea of that extraordinary project – whether Mark Wallinger's concept will be realised will be not be decided until a few weeks after we go to print. Thus this publication not only covers the two exhibitions in Braunschweig and Aarau, but also includes Wallinger's latest projects for and about public space. It is our aim to use this catalogue to link up with the one published by

VORWORT

Madeleine Schuppli und Janneke de Vries

Manche Ausstellungen kommen einfach zur richtigen Zeit. Das lässt sich im Voraus kaum planen. Wenn man Glück hat, kommen viele Dinge zusammen und führen zu einem durch und durch stimmigen Endergebnis. Für die Ausstellungen von Mark Wallinger im Kunstverein Braunschweig und im Aargauer Kunsthaus sowie des hier vorliegenden Katalogs ist das der Fall. Beide Präsentationen finden in einem Zeitraum statt, in dem der Künstler mit grossen und bedeutenden Projekten wie *State Britain* (2007 erstmals gezeigt in der Tate Britain in London) und *Zone* (für die Skulptur Projekte Münster 07) an die Öffentlichkeit trat. *State Britain* führte schliesslich zur Nominierung für den Turner Prize, mit dem Mark Wallinger dann auch ausgezeichnet wurde. Aktuell ist der Londoner Künstler mit dem Entwurf für ein weiteres faszinierendes Projekt im Gespräch: *Stallion of the South* ist die gigantische Skulptur eines Rassepferdes, welches in Südengland die Haltestelle des Eurostar-Zuges in Ebbsfleet markieren soll. Eine Idee von diesem aussergewöhnlichen Projekt gibt das Umschlagbild unserer Publikation – ob Mark Wallingers Konzept zur Ausführung kommt, wird sich erst ein paar Wochen nach Drucklegung entscheiden. Die Publikation spiegelt somit nicht nur die beiden Ausstellungen in Braunschweig und Aarau, sondern schliesst auch Wallingers neueste Projekte für und über den öffentlichen Raum ein. Unser Ziel ist es, mit diesem

Tate Liverpool in 2000, and comprehensively represent and reflect Mark Wallinger's creative work in recent years. The authors have ap-proached the complex work of the British artist from various different points of view. While Richard Grayson primarily sheds light on the socio-political meaning of Wallinger's position in his overview text, the contributions of Michael Diers and Janneke de Vries ana-lyse the two key works *State Britain* and *Zone*. Madeleine Schuppli examines the religious themes in Wallinger's work, and the artist himself has written a journal-type essay on his work *Sleeper*. We would like to warmly thank the authors invited to contribute for their well-researched texts. We would also like to thank Barbara von Flüe of the Aargauer Kunsthaus for her careful editorial and copy editing work.

The following people made an important contribution to the creation of the exhibition in Braunschweig, and they too are warmly thanked: Rainer Bullrich, Sina Deister, Andreas Eschment, Christine Gröning, Iris Schneider, Elisabeth Schuchardt and most particularly Ursula Schöndeling. The exhibition in Aarau was made possible by the enthusiastic commitment of many collaborators. Special thanks are due to Matthias Berger, David Blazquez, Filomena Colecchia, Arnold Glatthard, Stephan Kunz,

Verena Reisinger, Willy Stebler, Katrin Weilenmann and the whole development team.

We are also extremely grateful to the Neue Aargauer Bank, the main sponsor of the Aargauer Kunsthaus and the Aargauischer Kunstverein, as well as to the Volkswagen Bank and the Henry Moore Foundation, which supported the exhibition in Braunschweig. Without the generous financial backing of these bodies neither the exhibitions nor the publication would have been possible.

Both institutions warmly thank Mark Wallinger's galleries, carlier | gebauer, Berlin; Donald Young Gallery, Chicago; Galerie Krinzinger, Vienna and most particularly the Anthony Reynolds Gallery in London. Anthony Reynolds and Maria Stathi have provided us with quite crucial sup-port in many respects. We also address a special thank you to Lionel Bovier and Salome Schnetz of JRP|Ringier for the professional way they have handled the catalogue, and to Gilles Gavillet for its successful design. But our final and greatest thanks go to Mark Wallinger himself – for his tremendous commitment, his openness, his inspir-ing collaboration and our exchanges with him, which have been characterised by friendliness, wit and humour.

Katalog an denjenigen der Tate Liverpool aus dem Jahr 2000 anzuschliessen, und die letzten Jahre von Mark Wallingers Schaffen umfassend darzustellen und zu reflektieren. Die Autoren/innen nähern sich dem komplexen Werk des briti-schen Künstlers unter verschiedenen Gesichtspunkten an. Während Richard Grayson in seinem Überblickstext vor allem die soziopolitische Bedeutung von Wallingers Position beleuchtet, analysieren die Beiträge von Michael Diers und Janneke de Vries die beiden Schlüsselwerke *State Britain* und *Zone*. Madeleine Schuppli untersucht die religiösen Themen in Wallingers Werk, und der Künstler selber hat ein tagebucharti-ges Essay zu seiner Arbeit *Sleeper* verfasst. Den eingeladenen Autoren danken wir ganz herzlich für ihre fundierten Beiträge. Zudem bedanken wir uns bei Barbara von Flüe vom Aargauer Kunsthaus für die umsichtige Redaktions- und Lektoratsarbeit.

Zur Entstehung der Ausstellung in Braunschweig haben fol-gende Personen wesentlich beigetragen, bei denen wir uns herzlich bedanken: Rainer Bullrich, Sina Deister, Iris Schneider, Andreas Eschment, Christine Gröning, Elisabeth Schuchardt und ganz besonders Ursula Schöndeling. Die Ausstellung in Aarau ist dank dem grossen Engagement zahlreicher Mitar-beiter/innen möglich geworden. Besonderer Dank gebührt Matthias Berger, David Blazquez, Filomena Colecchia, Arnold

Glatthard, Stephan Kunz, Verena Reisinger, Willy Stebler, Katrin Weilenmann sowie dem gesamten Aufbauteam.

Ein grosser Dank geht auch an die Neue Aargauer Bank, den Hauptsponsor des Aargauer Kunsthauses, und an den Aargauischen Kunstverein, sowie an die Volkswagen Bank und die Henry Moore Foundatwion, die die Ausstellung in Braunschweig unterstützt haben. Ohne den grosszügigen finanziellen Beistand dieser Stellen wären weder Präsenta-tion noch Publikation möglich gewesen.

Beide Häuser bedanken sich herzlich bei Wallingers Galerien carlier | gebauer, Berlin, Donald Young Gallery, Chicago, Galerie Krinzinger, Wien und ganz besonders bei der Anthony Reynolds Gallery, London. Anthony Reynolds und Maria Stathi haben uns in vieler Hinsicht ganz entscheidende Unterstüt-zung zukommen lassen. Einen besonderen Dank richten wir zudem an Lionel Bovier und Salome Schnetz vom Verlag JRP|Ringier für die professionelle Betreuung des Kataloges, und an Gilles Gavillet für die gelungene Gestaltung. Der letzte und grösste Dank aber gebührt Mark Wallinger – für sein gros-ses Engagement, für seine Offenheit, für die inspirierende Zusammenarbeit und für den von Freundschaftlichkeit und geistreichen Humor geprägten Austausch.

A NUMBER OF DISAPPEARANCES

Richard Grayson

The TARDIS is shaped like a police box, a blue stocky rectangular structure with double doors on all four sides that used to be found standing at street corners in cities across Britain. The police box was a compact communications centre, office and occasional holding cell, large enough for a couple of people to stand in. There was a telephone mounted on the outside so that the public could report emergencies to the local station, and when the station needed to speak to the officer on the beat the blue light on the top of the box would flash. It was designed for a time when radios and telephones were hardly portable, and for system of policing that had local officers patrolling their neighbourhood on foot or bicycle. In the 1950s there were more than 700 of them across London, but by the end of the 1960s they had become obsolete, as ideas of policing had changed, with pedestrian patrols replaced by police cars with portable radios. Most of them had gone from the streets by 1970.

The TARDIS is part of the BBC television series *Doctor Who*, first broadcast on the same day as John Kennedy's assassination in 1963 and still running today. It takes its name from the acronym formed by the phrase 'Time And Relative Dimensions In Space', which describes a particular

ARTEN DES VERSCHWINDENS

Richard Grayson

Die TARDIS hat die Form eines Polizeihäuschens, sie ist eine blaue, gedrungen rechteckige Konstruktion mit Doppeltüren an allen vier Seiten, wie man sie einmal an Strassenecken in ganz Grossbritannien finden konnte. Dieser Kasten war Kommunikationszentrum auf kleinstem Raum, Büro, mitunter auch Arrestzelle, es konnten ein paar Leute darin stehen. An der Aussenseite gab es ein Telefon, von dem aus man Notfälle an die örtliche Polizeiwache melden konnte, und wenn diese Station Kontakt mit dem Streife laufenden Beamten aufnehmen musste, begann auf dem Dach der Box ein Blaulicht zu blinken. Diese Einrichtung wurde für eine Zeit entwickelt, in der Radios und Telefone noch kaum tragbar waren, und sie waren für ein Polizeisystem bestimmt, bei dem Revierbeamte zu Fuss oder auf dem Fahrrad durch ihre Nachbarschaft patrouillierten. In den 1950er Jahren fand man in ganz London noch mehr als siebenhundert von ihnen, doch gegen Ende der 1960er Jahre waren sie bereits überflüssig geworden, da sich die Polizeiarbeit durch die Ersetzung von Fusspatrouillen durch Polizeiautos mit Sprechfunk stark verändert hatte. Um 1970 waren die meisten von ihnen aus dem Strassenbild verschwunden.

Der Name TARDIS ist die Abkürzung des Ausdrucks „Time and Relative Dimensions in Space", durch den ein bestimmter

aspect of its nature and function: it has the unique quality of being able to disappear. One moment the box is solidly installed on the corner of a suburban street (or outside a country house, or inside a Victorian art gallery), the next, it generates a strange heaving and roaring sound, the blue light flashes and it dematerialises. This is how it moves into another dimension of time and space, to distant planets and epochs. The box is a home and a vehicle for 'The Doctor', an extra-terrestrial being who has travelled the universe for aeons, regenerating his body in a different human form every few years. He is the last survivor of the Time Lords, a race destroyed in the 'war with the Daleks ... with the whole of creation at stake ... ' He polices time and space in a constant (Manichean) struggle against evil and injustice. He has a special fondness for the planet Earth and seeks to protect it. Even before it's seen to disappear, the TARDIS announces its uncanny nature and its advanced technology through being much larger on the inside than it is outside. A shot repeated throughout the series is the look of shock on the face the Doctor's new sidekick (and there have been many) as they walk through the double blue doors to enter the confines of the police box, only to find a vast chamber unfolding in front of them.

The TARDIS is recreated in the artwork *Time and Relative Dimensions in Space* (2001) by Mark Wallinger, in reflective stainless steel. Unlike the Doctor's sidekicks, we cannot physically enter the door, but as we stand outside we can see ourselves standing inside its volume and notice that it contains everything that surrounds it. By giving the TARDIS the qualities of a mirror, Wallinger too makes his TARDIS disappear. This object collides narratives from a popular sci-fi television programme with the histories and mute languages of Minimalism: the glittering rhomboid brings to mind works by Robert Morris and Larry Bell, who were making mirrored cubes at the same time the Doctor first appeared – the early 1960s. Both their cubes and this TARDIS wish to become ghostly and fugitive: indeed when we watch this box dematerialise we are witness to a number of disappearances: that of the TARDIS, of the police box, whose form it has taken, of a structure of social and legal relationship that was facilitated by this box, of Robert Morris and the mute playful sternness of 1960s art, of the genial bobby on the beat who knew everybody's name, knew who was a bad apple and who could keep the kids in check. A world moving irrevocably from the present to the past.

Aspekt ihres Wesens und ihrer Funktion beschrieben wird: Sie besitzt die einmalige Eigenschaft, verschwinden zu können. In einem Moment steht der Kasten fest installiert an der Ecke einer Vorstadtstrasse (oder vor einem Haus auf dem Land, im Innenraum einer viktorianischen Kunstgalerie), doch im nächsten Moment erzeugt er einen seltsam stampfenden und brüllenden Lärm, das Blaulicht leuchtet auf und er löst sich in Luft auf. Auf diese Art verschwindet die TARDIS in andere Dimensionen von Zeit und Raum, zu fernen Planeten und Zeitaltern. Sie ist Bestandteil der BBC-Fernsehserie *Doctor Who*, deren erste Folge 1963 am Tag des Attentats auf John F. Kennedy ausgestrahlt wurde und die bis zum heutigen Tag läuft. Der Kasten ist Behausung und Beförderungsmittel für „The Doctor", ein ausserirdisches Lebewesen, das seit Ewigkeiten durch das Universum reist und alle paar Jahre seinen Körper in einer neuen menschlichen Gestalt regeneriert. Er ist der letzte der Timelords, einer Rasse, die „im Krieg mit den Daleks, [...] bei dem die gesamte Schöpfung auf dem Spiel stand", vernichtet wurde. Er wacht nun über Zeit und Raum, in immerwährendem (manichäischem) Kampf gegen das Böse und die Ungerechtigkeit. Für den Planeten Erde hat er eine besondere Vorliebe und versucht ihn deshalb zu schützen. Noch bevor man sie verschwinden sieht, zeigt die TARDIS bereits ihre unheimlichen Eigenschaften und ihre

überlegene Technologie, da sie innen viel grösser ist als aussen. Eine Einstellung, die im Laufe der ganzen Serie immer wieder aufs Neue zu sehen ist, zeigt den Schrecken im Gesicht von des Doctors neuem Helfer (und davon gab es viele), wenn sie durch die blaue Doppeltür die Enge der Polizeibox betreten, nur um dort zu sehen, wie sich vor ihnen ein ausgedehnter Raum eröffnet.

Die TARDIS hat Mark Wallinger in seinem Werk mit dem Titel *Time and Relative Dimensions in Space* (2001) aus reflektierendem Edelstahl wiedererschaffen. Im Unterschied zu den Helfern des Doctors können wir die Tür nicht physisch durchschreiten, doch wenn wir draussen stehen, können wir uns im Innenraum stehen sehen und stellen fest, dass er alles ihn Umgebende in sich eingeschlossen hat. Dadurch, dass er ihr die Eigenschaften eines Spiegels verliehen hat, lässt auch Wallinger seine TARDIS verschwinden. Dieses Objekt nun lässt Erzählungen aus einer populären Science-Fiction-Serie mit den Geschichten und stummen Sprachen des Minimalismus zusammenfallen: Der glänzende Rhomboid erinnert an Werke von Robert Morris und Larry Bell, die genau zu der Zeit verspiegelte Kuben bauten, als der Doctor zum ersten Mal erschien – in den frühen 1960er Jahren. Sowohl ihre Kuben als auch diese TARDIS wollen zu etwas Geisterhaftem und

Formally, Mark Wallinger's oeuvre is extraordinarily diverse. He works with equal facility across sculpture, photography, film, video installation, painting, installation and text. But in this TARDIS – as atypical of his other works as the other works are of each other – we find approaches and ideas and themes that re-occur across his practice. It has a range of references that run from the everyday and the particular to the metaphysical and mythic, linking particulars from sci-fi plots to ideas from religion and myth, touching on a history of policing, of television and the social and class structures of a country. It is notable for the easeful overlapping of different registers. Again and again his work presents us with forms which, like the TARDIS, at first seem contained, sealed, almost mute, but which are revealed to hold within them doubles: or a multiplicity of presences and a diversity of states, where different things, constructs and narratives occupy a mundane form, be it a bottle, a box, a bear, a pale man or footage of people walking into an airport.

Between the first broadcast of *Doctor Who* and the present day, the artist travelled from childhood to maturity, the doctor materialised a thousand times and the policemen on the beat disappeared. Over the same period, many of the concepts that shaped understanding in the 19th and the 20th centuries have slowly shifted tense. It has been a history of disappearance. Between that then and this now, defining narratives such as Nation, Church and Class have been eroded and made contingent by what Marx presciently described as the 'constant revolutionising of production, uninterrupted disturbance of all social conditions, everlasting uncertainty and agitation ... ' that is inherent in the workings of modern Capital. In addition, the world has become newly defined by the electronic signal, a nebulous linkage of impulses and exchanges that denies previous boundaries and contains its own logics and imperatives. When Marx continued his sentence to write, 'All that is solid melts into air, all that is sacred, profaned', at the time it seemed hyperbolic. Now it appears prophetic.

Britain has been a sort of experimental laboratory for these forces since the Industrial Revolution in the late 18th century, and the country has continued to be a Petri dish for market-driven cultures. Thatcher, inspired by American economists, gave the market free reign across all areas of life, dismantling organisations and structures

Flüchtigem werden. Und wirklich, wenn wir diese Box bei der Entmaterialisierung beobachten, werden wir Zeugen mehrerer Prozesse des Verschwindens: demjenigen der TARDIS; der Polizeibox, deren Form sie angenommen hat; einer Struktur gesellschaftlicher und gesetzlicher Beziehungen, die von dieser Box ermöglicht wurden; von Robert Morris und der stumm verspielten Strenge der 1960er-Jahre-Kunst; des genialen Bobbys auf Streife, der sich an jedermanns Namen erinnern konnte, wer ein schwarzes Schaf war und wer die Jungs in Schach halten konnte. Eine Welt, die sich unwiderruflich von der Gegenwart in Richtung Vergangenheit bewegt.

Formal ist Mark Wallingers Œuvre ausserordentlich vielseitig. Mit der gleichen Leichtigkeit bewegt er sich zwischen den Feldern der Skulptur, der Fotografie, des Films, der Videoinstallation, der Malerei, der Installation, des Texts. Doch findet man in dieser TARDIS – einem für sein Schaffen ebenso atypischen Werk wie es auch die anderen Werke im Verhältnis zueinander schon sind – Ansätze und Ideen und Themen, die sich in seinem Gesamtwerk immer wieder entdecken lassen. Sie weist eine Reihe von Referenzen auf, die sich vom Alltäglichen und Besonderen bis zum Metaphysischen und Mythischen erstrecken, Besonderheiten aus Science-Fiction-Erzählmustern mit Vorstellungen aus Religion und Mythos verbinden, und eine Geschichte des Polizeiwesens, des Fernsehens und der Gesellschafts- und Klassenstrukturen eines Landes berühren. Sie ist bemerkenswert wegen der Leichtigkeit, mit der sie verschiedenartige Register zur Überlagerung bringt. Immer wieder zeigt uns sein Werk Formen, die wie die TARDIS zunächst in sich verschlossen, hermetisch, geradezu stumm erscheinen, die sich dann allerdings als Träger von Doubles erweisen – oder als Vielzahl von Präsenzen und Verschiedenartigkeit von Zuständen, in denen unterschiedliche Dinge, Konstrukte und Narrative eine ganz banale Form besetzen, sei dies nun eine Flasche, ein Kasten, ein Bär, ein bleicher Mann oder Filmmaterial, auf dem man Menschen beim Betreten eines Flughafens sehen kann.

Zwischen dem Zeitpunkt der Erstausstrahlung von *Doctor Who* und heute hat sich der Künstler vom Kindesalter zur Reife entwickelt, der Doctor hat sich tausend Mal materialisiert und die Streifenpolizisten sind verschwunden. Im selben Zeitraum haben viele das Verstehen im 19. und 20. Jahrhundert entscheidend beeinflussende Vorstellungen langsam ihre Zeitform verändert. Es war eine Geschichte des Verschwindens. Zwischen jenem Damals und diesem Jetzt haben sich die bestimmenden Erzählungen von Nation, Kirche oder Klasse erschöpft und sind durch das kontingent geworden, was Karl

that might impede its operations. After Thatcher, Blair continued this agenda and today the two main British political parties share the ideology of privatisation and minimal state regulation of the market. There is no real opposition, no articulation of another possibility; the difference between the parties is only a matter of language, of degree. It is no coincidence that the model of deregulated, unfettered capital, set in aggressive opposition to the social communal structures of the state that are still maintained across much of the European Economic Community, is called the 'Anglo-Saxon' model.

Mark Wallinger's practice maps how these changes shape the society of which he is a part. He describes a world in which the orders of the past may be decaying, but our profound need for symbolic order and a means of making sense remains, made perhaps greater by this slow retreat. He explores the ways in which this finds expressions in our lived experience, our everyday life, and how this desire can conjure up ghosts.

Upside Down and Back to Front, the Spirit Meets the Optic in Illusion (1997) is a sparkling vortex of pun, metaphor and metonym. A bottle filled with clear liquid, with the mechanism with which they dole out pub measures – an optic – on top (which indicates that the bottle should be, will be, the other way up with the neck pointing down when it is placed in its natural working state), is set upright on a mirrored table such as you might find in cocktail bar. In our world, on this side of the mirror, the bottle's label is nearly impossible to read – its letters are inverted and reversed and nonsensical. It is only by looking into the world that lies tantalisingly on the other side of the mirror, that can we see what it says. In this other dimension the bottle hangs down into space, and we can read the words: 'The Spirit ... original and absolute, 100% Proof.' Seeing it pointed down in the reflection reminds us that the label, the description, its nature even, will remain garbled and imperfect even when it is inverted on our side of the glass. Only on the other side can it achieve its ideal form – a Platonic purity. (Although, tantalisingly, there is a hint of imperfection even there, as the purity of alcohol in the UK used to be tested on a scale that runs to 172.5 for pure ethanol, i.e. 72.5 degrees over proof.) We are to believe that this pure 'Spirit' is – in one way or another – the artist: bottled at source in Chigwell and labelled using his racing colours of violet, white and green.

Marx vorausschauend als die „andauernde Revolutionierung der Produktion, ununterbrochene Störung der gesellschaftlichen Verhältnisse, immerwährende Unsicherheit und Unruhe" beschrieben hat, die wesenhaft zum Funktionieren des modernen Kapitals gehörten. Zudem wurde die Welt inzwischen durch das elektronische Signal neu definiert, durch eine unklare Verknüpfung von Impulsen und Austauschbewegungen, die frühere Grenzziehungen leugnet und ihrer eigenen Logik und ihren eigenen Imperativen gehorcht. Als Marx seinen Satz damals fortsetzte: „Alles Fest löst sich in Luft auf, alles Heilige wird profaniert", erschien das noch wie eine Übertreibung. Inzwischen kommt es einem prophetisch vor.

Grossbritannien war seit dem späten 18. Jahrhundert eine Art Versuchslabor zur Erprobung solcher Kräfte, und das Land fungiert noch immer als Petrischale marktgerechter Kulturen. Inspiriert von amerikanischen Ökonomen hat Margaret Thatcher in allen Lebensbereichen die Zügel des Markts schiessen lassen und damit für die Zersetzung von Organisationen und Strukturen gesorgt, die dessen Funktionieren im Wege stehen könnten: Nach Thatcher hat Blair dieses Programm weiter fortgesetzt, die beiden grössten politischen Parteien in Grossbritannien vertreten eine gemeinsame Ideologie der Privatisierung und der minimalen Beeinflussung „des Markts" von staatlicher Seite. Eine wirkliche Opposition gibt es nicht, auch keine Artikulation irgendeiner anderen Möglichkeit. Der Unterschied zwischen den Parteien ist nur mehr eine Sache der Sprache, der Nuance. Es ist kein Zufall, dass dasjenige Modell des deregulierten, uneingeschränkten Kapitals, das sich in aggressiver Gegnerschaft zu den sozialen Gemeinschaftsstrukturen des Staats stellt, die es in weiten Teilen des europäischen Wirtschaftsbündnisses noch immer gibt, das „angelsächsische" Modell genannt wird.

Mark Wallingers Arbeitsweise zeichnet die Auswirkungen dieser Veränderungen auf die Gesellschaft nach, deren Teil er ist. Er beschreibt eine Welt, in der die Ordnungen der Vergangenheit im Niedergang sein mögen, in der jedoch auch ein tiefes Bedürfnis nach symbolischen Ordnungen und Mitteln der Sinnschöpfung weiter besteht; dieses Bedürfnis wird vielleicht sogar durch diesen langsamen Abbau noch verstärkt. Er untersucht die Art und Weise, wie dies in unserer gelebten Erfahrung, in unserem Alltagsleben Ausdruck findet, und wie dieses Verlangen Gespenster erzeugen kann.

Upside Down and Back to Front, the Spirit Meets the Optic in Illusion (1997) ist ein funkelnder Schlund an Wortwitz, Metaphern und Metonymien. Eine mit einer klaren Flüssigkeit

In this work, the transformations between the actual and the ideal are largely enacted through the vehicle of language. As the blind striding figure in *Angel* (1997) jerkily enunciates, 'In the beginning was the Word and the Word was with God and the Word was God.' In systems developed from the 'religions of the book' – the Talmud, Gemmatria, mediaeval theology and Fundamentalist Christianity – the word has power, which is reflected in Wallinger's approaches and practice. Its combinations and operations, its resemblances, echoes, puns and homophones have real significance, and they make and define a 'reality' as much as they describe it. A word attached to an object makes it abstract, symbolic, and so moves it from a physical into a metaphysical realm.

The Importance of Being Earnest in Esperanto (1996) represents an alternative world and an ideal realm. Esperanto was invented in 1887 by a Polish eye specialist, Dr Ludovic Lazarus Zamenhof, as a universal second language that would further international peace and understanding. Nation was to speak unto nation and encourage a community with a global consciousness to come into being. It was a humanist, modernist project for the perfectibility of mankind: the Old Testament

after all represents the variety of human language as a curse imposed by God as punishment of mankind's ambition to build a tower 'that would reach into heaven'. Zamenhof sought to lift this curse. It is not a project that has survived the 20th century: in 1911 there was a proposal to replace Chinese with Esperanto to modernise the country, but nowadays only a few speak or understand the language. Wallinger found a film of one of Oscar Wilde's sunny Edwardian comedies acted by Esperanto enthusiasts, and presents the ageing recording of the clumsy, touching, now incomprehensible performance, witnessed by a diverse and motley selection of empty seats.

Watching the man articulate words in his strange awkward and garbled locution in *Angel*, we become aware that the tape has been reversed. People on the flanking escalators are walking backwards up the stairs, and listening to the strange swallowed surges and clips in the constituent consonants and vowels of the speech it becomes clear that each syllable must have been enunciated somehow in reverse so that when the video was run from the end back to the beginning the sounds would reconstitute themselves into sense. A vast realm

gefüllte Flasche mit jenem Dosiermechanismus, einer Optik am oberen Ende, wie sie in Kneipen Verwendung findet (die anzeigt, dass die Flasche andersherum, mit dem Hals nach unten hängen soll und wird, wenn sie in ihren Gebrauchszustand überführt wird), wird mit ihrem Boden auf einen verspiegelten Tisch platziert, wie man ihn auch in einer Cocktailbar vorfinden könnte. In unserer Welt, diesseits des Spiegels, ist das Etikett kaum leserlich, die Buchstaben sind spiegelverkehrt, stehen auf dem Kopf und bleiben sinnlos. Nur wenn man in jene Welt hinüberschaut, die so verlockend auf der anderen Seite der gläsernen Barriere liegt, kann man sehen, was dort zu lesen ist. In dieser anderen Dimension hängt die Flasche in den Raum hinab und es gelingt uns zu entziffern: „The Spirit"... „original and absolute, 100% Proof". Sie so im Spiegelbild nach unten umgekehrt zu sehen, das gemahnt daran, dass dieses Etikett, die Beschreibung darauf, ja sein ganzes Wesen letztlich verdreht und unvollständig bleiben wird, auch wenn man es auf unserer Seite des Glases umdrehen würde. Nur auf der anderen Seite kann es seine Idealform erreichen – platonische Reinheit. (Doch wie verlockend noch dazu, dass es selbst da eine Spur des Unvollkommenen gibt, da der Reinheitsgrad von Alkohol in England früher auf einer bis 172.5 für pures Äthanol reichenden Skala ermittelt wurde). Man will uns glauben machen, dieser reine

„Spirit", dieser Geist sei – auf die eine oder andere Weise – der Künstler: am Ursprungsort Chigwell auf Flaschen gezogen und in Violett, Weiss und Grün, seinen eigenen Erkennungsfarben, etikettiert.

In dieser Arbeit vollziehen sich die Wandlungsprozesse zwischen dem Wirklichen und dem Idealen weitgehend über das Vehikel der Sprache. Wie es die blinde, ausschreitende Figur in der Arbeit *Angel* (1997) stammelnd ausspricht. „Am Anfang war das Wort und das Wort war bei Gott und das Wort war Gott." Innerhalb der als „Buchreligionen" entwickelten Systeme, dem Talmud, der Gematrie, der mittelalterlichen Theologie, dem fundamentalistischen Christentum hat das Wort grosse Macht, und das tritt in Wallingers Ansätzen und Arbeitsweisen deutlich hervor. Seine Kombinationen und Operationen, seine Ähnlichkeiten, Echos und Gleichklänge besitzen echte Bedeutsamkeit, und sie schaffen und definieren im selben Masse eine „Wirklichkeit" wie sie sie beschreiben. Weist man einem Gegenstand ein Wort zu, dann lässt dieses ihn abstrakt, symbolisch werden und versetzt ihn aus dem Bereich des Physischen in denjenigen des Metaphysischen.

The Importance of Being Earnest in Esperanto (1996) repräsentiert eine Alternativwelt, ein Reich des Idealen. Die Sprache

of arcane and popular reference and association is opened up here: the Black Mass is a Christian rite performed backwards. When record players allowed one to push the vinyl backwards against the needle, it was popularly believed that backwards satanic messages were hidden in the run-out grooves at the end of records by Led Zeppelin or Judas Priest to brainwash adolescent listeners made susceptible by glandular chemistry and/ or drugs. Here, however, the text is of the creation of the world. At the end of the work, against a rising swell of music from Handel's *Zadok the Priest*, the messenger is carried away by the moving staircase up to the vanishing point of heaven. Are the realms here, in the Angel Station Islington, the bottom of the longest escalator in Europe, themselves infernal? Is the sunglasses clad angel echoing or enacting the harrowing of hell, where between the time of the Crucifixion and the Resurrection, Jesus descended into Hades to bring salvation to the souls held captive there since the beginning of time? If so, they seem remarkably unbothered: there is the occasional bemused stare, a single flash of a camera, as they look at this unexpected, incomprehensible enactment unfolding in the middle their daily commute.

Oxymoron (1996) proposes an ideal state through reversals of colour rather than of space. The Union Jack of the British Isles combines the crosses of St George, representing England, St Andrew, representing Scotland, and St Patrick, representing Ireland, into a unitary flag representing the political union of Great Britain. In Ireland this was the banner of colonial oppression and represented the imposition of a schismatic church – the Church of England – for the majority Catholic population. After the south of Ireland gained independence – as Eire – this role was maintained in the north, where the IRA and other republican forces were locked in a vicious struggle both with the new Protestant majority and the British army. Wallinger substitutes the complementary colours red, white and blue of the Union Flag for the Irish tricolour, to make a banner that is both a contradiction in terms, as the title implies, but which allows an ideal state, an alternative history, a science-fiction resolution of opposites, to momentarily flutter into being.

The Underworld (2004) is a ring of 21 video monitors facing inwards, with a cacophonous wave of roaring coming from the speakers. Each screen shows footage from a

Esperanto wurde 1887 von Dr. Ludovic Lazarus Zamenhof, einem polnischen Augenspezialisten, als eine universelle Zweitsprache erfunden, die Frieden und Verständigung zwischen den Nationen befördern sollte. Nation sollte zu Nation sprechen und den Mut zu einer Gemeinschaft mit globalem Bewusstsein propagieren. Es war ein humanistisches, modernistisches Vorhaben, dem es um die Möglichkeit einer Vervollkommnung der Menschheit ging: Schliesslich stellt das Alte Testament doch die Vielfalt der menschlichen Sprachen als von Gott verhängten Fluch dar, durch den er die menschliche Hybris bestraft, einen Turm „bis in den Himmel" bauen zu wollen. Zamenhof wollte diesen Fluch aufheben. Als Projekt hat die Sprache das 20. Jahrhundert nicht überlebt: Im Jahr 1911 wurde diskutiert, Chinesisch durch Esperanto zu ersetzen, um China zu modernisieren, heutzutage gibt es nur noch wenige, die Esperanto sprechen oder auch nur verstehen können. Wallinger hat eine Verfilmung von Oscar Wildes heiterer Komödie aus der edwardianischen Zeit gefunden, die mit Esperantobegeisterten produziert wurde, und diese gealterte Aufnahme der in ihrer Ungelenkheit anrührenden, heute nicht mehr verständlichen Aufführung zeigt er aus der Perspektive einer höchst unterschiedlichen und bunt gemischten Auswahl leerer Sessel.

Während man in *Angel* den Mann beim Sprechen in seiner seltsam linkischen und verdrehten Sprache beobachtet, bemerkt man, dass das Videoband rückwärts läuft. Die Menschen gehen die seitlichen Rolltreppen rückwärts hinauf und lauschen den merkwürdig verschluckten Stimmhebungen und Abbrüchen in den Konsonanten und Vokalen, aus denen sich die gesprochene Sprache zusammensetzt. Es wird einem klar, dass jede einzelne Silbe irgendwie rückwärts ausgesprochen werden musste, um bei rückwärts laufendem Video die Klänge wieder einen Sinn ergeben zu lassen. Es eröffnet sich einem ein riesiges Feld von arkanen und populären Referenzen und Assoziationen: Die Schwarze Messe ist wie eine christliche, die jedoch in umgekehrter Reihenfolge vollzogen wird. Als es einem die Plattenspieler noch ermöglichten, die Vinylscheiben gegen die vorgesehene Laufrichtung der Nadel zu drehen, glaubte man weithin, in den Auslaufrillen am Ende der Schallplatten von Led Zeppelin oder Judas Priest würden sich satanische Botschaften verbergen, um die heranwachsende, durch hormonelle Chemie und/oder Drogenkonsum vorbereitete Hörerschaft einer Hirnwäsche zu unterziehen. Doch hier beschreibt der Text die Schöpfung der Welt. Zum Ende des Werks hin wird der Bote zur anschwellenden Musik aus Georg Friedrich Händels *Zadok der Priester* von der Rolltreppe bis zum Fluchtpunkt im Himmel davongetragen. Ist

recording of Verdi's *Requiem*, and each is inverted, so that we see the singers and orchestra hanging down into space, their mouths opening and closing. The performance has been cut up into its constituent 21 movements, and rather than being played in their sequential order, these are run simultaneously to fill the ring with light and image and to generate a fiendish noise. In the eighth circle of Hell described by Dante, the simoniacs hang upside down for eternity in baptismal fonts, their feet on fire.

By taking images from our everyday lived experience and refracting them through the ontological and mythical constructions of the past, Wallinger makes them speak powerfully of the mechanisms of loss and our desire for syntax and meaningful structure. *Threshold to the Kingdom* (2000) represents the doors at the airport, which people arriving from overseas pass through into the international arrival lounge, as a possible entry to heaven, and where the immigration officer has perhaps taken on the role of St Peter. People emerge after their flight and cross this barrier into their new domain. Their movements are shown in slow motion, to the background of Allegri's *Miserere*. *Landscape with Fall of Icarus* (2007)

replays footage of men plunging to earth from one of those television shows that focus on accidents and mishaps and broadcasts them as the occasion for impossible mirth. Through the work's title, a register is generated that articulates their efforts as an heroic striving to break free of terrestrial bonds, challenging the Gods, an act that has held human meaning for thousands of years – in mythology, in Brueghel's paintings and in the poetry of W. H. Auden (who returns this action to the everyday: "About suffering they were never wrong / The Old Masters; how well, they understood its human position; how it takes place / While someone else is eating or opening a window or just walking dully along").

Although they are profoundly shaped by loss, these works are not expressions of nostalgia: they are not proposing the return of a cannon, of a unifying grand narrative that runs from the Classical world through the St James Bible and Shakespeare up to the dawn of Modernity. They speak of our distance from this community as well as our proximity to it, and of how, in the contemporary world, these returns also conjure up a double, a dark side of superstition and fear, a universe that is supernatural and shaped by forces beyond our

dieses Reich hier, in der Angel Station Islington, am unteren Ende der längsten Rolltreppe Europas, selbst infernalisch? Ist unser Engel mit der Sonnenbrille ein Echo, eine Aufführung der Qualen der Hölle, wie in dem Zeitraum zwischen Kreuzigung und Auferstehen, als Jesus in den Hades hinab stieg, um jenen Seelen die Rettung zu bringen, die dort von Anbeginn der Zeit an gefangen gehalten wurden? Wenn dem so ist, dann erscheinen sie dadurch bemerkenswert unbeeindruckt: Es gibt wohl das eine oder andere verwirrte Starren, das vereinzelte Aufblitzen einer Kamera, wenn sie dieses unerwartete, unbegreifliche Schauspiel sehen, das sich ihnen auf ihrer täglichen Wegstrecke darbietet.

Oxymoron (1996) entwirft einen idealen Staat nicht über die Veränderung von räumlichen Bedingungen, sondern durch einen Austausch von Farben. Der Union Jack der britischen Inseln verbindet in sich die Kreuzformen des Heiligen Georg für England, des Heiligen Andreas für Schottland und des Heiligen Patrick für Irland zu einer einzigen Flagge, die für das politische Bündnis Grossbritannien steht. In Irland repräsentierte sie die koloniale Unterdrückung und die Erzwingung einer schismatischen Kirche – der englischen Staatskirche – für die katholische Mehrheitsbevölkerung. Nachdem Südirland als Eire die Unabhängigkeit erlangte, erhielt sich diese

Rolle im Norden, wo die IRA und andere republikanische Kräfte sich in einen erbitterten Kampf sowohl mit der neuen protestantischen Mehrheit als auch mit der britischen Armee verbissen. Wallinger ersetzt die Komplementärfarben Rot, Weiss und Blau der Unionsflagge durch die irische Trikolore, und gelangt so zu einem Banner, das, wie der Titel der Arbeit schon andeutet, einen Widerspruch in sich darstellt, dabei jedoch auch für einen flüchtigen Moment das Aufscheinen eines idealen Staates erlaubt, eine alternative Geschichte, eine Versöhnung der Gegensätze mit den Mitteln der Science-Fiction.

The Underworld (2004) ist ein Kreis aus 21 nach innen gewendeten Videomonitoren, deren Lautsprecher eine kakophonische Lärmwelle ausstrahlen. Auf jedem Bildschirm sind Aufnahmen einer Einspielung von Giuseppe Verdis *Messa da Requiem* zu sehen, und diese sind allesamt auf den Kopf gedreht, sodass wir die Sänger und das Orchester in den Raum hinabhängen und ihre Münder öffnen und schliessen sehen. Die Aufführung wurde in die 21 Sätze zerlegt, aus denen sich das Werk zusammensetzt, und statt sie der Reihe nach und nacheinander zu zeigen, werden sie hier alle gleichzeitig gespielt, wodurch sich der Monitorkreis mit Licht und Bildern anfüllt und den erwähnten Höllenlärm erzeugt. Im achten

control: where 48% of people questioned in a poll for Fox news in the USA in 2003 believed that they had witnessed a miracle. Certainly *Forever and Ever* (2002) seems to propose Christian theology as an endless loop of sin, penitence and delayed salvation. It takes the form of a vast Möbius strip of aluminium covered with the red and white stripes that indicate a hazard and a Gothic text running its endless length which reads, 'O Lamb of God, that takest away the sins of the world, have mercy upon us.' This is the penultimate line of the liturgy, the final line of which is, 'O Lamb of God, that takest away the sins of the world: grant us thy peace'. The work suggests an endless repetition of supplication and a repeated sacrifice by the 'Lamb of God' – Christ – to expiate our sins, but without the possibility of end, of resolution, of peace, which is endlessly deferred.

The End (2006) is a projection of a list 'in order of appearance' of named characters in the Old Testament and the start of the New up to the appearance of Jesus, as if they were rolling credits at the end of a film. This can be read as a reference to the *Ten Commandments*-type Biblical epic (with Charlton Heston as Moses), and how these figures and texts have provided material for heroic imaginings and representations for the last thousand years; perhaps how the Old Testament might itself be seen itself as a vast fiction, a collection of foundational myths of a tribal people. Alternatively, this list of names has other uses and implications. It recalls the genealogy used by Creationists to give a date for the creation of the universe and the world, not in the billions of years of the geological and astronomical sciences, but in the thousands: adding together the life-spans of Adam, Cain, Noah, Moses and so forth, Bishop James Ussher (1581–1656) arrived at the date of 4004 BC for the world's creation. The phrase 'The End' carries another loading. There was a great debate in the18th century as to whether the Jesus of the New Testament was the Messiah as predicted by the Old Testament and therefore the fulfilment of its prophecy, or whether he represented a new settlement between Man and God, which superceded the old. The decision that he was part of this syntax allowed the rather more atavistic and directive directions and beliefs of the Old Testament to become central in the evolution and construction of Christian Fundamentalism. A belief in Old Testament prophecy shapes the support of the Christian Right in the USA for Israel, as the Temple in Jerusalem must be

Kreis der Hölle, wie er bei Dante beschrieben wird, hängen die Simonisten in alle Ewigkeit kopfunter in Taufbrunnen hinein, ihre Füsse dagegen brennen.

Nimmt man Bilder aus unserer täglich gelebten Erfahrung heraus und spiegelt sie durch die ontologischen und mythischen Konstruktionen der Vergangenheit, dann erlangen sie einen hohen Grad an Aussagekraft über Verlustmechanismen und über unser Bedürfnis nach einer Syntax und einer sinnhaften Struktur. *Threshold to the Kingdom* (2000) zeigt uns jene Türen auf Flughäfen, durch die Menschen aus fernen Ländern in die internationalen Ankunftshallen gehen, die wie mögliche Pforten zum Himmel erscheinen: Der Beamte der Einwanderungsbehörde spielt dort vielleicht die Rolle des Heiligen Petrus. Menschen treten nach ihrer Landung aus ihnen heraus und überschreiten diese Barriere in Richtung ihres neuen Bereichs. Man sieht ihre Bewegungen in Zeitlupe, zu den Klängen von Gregorio Allegris *Miserere* im Hintergrund. *Landscape with Fall of Icarus* (2007) wiederholt Filmmaterial von zur Erde stürzenden Menschen aus einer jener Fernsehshows, die sich auf Bilder von Unfällen und Missgeschicken als Gelegenheit zur Schadenfreude spezialisieren. Über den Titel der Arbeit entsteht ein neues Bedeutungsregister, das die Bemühungen wie heroische Versuche einer Selbstbefreiung von den Fesseln des Erdendaseins aussehen lassen, wie eine Herausforderung der Götter, ein seit Jahrtausenden menschlicher Geschichte bedeutungsvoller Akt; in der Mythologie, in dem gleichnamigen Gemälde von Pieter Brueghel und in der Dichtung von W. H. Auden (der diese Handlung ins Alltägliche zurückversetzt: „Was immer das Leiden angeht und seinen Rang – die Alten Meister, da sahn sie durch! Wie die verstanden, es einzuordnen ins Alltagsleben. Und wie so was abläuft, das Unerhörte, indessen irgendwower am Futtern ist / Oder öffnet grad wo ein Fenster / Oder schlendert gelangweilt wohin" [Übers. Wolf Biermann]).

Obwohl sie zutiefst von Verlusterfahrungen geprägt sind, drücken diese Arbeiten doch keine Nostalgie aus: Sie treten nicht für die Rückkehr eines Kanons oder einer grossen Einheitserzählung ein, die sich aus der klassischen Antike über die Saint-James-Bibel und William Shakespeare bis zum Anbruch der Moderne erstreckte. Sie künden von unserer Distanz wie von unserer Nähe zu der so zu umreissenden Gemeinschaft, und davon, wie in unserer heutigen Welt diese Rückkehrbewegungen auch ihr Gegenteil, ihre dunkle Seite, Aberglauben und Angst hervorrufen, ein Universum des Übernatürlichen, das von Mächten jenseits unserer Einwirkungsmöglichkeiten kontrolliert wird und in dem im Jahre 2003 bei einer Umfrage für

re-built if Christ is ever to re-appear, so initiating the 'End of Days'.

It is difficult to think of any other major contemporary artist who so consistently invokes Christian iconography and biblical reference in their practice. His expressions are even more unusual as they are not driven by the iconoclastic imperatives that are the more common default position for the progressive artist of the European avant-garde when dealing with issues of religion and the Church, nor are they the awed eternal expressions of a mystic. His references draw on the British non-conformist Christian tradition rather than the European Catholic one. The country has a complex and nuanced relationship with faith: in common with much of Europe, a small – and declining – number of people actually go to church; under six percent worship on a regular basis in the UK as opposed to over 50% in the USA. Nor is the political arena much influenced by issues of faith. As an advisor to Prime Minister Tony Blair famously said, 'We don't "do" God.' The Church of England maintains a discrete, albeit agonised, presence in daily life. The Protestant tradition, however, is also one of dissent. The English Civil War between Royalists and Republicans was fuelled by the imperatives of Puritanism, and the history of progressive politics has been inextricably entwined with faith groups who have privileged freedom of conscience, self-sufficiency and a non-mediated relationship with the divine, in what has become a tradition of radical non-conformism. From Diggers to Methodists, from Milton to Wesley, it has been at the forefront of change and reform and, without the burden on original sin, the imagining of perfectibility. It speaks in the work of William Blake, who saw the outlines of a 'New Jerusalem', where Christ might walk again, under the 'dark Satanic Mills' of his newly industrialised country. Conversely, these non-conformist and dissenting sects – the Baptists, the Quakers, the Presbyterians, with their ethos of self reliance, self improvement and duty as moral imperatives – helped shape the creation of the new entrepreneurial class which drove forward the Industrial Revolution. History books used to describe how in the 19th century a combination of Methodism and Chartism uniquely redirected energies that were otherwise expressed as revolution across Europe.

den Nachrichtensender Fox 48% der Befragten angaben, sie hätten schon einmal ein Wunder erlebt. *Forever and Ever* (2002) scheint christliche Theologie als einen endlosen Kreislauf von Sünde, Busse und aufgeschobener Erlösung zu entwerfen. Diese Arbeit bildet einen riesigen Möbiusstreifen aus Aluminium, der mit roten und weissen, auf Gefahr deutenden Streifen und mit einem Text in gotischen Lettern versehen ist, der in die ganze endlose Länge der Schleife eingeschrieben ist: „Lamm Gottes, Du nimmst hinweg die Sünde der Welt, erbarme Dich unser." Das ist die vorletzte Zeile der Liturgie, die letzte lautet: „Lamm Gottes, Du nimmst hinweg die Sünde der Welt, gib uns Deinen Frieden." Die Arbeit deutet eine unaufhörliche Wiederholung der Fürbitte und die wiederholte Opferung des „Lamm Gottes" – Christi – an, zur Tilgung unserer Sünden, jedoch ohne jede Aussicht eines Endes, einer Auflösung, eines Friedens, der immer wieder aufgeschoben wird.

The End (2006) ist die Projektion einer Liste namentlich erwähnter Gestalten aus dem Alten und vom Beginn des Neuen Testaments bis zur Erscheinung Jesu, ganz so als handle es sich um einen Filmabspann. Dies kann man als Referenz auf das biblische Epos im Stil von *Die Zehn Gebote* (mit Charlton Heston als Moses) lesen, und auch darauf, wie diese Figuren und Texte in den letzten tausend Jahren Stoff für heroische Einbildungen und Darstellungen hervorgebracht haben, wie man vielleicht auch das Alte Testament selbst als eine gigantische Fiktion, als Sammlung der Ursprungsmythen eines Stammesvolks verstehen kann. Daneben deutet diese Namenliste aber auch auf andere Gebrauchsformen und Folgen hin. Sie erinnert an die von den Kreationisten gebrauchte Genealogie zur Datierung der Schöpfung des Universums und der Welt, die nicht in den Jahrmilliarden der geologischen und astronomischen Wissenschaften gedacht ist, sondern in Jahrtausenden: Bischof James Ussher (1581–1656) gelangte, indem er die Lebensspannen von Adam, Kain, Noah, Moses usf. zusammenrechnete, zu dem Ergebnis, die Schöpfung habe sich im Jahre 4004 vor Christus ereignet. Der Ausdruck „The End" trägt noch eine weitere Bedeutungsebene. Im 18. Jahrhundert gab es eine grosse Debatte darüber, ob der Jesus des Neuen Testaments der im Alten Testament vorhergesagte Messias sei, also die Erfüllung einer alttestamentarischen Prophezeiung, oder ob er einen neuen Bund zwischen Mensch und Gott bedeutete, der den alten Bund ablöste. Die Entscheidung, dass er Teil dieser Syntax war, sorgte dafür, dass die eher atavistischen Überzeugungen und Anweisungen des Alten Testaments eine zentrale Rolle in der Herausbildung und Konstruktion des christlichen Fundamentalismus erhalten konnten. Der Glaube an die Weissagungen des Alten

Although Britain is now only nominally a Christian country, Christian images and languages have long shaped how potential has been imagined. They have been formative in the constructions of culture, class, conscience and the traditions of liberty, as well as superstition and oppression. Wallinger's work draws upon these many narratives. We can sense its strange certainties in the lonely figure of Brian Haw, the man who originated the protest that Wallinger recreated as *State Britain* (2007), we can feel its transformative power in the swelling chords of Allegri's *Miserere* in *Threshold to the Kingdom*, we can see its darker impulses in the ungainly figure of 'Blind Faith' – part Roy Orbison part Robert Mitchum in *Night of the Hunter* – as he strides towards us with his white stick and sunglasses in *Angel*.

In the development of his work and concerns from the early exploration of nation and class to his investigation of (other) belief systems, Wallinger has reflected and anticipated profound effects as a result of the fall of the Berlin Wall. This event marked an accelerated evaporation of the ideas of class and political ideology that allowed individuals and groups to analyse their position in society and imagine and propose alternatives.

Concepts and identities that had been central to how 'opposition' was imagined have become hazy and ethereal since the first crowds, grinning and celebratory, crossed the abandoned borders from the East into the West. Enlightenment values of scientific rationalism, of testability, of individual questioning that have underpinned notions of progress from Montaigne through Voltaire onwards have become increasingly qualified. More and more, the atomised certainties of theology are occupying territories once inhabited by ideology. Beliefs and positions are relativised: things are seen as true because they are believed in rather than believed in because they are true. Homeopathy has the same credence as medical science, Creationist ideas can be taught in state-supported academies at the same time as Evolution. Any position is understood to be one option among others. Ideas of direction, of development, become subsumed in a Brownian motion of equivalence.

Sleeper (2004) was shot in Berlin over a continuous two-and-a-half hour section of a ten-night-long performance, 15 years after the Wall fell, and shows a bear moving slowly through the vast empty spaces of a modernist building at night. The bear sits down in a way that

Testaments prägt auch die unterstützende Haltung der US-amerikanischen christlichen Rechten für Israel, denn diese geht davon aus, dass bei der letztendlichen Rückkehr Christi zum „Jüngsten Gericht" der Tempel in Jerusalem wiedererbaut sein muss.

Es fällt einem kaum ein anderer zeitgenössischer Künstler ein, der sich in seiner Arbeit so durchgängig auf christliche Ikonographie und biblische Bezüge berufen würde. Seine Art des Ausdrucks macht noch ungewöhnlicher, dass Wallingers Arbeit nicht von einem bilderstürmerischen Imperativ getrieben ist, wie dies immer das Grundmodell des progressiven Künstlers europäischer Avantgarden im Umgang mit den Themen Religion und Kirche war, und er lässt sich auch nicht von den ewigen Ausdrucksformen einer Mystik in Bann schlagen. Seine Bezugslinien verlaufen in Richtung der britisch-nonkonformistischen Tradition des Christentums und nicht so sehr in Richtung des kontinentaleuropäischen Katholizismus. Das Land hat eine sehr komplexe und nuancenreiche Beziehung zum Glauben: Mit weiten Teilen Europas verbindet es die Tatsache, dass nur eine geringe – und tendenziell noch abnehmende – Anzahl von Menschen tatsächlich zur Kirche geht. In Grossbritannien besuchen weniger als 6% regelmässig die Heilige Messe, in den Vereinigten Staaten sind es

dagegen über 50%. Auch die politischen Auseinandersetzungen sind von „Glaubensfragen" recht wenig berührt. Wie es ein Berater von Premierminister Tony Blair formuliert haben soll: „We don't ‚do' God" (sinngemäss: „Gott kann für uns in der Politik kein Thema sein"). Die englische Staatskirche erhält sich als diskrete, wenn auch innerlich zerrissene Präsenz im Alltagsleben. Doch ist die protestantische Tradition auch eine Tradition der Andersdenkenden. Der englische Bürgerkrieg zwischen Royalisten und Republikanern wurde von den Forderungen des Puritanismus angestachelt, und die Geschichte progressiver Politiken ist untrennbar mit jenen Glaubensgruppen verbunden geblieben, die Gewissensfreiheit, Selbstgenügsamkeit und eine unmittelbare Beziehung zum Göttlichen vornan gestellt und zu einer Tradition des radikalen Nonkonformismus geformt haben. Von den Diggers zu den Methodisten, von Milton bis zu Wesley, war diese Tradition an vorderster Front bei Veränderungen und Reformen und, befreit von der Last der Erbsünde, bei der Entwicklung einer Vorstellung von menschlicher Vollkommenheit. Man kann sie auch im Werk von William Blake vernehmen, der die Umrisse eines „Neuen Jerusalem", durch das Christus wieder schreiten könnte, unter den „finsteren Teufelsmühlen" seines gerade industrialisierten Landes auszumachen glaubte. Umgekehrt haben diese nonkonformistischen und abweichlerischen

is comic and a little sad; it shuffles around, gesturing. The building is like a cage. How did it get there? Our bear doesn't really seem to be doing anything much. Our bear is many things and nearly nothing. But it is not a bear, it is Mark Wallinger in a dusty, fusty bear suit. Shot from outside, through the vast glass walls of the Neue Nationalgalerie, Mies van der Rohe's iconic building in Berlin, the work offers us possibilities to narrate our bear in many different ways: he is the Symbolic Bear representing the city of Berlin, he is the Enchanted Bear from the *Singing Ringing Tree*, a television program made in Communist East Germany in the 1960s and broadcast in the UK, but never seen in West Germany. He is the Mythic Bear from the dark Germanic forest of a Grimm's fairy tale. Perhaps he is the Russian Bear, or the Bear of Nature trapped in the glass cube of culture, of modernity. But he is not even real. Ultimately our bear is always returned to a man dressed up as a bear in a theatrical hire suit, shuffling around an empty space. Our bear is all and none of these identities; they are potential not actual. He is a kind of 'sleeper' – a term that comes from the Intelligence Services and signifies those in the pay of a government buried deep in a foreign organisation, just doing what should be done day to day,

not drawing attention to themselves, unremarkable. In theory they are agents of an opposing power, perhaps an opposing ideology, but while they are sleepers they remain dormant, entirely mute, latent.

For most of the 20th century the 'outsider' figure was a foundational myth of the revolutionary imagination; an individual who operates alone, without the received beliefs of society, who, agnostic, atheist, forges his/her own credo in an uncaring world. A person who is without illusion, and whose forensic glare reveals the emptiness of heaven. This individual is a logical outcome of the interrogative agenda of the Enlightenment. It is Meursault in the *L'Étranger*, opening himself up to the indifference of the Universe. Given a social sphere that seems increasingly to be without unifying narrative or ontological drive, the outsider is the figure who has a belief that stands apart. Revealed Truth provides a basis and impetus for change and action. This may be benign or possessed of what Yeats described as 'a passionate certainty'. In a deracinated materialist culture it becomes a node for proposition and opposition, and it is this complex return that the pale presence of Wallinger's *Ecce Homo* (1999) conjures up.

Sekten – die Baptisten, die Quäker, die Presbyter – mit ihrem Ethos der Selbstgenügsamkeit, der Selbstverbesserung und der Pflichterfüllung als moralischem Imperativ zur Herausbildung einer neuen Klasse des Unternehmertums beigetragen, die die Industrielle Revolution vorantrieb. In Geschichtsbüchern stand oft zu lesen, wie im 19. Jahrhundert eine Kombination aus Methodismus und Chartismus in einzigartiger Weise Energien umgelenkt habe, die überall sonst in Europa ihren Ausdruck in der Revolution gefunden hatten.

Obwohl es sich heutzutage nur dem Namen nach um ein christliches Land handelt, lieferten hier christliche Bilder und Sprachen lange Zeit die wichtigste Form, in der sich Potenziale ausdrücken liessen. Sie waren entscheidend beteiligt an den gesellschaftlichen Konstruktionen von Kultur, Klasse, Gewissen, wie auch an Traditionen wie Freiheit, Aberglauben und Unterdrückung. Wallingers Werk bezieht sich auf dieses ganze Spektrum von Erzählungen. Seine merkwürdigen Gewissheiten werden für uns in der einsamen Figur des Brian Haw erahnbar, jenes Mannes, der den von Wallinger in der Arbeit *State Britain* (2007) wieder erschaffenen Protest ursprünglich ausgelöst hat; wir können seine Verwandlungskraft in den anschwellenden Akkorden von Allegris *Miserere* in *Threshold to the Kingdom* erahnen, wir können seine

dunkleren Impulse in der unbeholfenen Figur des „Blinden Glaubens" – teils Roy Orbison, teils Robert Mitchum in *Die Nacht des Jägers* – ausmachen, wenn er in *Angel* mit seinem weissen Blindenstock und seiner dunklen Brille auf uns zugeht.

In der Entwicklung seines Werks und seiner Themen hat Wallinger – von seinen frühen Erkundungen zu Nation und Klasse bis zu seiner Auseinandersetzung mit (anderen) Glaubenssystemen – die tiefgehenden Auswirkungen des Falls der Berliner Mauer reflektiert und vorweggenommen. Dieses Ereignis stand am Anfang eines beschleunigten Verfalls von Klassenvorstellungen und politischen Ideologien, der es Einzelnen und Gruppen ermöglichte, ihre Positionen in der Gesellschaft analytisch zu betrachten und Alternativentwürfe zu entwickeln und vorzulegen. Ehemals für die Art der Imagination von etwas Oppositionellem zentrale Begrifflichkeiten und Identitäten sind unscharf bis zur Verflüchtigung geworden, seitdem die ersten freudig grinsenden und feiernden Menschenmassen die aufgegebenen Grenzen vom Osten aus in Richtung Westen überschritten haben. Wertvorstellungen der Aufklärungstradition – wissenschaftlicher Rationalismus, Nachprüfbarkeit und individuelle Möglichkeiten der Infragestellung, die die Fortschrittsbegriffe von Montaigne über

Originally conceived for an empty plinth in Trafalgar Square, London, as part of a public commission to find a modern work of art to join the bronze figures of lions, dignitaries and generals from a previous age that surround it, *Ecce Homo* is a body cast of a male figure. He is white, made from resin mixed with marble dust. He is individual, unremarkable, his eyes are closed, his hands are tied behind him and his head girdled by a band of gold-plated barbed wire. When standing on the plinth, this slight figure seemed dwarfed by the scale of architecture and sculpture around him, and this vulnerability is maintained when we see the figure in a gallery. It is so restrained, of the world, mundane, that it recalls the actors and students and street entertainers who, covered in pigment, stand motionless on boxes in parks and avenues across Europe as living statues for tourists, as much as it reminds us of a marble statue in a museum or gallery.

Much of the (overwhelmingly positive) public reaction to *Ecce Homo* took it to be a humanist representation of Christ: the title refers to the moment that Pilate presents Christ for judgment saying, 'Behold the man!' This is a man alone, betrayed, stripped of association and

persecuted for his beliefs, trapped in a trial that has as its inevitable outcome his torture and death: events that lead him to ask why he has been forsaken by God. The pale figure, alone on the plinth, talks of a shared humanity, of the oppressed and downtrodden, the persecuted, the vulnerable, the scorned. His palpable isolation speaks of the condition of man. This is 'The Son of Man'.

The figure is also the opposites of these qualities. It is supra-human, the Divine given form on earth. A unique manifestation of the Godhead: 'God the Son' which, according to the Nicene Creed is of the same substance as God (and is both fully divine and fully human). This is the miraculous body, which, daily in Catholic Masses across the world, is 'truly present' in the bread and wine consumed by the faithful in thousands of churches in hundreds of countries. It is his sacrifice on the cross that gives us hope, that redeems the sin with which we have been tainted since the Fall and the expulsion of man from the Garden of Eden. The different understandings of this figure and its relation to God have given rise to different heresies across history – Arianism, Ebionitism, Monophysitism, Docetism and so forth. What you believe this statue to represent fundamentally determines how

Voltaire und darüber hinaus gekennzeichnet haben – sind immer stärker qualifiziert worden. Mehr und mehr trifft man die atomisierten Gewissheiten der Theologie an Stellen an, die zuvor der Ideologie vorbehalten waren. Überzeugungen und Positionierungen sind relativiert worden: Dinge werden für wahr gehalten, weil man an sie glaubt, und nicht mehr geglaubt, weil sie wahr sind: Die Homöopathie hat die gleiche Glaubwürdigkeit wie die Medizinwissenschaften, an staatlich finanzierten Akademien können kreationistische Ideen neben evolutionistischen gelehrt werden. Jede mögliche Positionierung wird lediglich als eine Option unter vielen verstanden. Vorstellungen von Gerichtetheit oder Entwicklung heben sich in einer Brown'schen Äquivalenzbewegung auf.

Sleeper (2004) wurde als ununterbrochenes Zweieinhalb-Stunden-Segment einer zehn Nächte während Performance 15 Jahre nach dem Fall der Mauer in Berlin aufgenommen. Der Film zeigt einen Bären, der sich bei Nacht gemächlich durch die riesigen, leeren Räume eines modernistischen Gebäudes bewegt. Er setzt sich auf eine komische und ein wenig traurige Art und Weise hin; er geht schleppend herum und gestikuliert. Das Gebäude ist wie ein Käfig. Wie ist er da wohl hineingeraten? Unser Bär scheint nicht wirklich besonders viel zu tun zu haben. Unser Bär ist vieles, zugleich aber

auch fast gar nichts. Aber es ist auch kein Bär, sondern Mark Wallinger in einem staubigen, muffigen Bärenkostüm. Da es von aussen gefilmt ist, durch die ausgedehnten Glaswände der Neuen Nationalgalerie, Mies van der Rohes ikonischem Berliner Bau, bieten sich einem in dieser Arbeit sehr viele verschiedene Möglichkeiten an, die Geschichte unseres Bären zu erzählen: Er ist das Maskottchen, das die Stadt Berlin symbolisiert, er ist der verzauberte Bär aus *Der singende, klingende Baum*, einem im kommunistischen Ostdeutschland der 1960er Jahre produzierten Fernsehfilm, der in England nie, sehr wohl aber in Westdeutschland ausgestrahlt wurde. Er ist der mythische Bär aus dem finsteren deutschen Wald eines Grimm'schen Märchens. Vielleicht ist er auch der Russische Bär oder der Bär der Natur, der im Glaskubus der Kultur, der Moderne gefangen ist. Aber er ist noch nicht einmal echt. Letzten Endes ist unser Bär immer wieder nur ein als Bär verkleideter Mann, einer, der in einem Kostüm aus dem Theaterfundus in einem leeren Raum umhertappt. Unser Bär hat zugleich alle und keine dieser Identitäten, sie sind möglich, nicht wirklich. Der Ausdruck „Schläfer" stammt aus der Sprache der Geheimdienste und bezeichnet von Regierungen bezahlte verdeckte Agenten, die sich in eine ausländische Organisation einschleichen, dort unauffällig ihrem Tagwerk nachgehen, keinerlei Aufmerksamkeit auf sich ziehen, nichts

you understand your being and conceive your place in the world, the solar system, the galaxy, the universe. What we see in front of us here is not a statement as much as it is a question, the response to which defines everything.

Like any good work of art, *Ecce Homo* shifts meaning as contexts change. The statue was conceived and made two years before the attacks on the World Trade Center, New York. After this event and after the Madrid, Bali, Istanbul and London bombings and the innumerable suicide attacks in Iraq, we cannot help but conceive of the relationship between the human and divine in different ways: individuals who see themselves as messengers of heaven take on another loading. Cambridge University historian Christopher Andrew has calculated that in the 1960s there was not a single religious or cult-based terrorist group anywhere, and as recently as 1980 only two of the world's 64 known terrorist groups were religious. Since then, however, Shi'a extremists alone have been responsible for more than a quarter of the deaths from terrorism. The fact that the figure in *Ecce Homo* is so normal, so unremarkable, might now become a cause of unease. There seems to be nothing to indicate his elevated

state. He is what the security forces would describe as a 'clean-skin'. This puts a particular spin on the fashionable 1960s and 70s constructions of Jesus as a 'freedom fighter' promoting love and redistribution analogous to other good-looking, charismatic, long-haired leaders like Che Guevara.

A similar sea change has taken place with *Passport Control* (1988). This is a series of photographs of the artist, from photo-booths that take images approved for use in passports. Wallinger has variously altered his appearance with a felt tip pen and some Tippex. On one photograph he has drawn on glasses, on another he has blacked up his face. In others he is wearing a beard and a turban, an Arab headdress and moustache. He has the full beard, the ringlets and the black homburg of the Hassidic Jew, or a brimless cap and goatee, pulling up the corners of his eyes with his fingers to become Chinese. Originally these works spoke of ethnicity and identity, but now we read them also in terms of disguise, in terms of religion and, *pace Threshold to the Kingdom*, imagining which heaven they believe they will be entering.

Bemerkenswertes an sich haben. Theoretisch sind sie Agenten einer gegnerischen Macht, vielleicht einer feindlichen Ideologie, doch in ihrem Schläfer-Zustand schlummern sie weiter, bleiben völlig stumm, latent.

Über weite Strecken des 20. Jahrhunderts war die Figur des „Aussenseiters" ein Gründungsmythos revolutionärer Einbildungskraft. Das allein operierende Individuum, das keinen in der Gesellschaft verbreiteten Überzeugungen anhängt, das sich als Agnostiker, als Atheist in einer gnadenlosen Welt sein eigenes Credo konstruiert. Ein Mensch ohne Illusionen, dessen forensischer Blick die Leere des Himmels erweist. Dieses Individuum ist das logische Resultat der Fragenprogramme der Aufklärung. Es ist jener Meursault in Albert Camus' *Der Fremde*, der sich auf die Gleichgültigkeit des Universums hin öffnet.

Geht man von einer sozialen Sphäre aus, die immer weniger über ein einheitliches Narrativ oder eine ontologische Triebkraft zu verfügen scheint, dann ist es die Figur mit der Überzeugung, die sich von den anderen abhebt. Die enthüllte Wahrheit liefert eine Basis und einen Antrieb für Veränderung und Handeln. Das mag gutartig sein oder auch besessen von dem, was W. B. Yeats als „eine leidenschaftliche Gewiss-

heit" beschrieben hat. In einer entwurzelten, materialistischen Kultur wird es zum Knotenpunkt für Aussagen und Gegenaussagen, und es ist eben diese komplexe Erwiderung, die von der fahlen Präsenz von Wallingers *Ecce Homo* (1999) wachgerufen wird.

Ecce Homo war ursprünglich für einen der Sockel auf dem Trafalgar Square in London bestimmt und Teil eines öffentlichen Auftrags zur Schaffung eines modernen Kunstwerks, das zu den umstehenden Bronzefiguren von Löwen, Würdenträgern und Generälen aus vergangenen Zeiten passen sollte. Es ist der Körperabguss einer männlichen Figur. Sie ist weiss und aus einer Mischung aus Harz und Marmorstaub hergestellt. Die Figur ist individuell ausgearbeitet, unspektakulär, ihre Augen sind geschlossen, die Hände sind auf dem Rücken gebunden und ihr Kopf ist mit einem Band aus goldbeschichtetem Stacheldraht bekrönt. Wenn diese zierliche Figur auf einem Sockel steht, dann ist sie verschwindend klein im Verhältnis zur Architektur und den anderen Skulpturen um sie herum; und dieser verletzliche Charakter bleibt erhalten, wenn man die Figur im Innenraum einer Galerie sieht. Sie ist so zurückgenommen, so diesseitig, so profan, dass man mindestens ebenso sehr an die Schauspieler und Studenten und Strassenkünstler denkt, die bewegungslos und mit Farbpigment

In 2001 Brian Haw started his protest against the war in Iraq. Over time this developed into a roadside barricade of images, photos, banners and texts that ran for 40 metres on the pavement opposite the Houses of Parliament in London. On 23 May 2006, police dismantled this under powers granted them by the Serious Organised Crime and Police Act of 2005, an act the government had legislated in part to be able to remove the embarrassment of this display. In 2007 Mark Wallinger presented a detailed simulacrum of the barrier as it had existed at its fullest extent, installing it in a line running the length of the Duveen Galleries of Tate Britain.

The Iraq War had triggered the biggest peacetime protest march ever seen in England. Hundreds of thousands of people walked through London in a demonstration that seemed to have no effect at all on government policy. Brian Haw's solo protest is the last trace of this mass mobilisation. In contrast to most of the marchers, his action has been determined and propelled by a fierce Christian faith. This provides the charge that drives his moral crusade and allows him to continue when others have become increasingly disengaged and disillusioned with politics. The supernatural basis of his beliefs serves to set him outside of this mainstream political expression. Instead he is 'bearing witness' to the evils of this world, like an early Christian in the desert.

Wallinger started documenting the protest before it was taken down, and his re-materialisation of the barricade in the gallery allowed people to wander along its length and focus on its components – Teddy bears, messages of support, Banksy Graphics, B.liar posters, horrifying photographs of a bandaged Iraqi child with eyes burnt by depleted uranium. Cutting across this display was a black line that had been taped to the gallery floor, and this gave the first installation of the work in Tate Britain a particular charge. Owing to its desire to legislate against protest, the government passed an act that created an exclusion zone of 'no more than one kilometre in a straight line from the point nearest to it in Parliament Square (Serious Organised Crime Act 2005 138.3)'. Within this area the Home Secretary and the police could, if so minded, prevent any protest taking place. *State Britain* crossed into this zone. On one side of the line Wallinger's right to expression was curtailed, on the other side of the line it wasn't. By crossing the line, *State Britain* raised fundamental questions of

überzogen auf Kisten in den Parks und Fussgängerzonen Europas als lebende Statuen für Touristen posieren, wie an eine Marmorstatue in einem Museum oder einer Galerie.

Viele der (überwältigend positiven) Reaktionen von Seiten der Öffentlichkeit verstanden *Ecce Homo* als eine humanistische Darstellung Christi: Der Titel bezieht sich auf den Augenblick, in dem Pontius Pilatus Christus zur Beurteilung vorführt und sagt: „Siehe, der Mensch!" Hier ist ein Mann ganz allein, verlassen, von jeder Begleitung getrennt, wegen seiner Überzeugungen verfolgt und in der Falle einer Prozessführung, die nur ein mögliches Ende kennt: seine Folterung und Ermordung; Ereignisse, die ihn fragen lassen, warum Gott ihn verlassen hat. Die bleiche Figur, die allein für sich auf einer Plinthe steht, spricht von einem gemeinsamen Menschsein, von den Unterdrückten und Erniedrigten, den Verfolgten, den Verletzlichen, den Verachteten. Seine geradezu spürbare Isolation spricht von den Daseinsbedingungen des Menschen. Dies ist: „Der Menschensohn".

Die Figur trägt aber auch das Gegenteil dieser Eigenschaften in sich: Sie ist übermenschlich, etwas Göttliches, dem irdische Form verliehen wurde. Eine einmalige Manifestation der Gottheit: „Gottes Sohn", der gemäss dem nizäischen Glaubensbekenntnis von einer Substanz mit Gott ist (und sowohl ganz Gott als auch ganz Mensch ist). Dies ist der wunderbare Körper, der Tag für Tag in den katholischen Gottesdiensten in aller Welt „wahrhaft anwesend" ist in Brot und Wein, das von den Gläubigen in vielen tausend Kirchen in Hunderten von Ländern empfangen und verzehrt wird. Es ist sein Opfertod am Kreuz, der uns Hoffnung gibt; der uns von unseren Sünden befreit, mit denen wir seit dem Sündenfall und der Vertreibung des Menschen aus dem Garten Eden behaftet sind. Die unterschiedlichen Deutungen dieser Figur und ihres Verhältnisses zu Gott haben im Verlauf der Geschichte auch Anlass zu verschiedenen Häresien gegeben, zum Arianismus etwa, zum Ebionitismus, Monophytismus, Doketismus und anderen. Die Auffassung, die jeder Einzelne davon hat, was diese Statue darstellt, legt grundsätzlich fest, wie dieser Einzelne sein Dasein und seine Stellung in der Welt, im Sonnensystem, in der Galaxie, im Universum versteht. Was wir hier vor uns sehen, ist weniger eine Aussage denn eine Frage, deren Beantwortung absolut alles bestimmt.

Wie bei jedem guten Kunstwerk verschiebt sich auch die Bedeutung von *Ecce Homo* nach Massgabe seines Kontexts. Die Statue wurde zwei Jahre vor den Angriffen auf das World Trade Center in New York konzipiert. Nach diesem Ereignis

representation and being. Did the fact that this was a reproduction of Brian Haw's original protest stop it being a protest? Had it become denatured when it was transmogrified into art? Did its representation mean it was exempt from law?

The work also operates as history painting, a mourning of, and exhortation to, ideals and past glories. The fence of cardboard and bears and bottles is a distant echo of the barricade of fallen comrades and soldiers over which Eugène Delacroix represents Liberty leading the French people to their freedom (*Liberty Leading the People*, 1830). *State Britain* serves to memorialise the erasure of protest both within popular imagination and the political arena. It is perhaps the most important work that the war has yet produced.

By representing Haw's demonstration – an expression of moral rage, driven by religious belief and faith rather than ideology – Wallinger also challenges the elisions of current political expression under the new hegemonies of capital, and poses important questions as to how politics can function in a post-ideological world. What can they be built on? What is their ideological basis? Or can they now only be expressed through the darker irrationalities of belief?

Mark Wallinger continues to develop one of the most necessary and compelling practices in contemporary art. He has refused to repeat himself or commodify his expression into productions designed to fulfil the expectations of an audience or marketplace. His work talks about how we might construct meaning in the world that is evolving around us, how we relate to the past that is fading behind us, about loss, about ghosts and how the future might be imagined. *State Britain*, *Ecce Homo*, *Sleeper*, all of his works, refuse the emptiness of easy answers. It is difficult to imagine more important questions.

und nach den Bombenanschlägen in Madrid, Bali, Istanbul und London, und nach den unzähligen Selbstmordattentaten im Irak haben wir das Verhältnis zwischen Menschlichem und Göttlichem zwangsläufig anders zu fassen: Einzelne, die sich selbst als Botschafter des Himmels verstehen, nehmen eine andere Bedeutung an. Der an der Cambridge University lehrende Historiker Christopher Andrew hat ermittelt, dass es in den 1960er Jahren nirgends auch nur eine einzige religiöse oder auf einem Kult basierende Terroristengruppe gegeben hat, und dass noch 1980 nur zwei der 64 weltweit bekannten Terroristengruppen religiösen Charakter hatten. Doch seitdem sind allein schiitische Extremisten für mehr als ein Viertel aller durch Terrorakte hervorgerufenen Todesopfer verantwortlich. Nun könnte die Tatsache, dass die Figur von *Ecce Homo* so normal, so unspektakulär ist, auch Anlass zu Unbehagen sein. Nichts scheint ihren erhöhten Zustand anzudeuten. Die Figur ist, was Sicherheitsbeamte „sauber" nennen würden. Dies gibt den in den 1960er und 1970er Jahren so modischen Konstruktionen eines Jesus als „Freiheitskämpfer", der in Analogie zu anderen gutaussehenden, charismatischen, langhaarigen Führerfiguren wie Che Guevara, Liebe und Umverteilung predigt, einen besonderen Beigeschmack.

Eine ähnlich grundlegende Wende hat sich auch mit der Arbeit *Passport Control* (1988) ereignet. Hierbei handelt es sich um eine Fotoserie des Künstlers, die er in offiziell zugelassenen Passbildautomaten aufgenommen hat. Wallinger hat sein Erscheinungsbild auf diesen Fotos mit Hilfe eines Filzstifts und etwas Tipp-Ex auf verschiedene Art und Weise verändert. Auf einer Aufnahme hat er sich eine Brille ins Gesicht gezeichnet, auf einer anderen hat er sein Gesicht geschwärzt. Auf wieder anderen trägt er Vollbart und Turban, eine arabische Kopfbedeckung und einen Schnauzbart. Er trägt den langen Bart, die seitlichen langen Locken und den schwarzen Homburger Hut eines chassidischen Juden, oder eine schirmlose Mütze und einen Kinnbart, und zieht dabei seine Augenwinkel in die Länge, um chinesisch auszusehen. Ursprünglich ging es in diesen Arbeiten um Ethnizität und Identität, doch inzwischen kann man sie auch als Verkleidungen verstehen, als Auseinandersetzung mit Religionen und, wie bei *Threshold to the Kingdom*, mit der Frage, wer in welchen Himmel zu gelangen glaubt.

Im Jahr 2001 begann Brian Haw seinen Protest gegen den Irakkrieg. Im Laufe der Zeit entwickelte sich das zu einer Strassenbarrikade mit Bildern, Fotos, Flaggen und Texten auf vierzig Metern Fussweglänge – gleich gegenüber den Houses

of Parliament in London. Am 23. Mai 2006 wurde diese Wand von der Polizei abgebaut. Sie bezog dabei ihre Befugnis aus dem „Serious Organised Crime and Police Act" des Jahres 2005, einer Gesetzesvorlage, die die Regierung teilweise deswegen ratifizierte, um sich der Peinlichkeit dieser öffentlichen Aktion entledigen zu können. 2007 präsentierte Mark Wallinger einen detaillierten Nachbau dieser Barriere, genauso, wie sie zur Zeit ihrer grössten Ausbreitung ausgesehen hatte, und baute ihn an einer Linie entlang der Duveen Galleries der Tate Britain auf.

Der Irakkrieg hatte den bislang grössten Protestmarsch ausgelöst, den England in Friedenszeiten jemals erlebt hatte. Hunderttausende liefen demonstrierend durch London, doch schienen sie damit auf Seiten der Regierung keinerlei Reaktion zu bewirken. Brian Haws Einzelprotest ist die letzte Spur dieser Mobilisierung der Massen. Im Gegensatz zu den meisten anderen Demonstranten war sein Protest von einem zu allem entschlossenen christlichen Glauben bestimmt und bestärkt. Dies gab seinem moralischen Kreuzzug die eigentliche Aufladung und erlaubte es ihm weiterzumachen, als die anderen in ihren Protesten bereits nachliessen und sich desillusioniert zeigten. Die übernatürliche Grundlage seiner Überzeugungen führt dazu, ihn jenseits dieser politischen Ausdrucksformen

eines Mainstreams zu verorten. Stattdessen „legt er Zeugnis ab" von den Übeln dieser Welt, wie ein frühchristlicher Rufer in der Wüste.

Wallinger begann mit der Dokumentation dieser Protestaktion, bevor sie abgebaut wurde, und seine Wiederherstellung der Barrikade im Galeriekontext erlaubte es, sie in ihrer ganzen Länge abzuschreiten und sich auf ihre einzelnen Bestandteile zu konzentrieren – Teddybären, Unterstützerbotschaften, grafische Elemente von Banksy, Poster mit der Aufschrift „B.liar", erschütternde Fotos von einem bandagierten irakischen Kind, dessen Augen von abgereichertem Uran verbrannt sind. Quer durch diese Anordnung verlief eine schwarze Linie, die auf den Boden der Galerie geklebt wurde, und die der ersten Installation dieser Arbeit in der Tate Britain ihre besondere Aufladung verlieh. Im Sinne ihres Wunsches, über eine gesetzliche Handhabe gegen bestimmte Formen des Protests zu verfügen, setzte die Regierung ein Gesetz durch, das eine Zone des Ausschlusses herstellte, die sich „nicht weiter als einen Kilometer in einer geraden Linie von jenem Punkt erstreckt, der dem Parliament Square am nächsten ist (Serious Organised Crime Act 2005 138.3)". In diesem Gebiet konnten der Innenminister und die Polizei ganz nach ihrem eigenen Gutdünken jegliche Form des Protests verhindern.

State Britain wagte sich in diese Zone vor. Auf der einen Seite der Linie wurde Wallingers künstlerische Ausdrucksfreiheit beschnitten, auf der anderen Seite nicht. Durch die Überschreitung dieser Linie warf *State Britain* grundsätzliche Fragen über Darstellungs- und Daseinsformen auf. War dies kein Protest mehr, nur weil es sich hier um eine Reproduktion von Brian Haws ursprünglicher Protestaktion handelte? Hatte es in dem Moment einen entscheidenden Wesenszug verloren, als es zu Kunst umfunktioniert wurde? Bedeutete die Tatsache, dass es sich um eine Repräsentation handelte auch, dass das Gesetz nicht darauf anwendbar war?

Das Werk funktioniert auch als Historienbild, als ein Akt der Trauer und zugleich als Ermahnung, sich an Ideale und vergangene Ruhmestaten zu erinnern. Der Zaun aus Pappe, Teddybären und Flaschen ist ein entferntes Echo jener Barrikaden aus gefallenen Kameraden und Soldaten, auf denen Eugène Delacroix die allegorische Figur der Liberté darstellte, die das französische Volk zur Freiheit führt (*Die Freiheit führt das Volk an*, 1830). *State Britain* dient der Erinnerung an die Auslöschung des Protests sowohl in der populären Imagination als auch im Feld der Politik. Es ist das vielleicht wichtigste Kunstwerk, das dieser Krieg bislang hervorgerufen hat.

Durch die Repräsentation von Haws öffentlicher Aktion – einem Ausdruck moralisch begründeten Zorns, der mehr von religiöser Überzeugung und Glauben als von Ideologie angetrieben ist – stellt Wallinger auch die Auslöschung heutiger politischer Ausdrucksformen unter der neuen Hegemonialmacht des Kapitals in Frage und wirft wichtige Fragen dazu auf, wie Politik in einer post-ideologischen Welt überhaupt funktionieren kann. Worauf kann sie gründen? Was ist ihre ideologische Basis? Oder kann sie heute nur mehr durch die dunklere Irrationalität des Glaubens zum Ausdruck finden?

Mark Wallinger entwickelt eine der notwendigsten und zwingendsten Arbeitsweisen in der zeitgenössischen Kunst immer weiter. Er weigert sich, seine Werke zu wiederholen oder seine Art des künstlerischen Ausdrucks zu Produkten werden zu lassen, die auf die Erwartungen eines Publikums oder eines Markts zugeschnitten sind. Sein Werk handelt davon, wie man in der uns umgebenden Welt Bedeutung konstruieren kann, wie man sich zur schwindenden Vergangenheit verhalten kann, zu Verlusten und Gespenstern, und wie man sich die Zukunft vorstellen kann. *State Britain*, *Ecce Homo*, *Sleeper*, alle seine Werke verweigern sich der Leere einfacher Antworten. Es fällt schwer, sich drängendere Fragen vorzustellen.

Time and Relative Dimensions in Space, 2001
British Pavilion, Biennale di Venezia, 2001

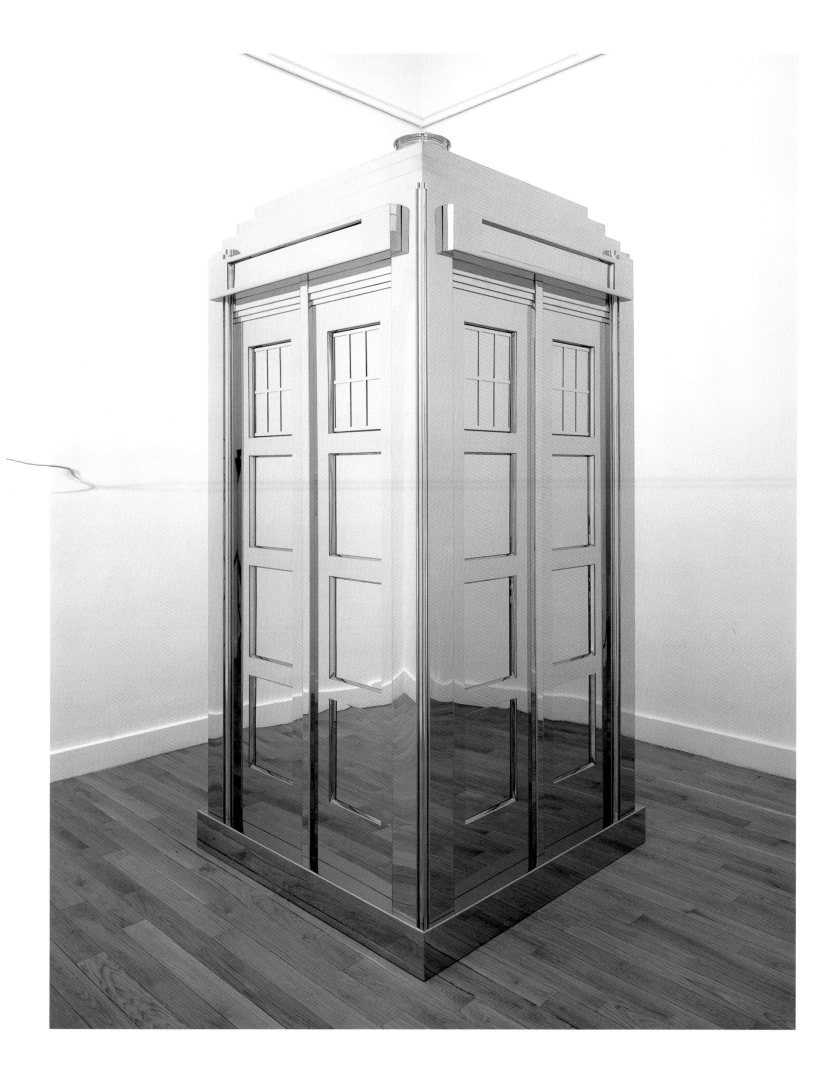

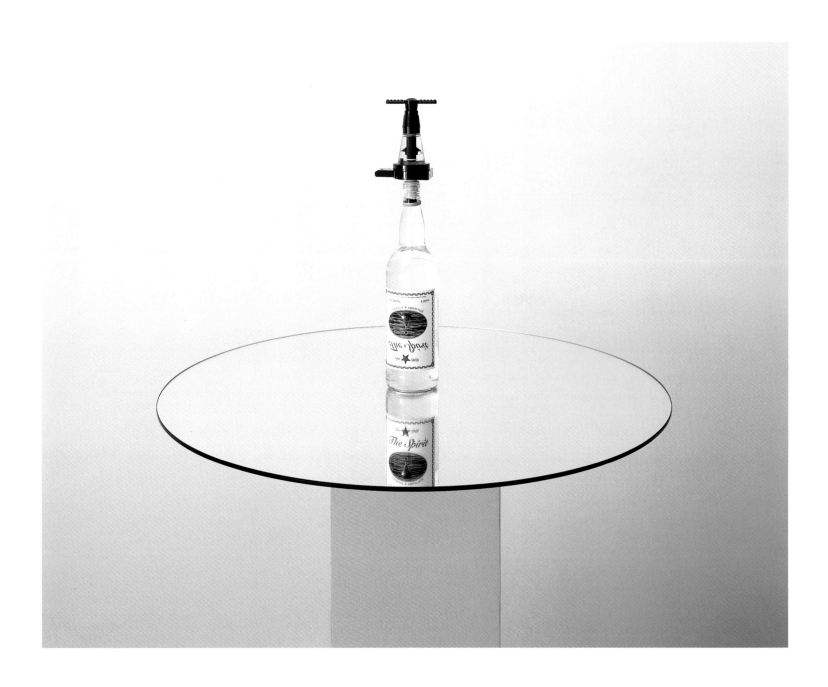

Upside Down and Back to Front,
the Spirit Meets the Optic in Illusion, 1997

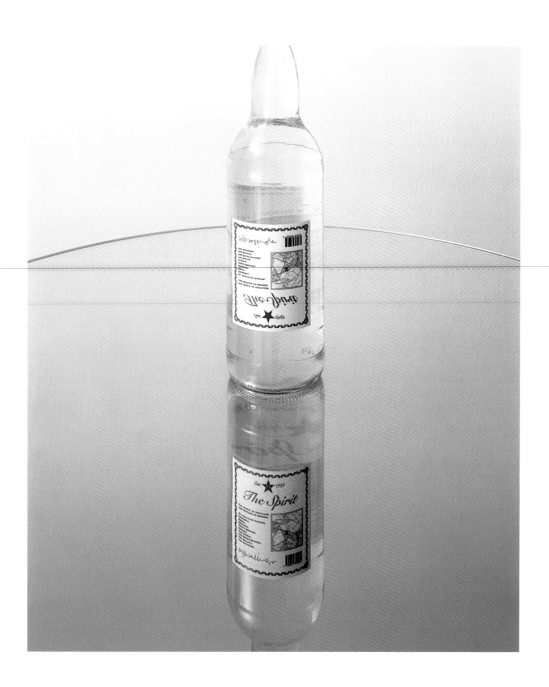

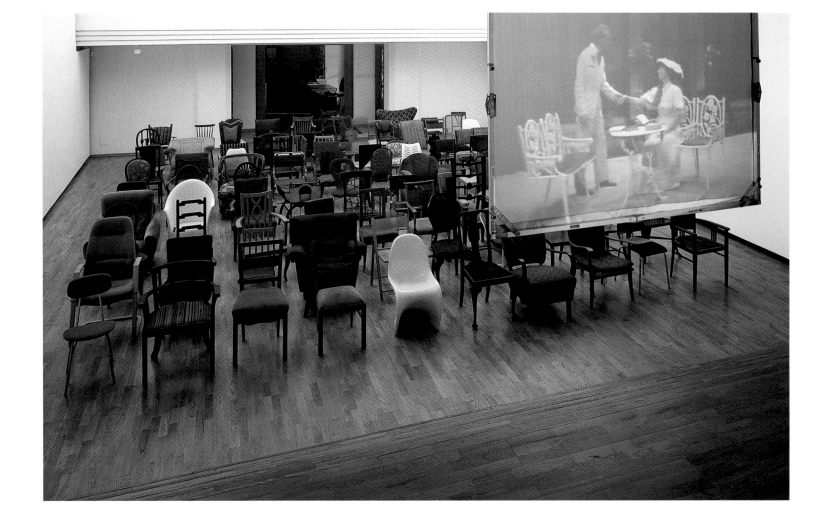

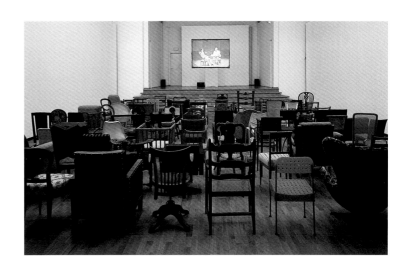

The Importance of Being Earnest in Esperanto, 1996
Jiri Svestka Gallery, Prague 1997

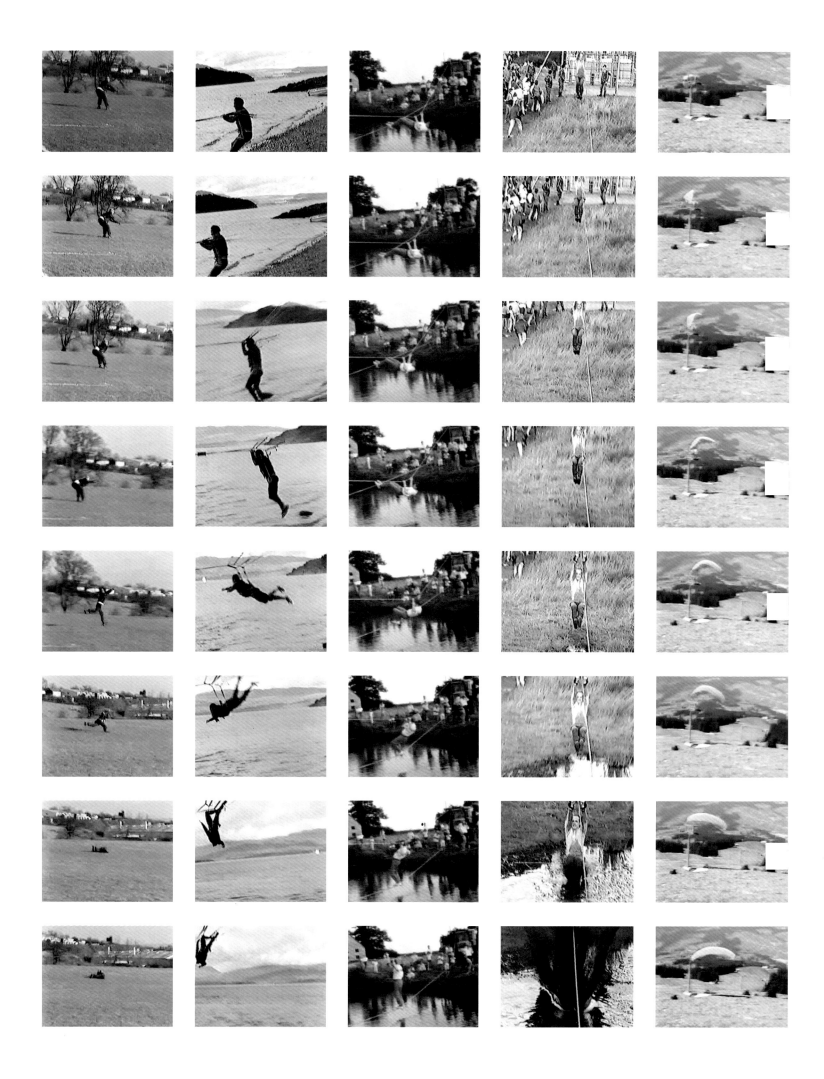

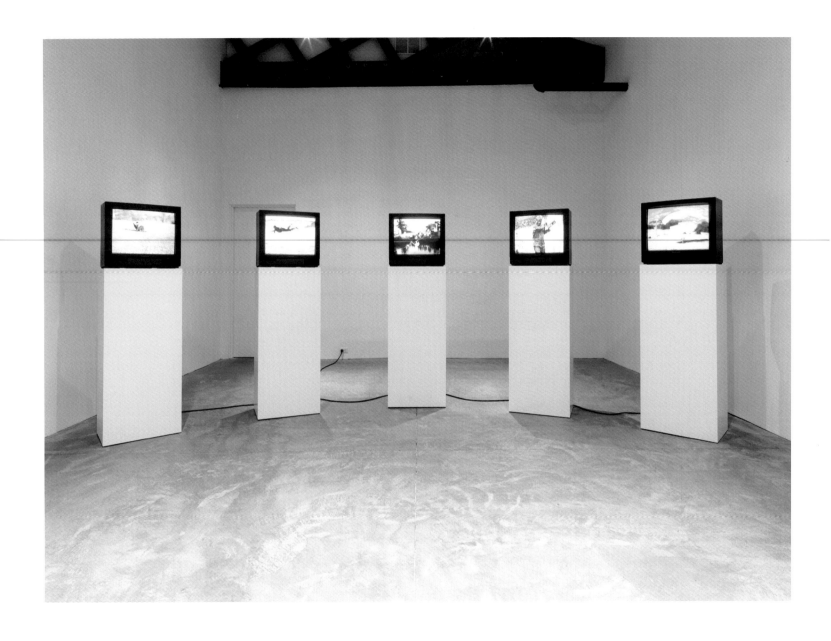

Landscape with The Fall of Icarus, 2007
Donald Young Gallery, Chicago 2007

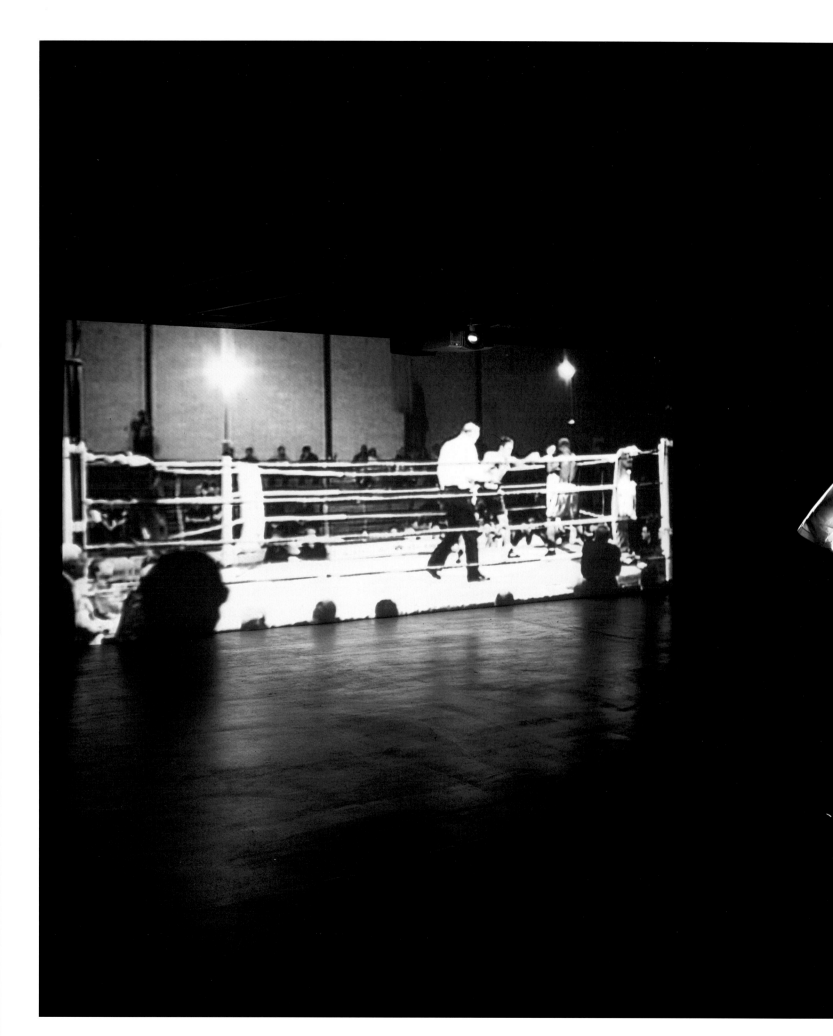

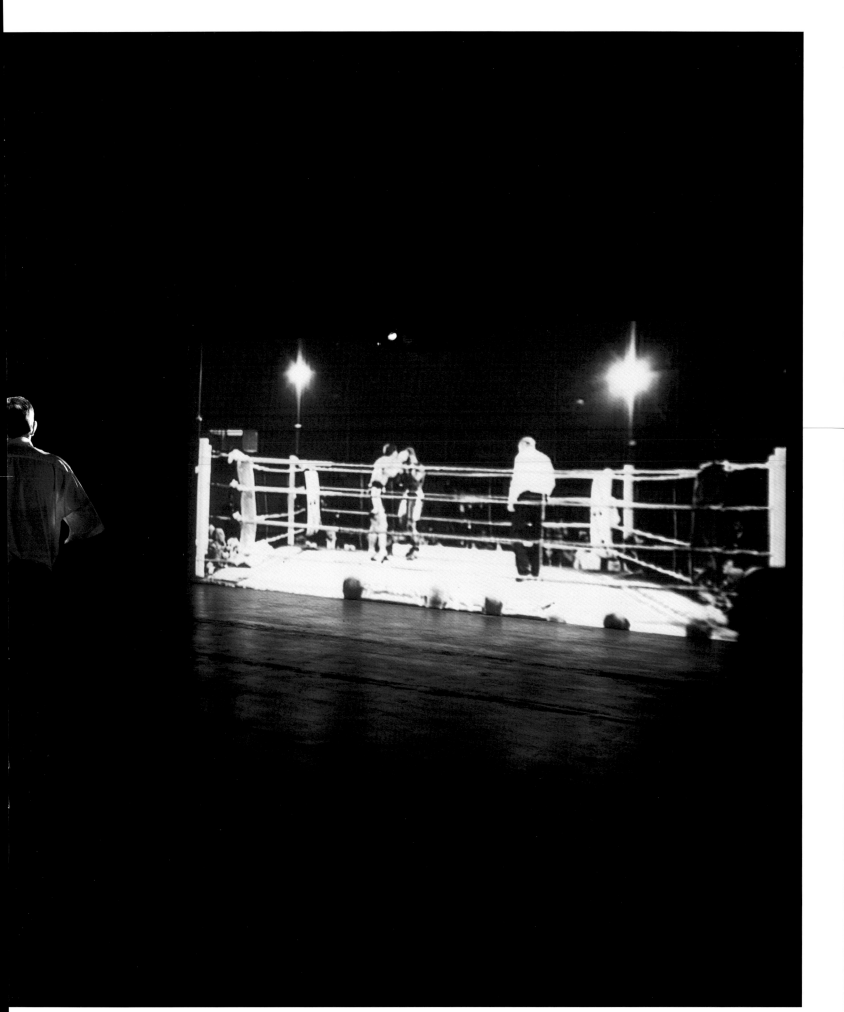

← *Cave*, 2000
Tate Gallery, Liverpool 2000

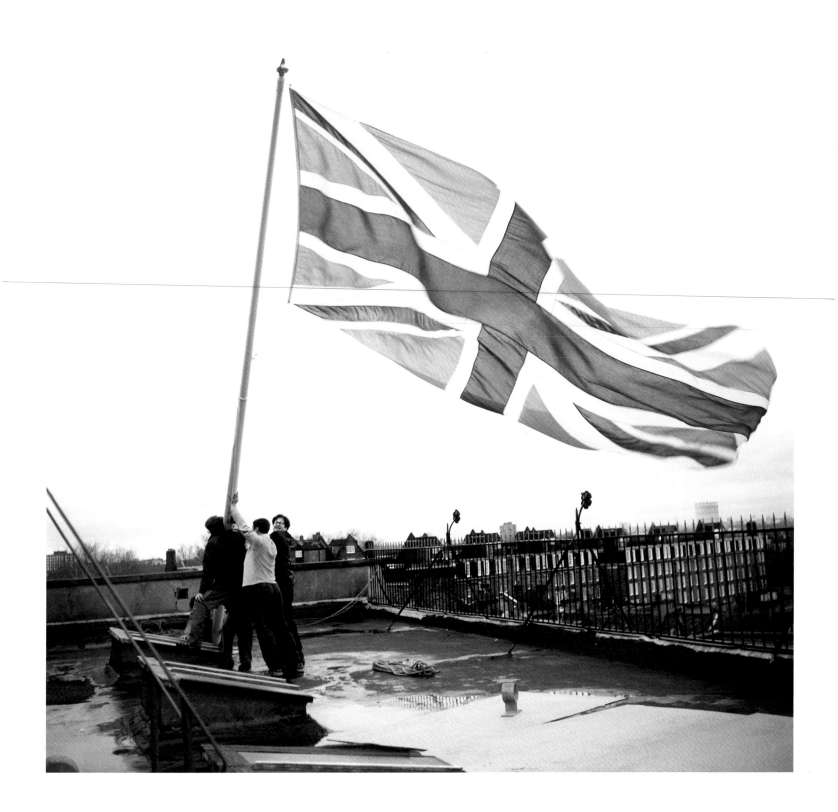

Oxymoron, 1996

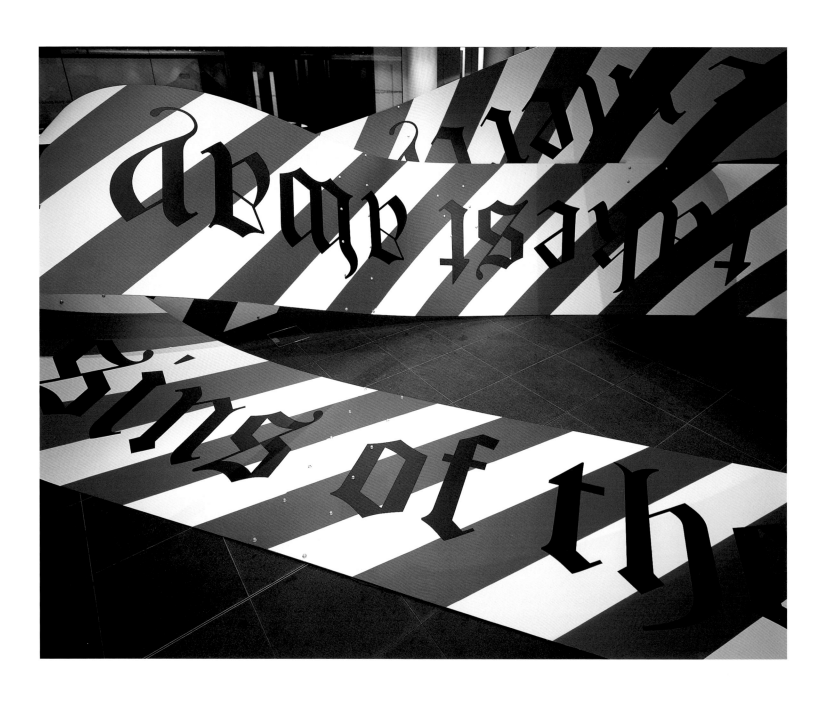

Forever and Ever, 2002
Bloomberg Space, London 2002

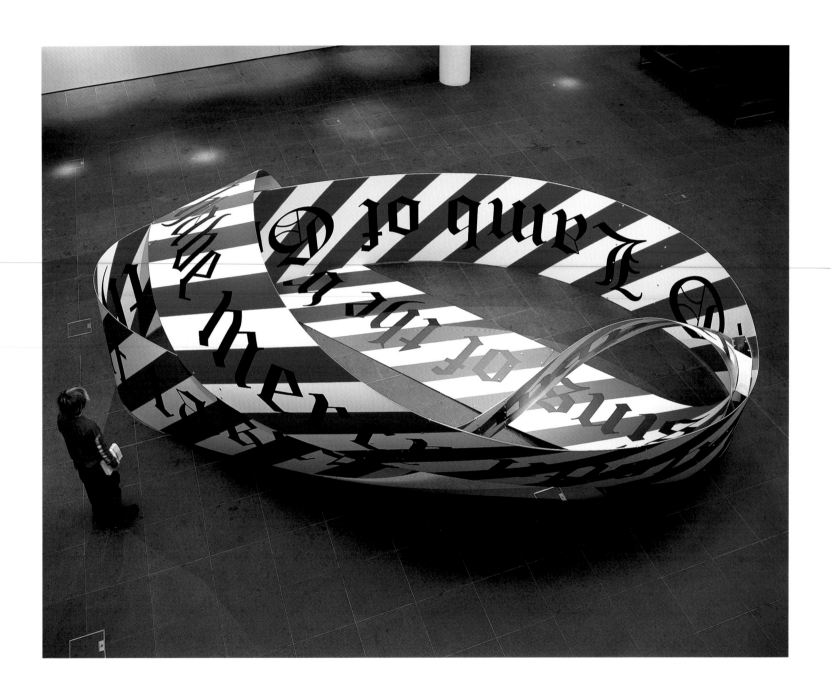

Man United, 1996

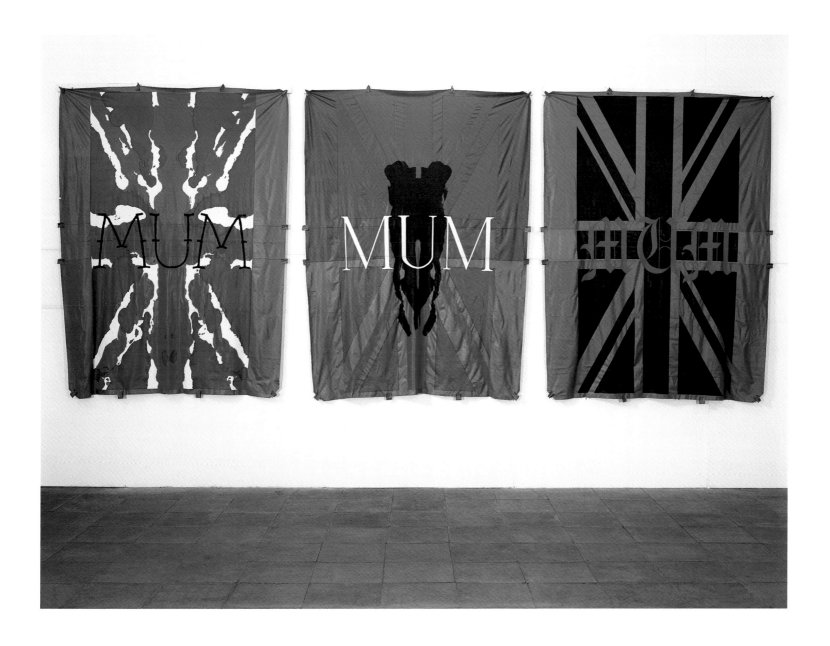

Tattoo, 1987
Serpentine Gallery, London 1987

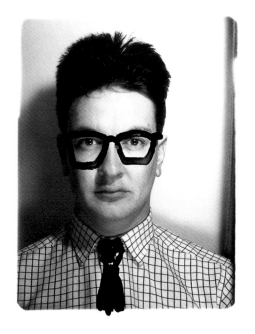
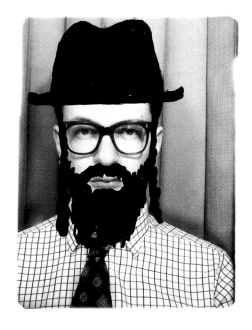
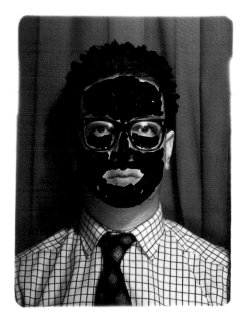
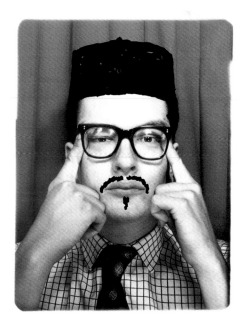
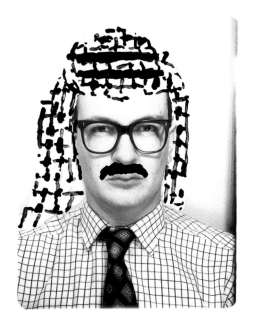
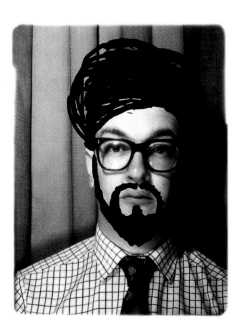

Passport Control, 1988

Self portrait (Wide Latin / Freehand 3 / Copperplate Gothic Bold, Shortened), 2007
Museum für Gegenwartskunst, Basel 2008

Self portrait (Engravers MT), 2007

Ghost, 2001

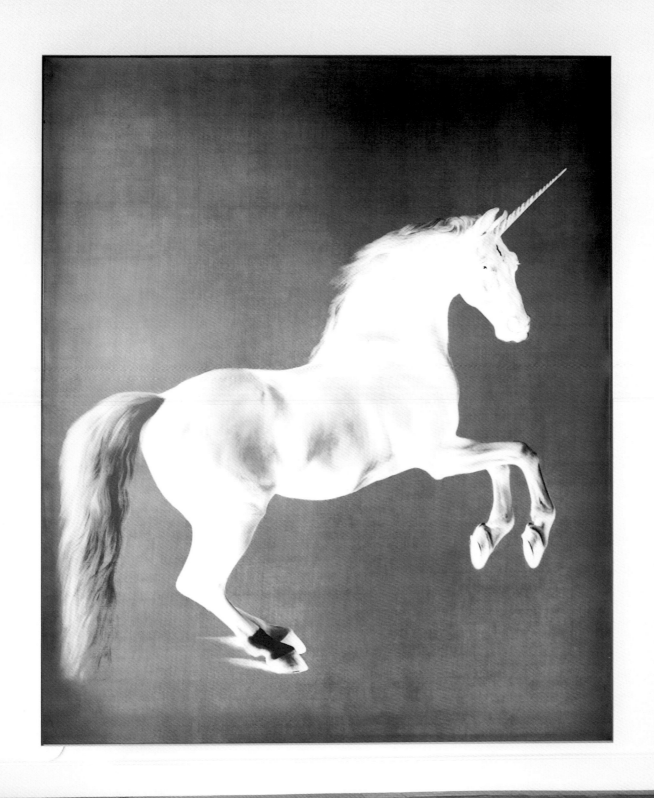

Half Brother (Diesis - Keen), 1994–1995

WALLINGER AND RELIGION

Madeleine Schuppli

Heaven, Hymn, Credo, Angel, Seeing is Believing, Threshold to the Kingdom, Ecce Homo, Via Dolorosa, The Underworld, Easter: these are titles Mark Wallinger has used for some of his works since the 1980s. The titles contain references to biblical themes and Christian liturgy, or indicate a religious connection. In particular since the artist exhibited a Christ figure in Trafalgar Square in London in the form of *Ecce Homo* (1999) at the time of the passing of the millennium, thereby triggering a major debate about the role of religion in our society, Wallinger has been regarded as one of the few living Western artists dealing openly with questions of faith in their creative work. Even in Wallinger's monumental *State Britain* (2007), which was described by Yve-Alain Bois in *Artforum*, for example, as 'one of the most remarkable political works of art ever',[1] religious themes play a considerable role, though up to now this aspect has been largely disregarded in the reception of the work. This essay sets out to come in at this point and pick up the motifs in Mark Wallinger's work associated with religion, even where they are less obvious in their impact.

Ecce Homo is as a key work in Wallinger's output, and many writers have already addressed it extensively.[2] It

WALLINGER UND DIE RELIGION

Madeleine Schuppli

Heaven, Hymn, Credo, Angel, Seeing is Believing, Threshold to the Kingdom, Ecce Homo, Via Dolorosa, The Underworld oder *Easter* sind Titel, die Mark Wallinger für einige seiner seit den 1980er Jahren entstandenen Werke verwendet hat. Die Titel enthalten Verweise auf biblische Themen und die christliche Liturgie oder deuten auf einen religiösen Zusammenhang. Nicht zuletzt seit der Künstler anlässlich der Jahrtausendwende auf dem Londoner Trafalgar Square mit *Ecce Homo* (1999) eine Christusfigur aufstellte, und damit eine grosse Debatte über die Rolle der Religion in unserer Gesellschaft auslöste, gilt Wallinger als einer der wenigen westlichen Gegenwartskünstler, die Fragen des Glaubens in ihrem Schaffen offen verhandeln. Sogar in Wallingers Monumentalwerk *State Britain* (2007), das etwa vom Kritiker des *Artforums* als „eines der bemerkenswertesten politischen Kunstwerke aller Zeiten"[1] bezeichnet wurde, spielen religiöse Themen eine wesentliche Rolle, wobei dieser Aspekt bei der Rezeption des Werks bisher weitgehend ausgeklammert blieb. Der vorliegende Beitrag will hier einsetzen und die mit Glauben und Religion verbundenen Motive in Wallingers Werk aufgreifen, auch wo sie weniger offensichtlich zum Tragen kommen.

Ecce Homo kann als ein Schlüsselwerk in Wallingers Arbeit bezeichnet werden, und zahlreiche Autorinnen und Autoren

will serve as a starting point for my ideas in considering his artistic strategy when dealing with religious themes. There are two ways of looking at this work which may seem to contradict each other: on the one hand the artist explores the origin of the religious meaning of social rituals; on the other he succeeds in opening up and expanding the biblical theme, and through this a new, wider access to the traditional iconography becomes possible.

The turn of the millennium was celebrated around the world with a great fanfare and considerable commercial outlay, with the Millennium Dome in London being one of the largest projects. However, the fact that the year 2000 was a Christian anniversary relating to the birth of Christ as the beginning of our calendar hardly registered with the public at large. When Wallinger was invited in 1997 to create a temporary work of art for a plinth on Trafalgar Square that was empty, he developed the idea of an *Ecce Homo* figure that would stand in the London square identified with celebration and protest. The work took the form of a life-size figure of Jesus that stood in an elevated position at the edge of the square from July 1999 to February 2000. *Ecce Homo* shows Christ in

bonds, naked except for a loincloth. The scene from the story of the Passion tells how Pontius Pilate brought the prisoner before the people and asked the crowd to decide his fate. By choosing this moment from the New Testament, Wallinger was questioning the perception of the transition from the second to the third millennium in relation to its actual historical basis, and uncovering the layers of meaning that had accumulated in the process. He used a comparable strategy when, at the invitation of *The Guardian* newspaper, he designed wrapping paper for Christmas 2007, a paper printed all over with the name Jesus Christ, succinctly reminding people of the person whose birthday is the reason for Christmas; there was no shortage of negative reactions.[3] Both this wrapping paper and *Ecce Homo* prompt us to think back to the origins of a culture which is based on the Christian tradition, even if it has meanwhile changed into a multi-cultural and multi-religious society. Questions about identity and basic social values are essentially extremely closely linked to religion. Wallinger's attitude strikes us as provocative in a society that is split between the poles of a narrow-minded religious racism on the one hand and unchallenged tolerance verging on self-abnegation towards those of

haben sich bereits fundiert mit dieser Arbeit auseinandergesetzt.[2] Für meine Überlegungen soll es als Ausgangspunkt dienen, um die künstlerische Strategie im Umgang mit religiösen Themen zu reflektieren. So lassen sich bei *Ecce Homo* zwei inhaltliche Prozesse beobachten, die sich – vordergründig betrachtet – zu widersprechen scheinen: Einerseits ist der Künstler bestrebt, den religiösen Bedeutungsursprung von gesellschaftlichen Ritualen herauszuarbeiten, anderseits gelingt ihm ein Öffnung und Erweiterung des biblischen Themas, wodurch ein neuer, breiterer Zugang auf die tradierte Ikonographie möglich wird.

Die Jahrtausendwende wurde rund um die Welt mit grossem Brimborium und beträchtlichem kommerziellem Aufwand begangen, wobei der Londoner Millennium Dome zu den gigantischsten Projekten gehörte. Dass es sich beim Jahr 2000 um ein christliches Jubiläum handelte, das sich auf Christi Geburt als Beginn unserer Zeitrechnung bezog, war für die breite Öffentlichkeit jedoch kaum ein Thema. Als Wallinger 1997 eingeladen wurde, für eine leer gebliebene Säule auf dem Trafalgar Square ein temporäres Kunstwerk zu schaffen, entwickelte er die Idee einer Ecce-Homo-Figur, die während der Jahrtausendwende auf dem bekanntesten Londoner Platz stehen sollte. Der Künstler schuf eine lebensgrosse Jesusfigur,

die von Juli 1999 bis Februar 2000 in erhöhter Position am Rande des Platzes stand. *Ecce Homo* zeigt den gefesselten, bis auf einen Lendenschurz nackten Christus. Die Szene aus der Passionsgeschichte erzählt von Pilatus, der den Gefangenen vors Volk führt und die Massen dazu auffordert, über das Schicksal des Wehrlosen zu entscheiden. Mit der Wahl dieses Themas aus dem Neuen Testament befragte Mark Wallinger den Jahrtausendwechsel nach seinem Ursprung und deckte die Bedeutungsschichten auf, die von der allgemeinen Geschäftigkeit überlagert wurden. Eine vergleichbare Strategie wendete der Künstler an, als er auf Anfrage der Tageszeitung *The Guardian* für Weihnachten 2007 ein Geschenkpapier entwarf. Wallinger entwarf ein flächendeckend mit dem Namen „Jesus Christus" bedrucktes Papier und erinnerte damit an den Menschen, dessen Geburtstag Anlass für Weihnachten ist; ablehnende Reaktionen blieben nicht aus.[3] Dieses ungewöhnliche Geschenkpapier wie auch *Ecce Homo* regen eine Rückbesinnung auf den Ursprung einer Kultur an, die in der christlichen Tradition gründet, auch wenn sie sich unterdessen zu einer multikulturellen und multireligiösen gewandelt hat. Fragen nach der Identität oder den gesellschaftlichen Grundwerten sind in ihrem Kern aufs Engste mit Religion verknüpft. Wallingers Haltung wirkt provozierend in einer Gesellschaft, die zwischen den Polen eines tumben religiösen

different faiths on the other. Against this background, André Malraux's statement that the 21st century either will or will not be a religious one again takes on a completely new topicality.

While the linking of the *Ecce Homo* theme to the start of the new millennium implies looking back and searching for self-reassurance, in his attention to the details of the historical theme Wallinger presents us with a very contemporary reinterpretation. His Christ figure appears very lifelike. The body was cast from a young workshop assistant[4]; it is not idealised, but neither does it show traces of the flagellation Christ had undergone beforehand. However, the shaved head represents perhaps the most significant deviation from the iconic tradition.

In the 20th century, the shaving of head hair was a measure widely used for disciplining or humiliating prisoners – we are reminded of pictures of concentration camp inmates or, more recently, prisoners of war from the Yugoslav War.[5] As the figure deviates from the usual image of Christ, its interpretation opens up, turning the event depicted into a general human metaphor for injustice, repression and intolerance. Replacing the crown of thorns by a wreath of barbed wire also creates a distance from the biblical narrative and removes the interpretation of the work from its original context. Here it is no longer (only) the event in Jerusalem just 2000 years ago that is referred to, but also the exposure and humiliation of an anonymous individual. Barbed wire is a well-known symbol of repression. Originally developed to fence off herds of livestock, since the late 19th century the 'Devil's Rope'[6] has increasingly been deployed against people; barbed wire has therefore mutated into a symbol of modern repression. While in the biblical tradition Christ eventually emerges from his martyrdom as the Redeemer, there are no indications of this in *Ecce Homo*. The artist himself gives a hint of this when he says that the unusual thing about the work is that a publicly exhibited statue should be devoted to a victim rather than a victor.[7]

Since its presentation in Trafalgar Square, the artist has shown the sculpture in several exhibition venues, from the British Pavilion in Venice (2001) to its current presentation in Aargau Kunsthaus (2008). On each occasion the figure has been placed directly in the exhibition space, with no plinth or enclosure, and so it becomes

Rassismus einerseits und der an Selbstverleugnung grenzenden unhinterfragten Toleranz gegenüber Andersgläubigen anderseits gespalten ist. André Malraux' Formulierung, das 21. Jahrhundert werde ein religiöses sein oder nicht sein, erhält vor diesem Hintergrund nochmals eine ganz neue Aktualität.

Während die Verknüpfung des Ecce-Homo-Themas mit der Jahrtausendwende eine Rückbesinnung und Selbstvergewisserung impliziert, kommt Wallingers Interpretation des kunstgeschichtlichen Topos einer zeitgenössischen Neuauslegung gleich. Der sehr lebensnah wirkende Körper der Christusfigur wurde nach dem Modell eines jungen Werkstattassistenten geschaffen[4] und ist weder idealisiert noch weist er Spuren der vorangegangenen Geisselung auf. Die vielleicht bedeutsamste Abweichung gegenüber der Bildtradition stellt jedoch der kahl geschorene Schädel dar.

Das Rasieren des Kopfhaars ist im 20. Jahrhundert eine verbreitete Massname, um Gefangene zu disziplinieren oder zu erniedrigen – wir werden an Bilder von KZ-Insassen oder von Kriegsgefangenen aus dem Jugoslawienkrieg gemahnt.[5] Da die Figur dem gewohnten Christusbild nicht entspricht, öffnet sich die Interpretation und macht das dargestellte Ereignis zu einer allgemein menschlichen Metapher für Ungerechtigkeit, Unterdrückung und Intoleranz. Das Ersetzen der Dornenkrone durch einen Stacheldrahtkranz schafft zusätzlich Distanz zur biblischen Narration und führt die Deutung des Werks weg aus ihrem ursprünglichen Kontext. Hier ist nicht mehr (nur) das Ereignis in Jerusalem vor knapp 2000 Jahren gemeint, sondern ebenso die Blossstellung und Demütigung eines anonymen Individuums. Mit dem Stacheldraht greift Wallinger auf ein bekanntes Symbol für Unterdrückung zurück. Ursprünglich für die Abzäunung von Viehherden entwickelt, wurde der „Devil's Rope"[6] (Teufelsstrick) seit dem späten 19. Jahrhundert vermehrt gegen Menschen eingesetzt; der Stacheldraht mutierte damit zum Sinnbild moderner Repression. Während Christus in der biblischen Tradition schliesslich als Erlöser aus seinem Martyrium hervorgeht, gibt es bei Wallingers *Ecce Homo* keine Anzeichen dafür. Der Künstler selber macht eine Andeutung in diese Richtung, wenn er sagt, das Aussergewöhnliche an der Arbeit bestehe darin, dass eine öffentlich gezeigte Statue einem Opfer und nicht einem Sieger gewidmet sei.[7]

Seit ihrer Präsentation auf dem Trafalgar Square hat der Künstler die Plastik verschiedentlich in Ausstellungsräumen präsentiert, vom Britischen Pavillon in Venedig (2001) bis zur

possible to get almost frighteningly close to it. As a result, a further noteworthy aspect of the figure becomes more evident: the closed eyes. When Christ looks directly at the faithful in church representations, this promotes identification and empathy. Here, on the other hand, there is no eye contact. Thus the contrast with ecclesiastical, religious art becomes clear. Wallinger's work does not set out to strengthen faith or encourage spirituality; he is far more concerned with intellectual and emotional reflection.

Via Dolorosa is the road in Jerusalem leading from Pilate's governor's office, the site of the *Ecce Homo* episode, to the place of execution on Golgotha. According to the Gospels, Jesus had to follow this path on his final day, carrying the cross on his shoulders. Wallinger's work, *Via Dolorosa* comprises 18 minutes of Franco Zefferelli's *Jesus of Nazareth*,[8] from which the artist obliterates 90 per cent of the picture with a black rectangle so that the viewer is only able to see a narrow pictorial frame. The film is silent. Since the beginnings of Christian art, the story of the Passion has been recorded pictorially in countless portrayals; the Stations of the Cross and the Crucifixion are central elements of

the Western religious pictorial tradition. For a public that has grown up surrounded by traditional Christian iconography, the fragments of pictures visible in *Via Dolorosa* are simple to fill out; the black rectangle is not a blind spot, but transparent through the imagination. For instance, when parts of the wooden cross become visible on the side and bottom edges of the picture, the concealed figure of the crucified Christ can be completed intuitively. The obscuring of the picture is redolent of censorship, and inevitably brings to mind iconoclasm, the great censorship of pictures by the Church. The iconoclastic controversy that raged during the Middle Ages, and which erupted again during the Reformation, was directed against the worship of images of saints, and led to the removal of religious art from churches. Instead of venerating a piece of painted wood, the iconoclasts believed that the faithful should keep directly to the word of the Bible and develop pictorial concepts of a spiritual nature from it. An idea that presumably is not so far from that of Wallinger, who with *Via Dolorosa* seems to question the relevance of an illustrational visualisation. It is worth noting that this work has also been shown outside of a museum context; it has been on view as a permanent installation in the

aktuellen Präsentation im Aargauer Kunsthaus (2008). Dabei wird die Figur jeweils ohne Sockel oder Abschrankung direkt in den Ausstellungsraum gestellt, wodurch eine fast beängstigende Nähe zu ihr möglich wird. In dieser Betrachter / Werk-Konstellation gewinnt ein weiterer bemerkenswerter Aspekt der Figur an Bedeutung: die geschlossenen Augen. Wenn in kirchlichen Darstellungen Christus die Gläubigen direkt anschaut, werden so Identifikation und Mitgefühl begünstigt. Hier hingegen gibt es keinen Blickkontakt. Dadurch wird der Gegensatz zur kirchlich-religiösen Kunst deutlich. Wallingers Arbeit will nicht den Glauben stärken oder Spiritualität fördern; vielmehr geht es ihm um eine intellektuelle und emotionale Reflexion.

Via Dolorosa bezeichnet den Weg in Jerusalem, der vom Statthalteramt des Pilatus, dem Schauplatz von *Ecce Homo*, bis zur Hinrichtungsstelle auf dem Hügel Golgatha führt. Laut dem Evangelium musste Jesus an seinem letzten Tag diesen Leidensweg gehen, das Kreuz auf den Schultern tragend. Für seine Videoinstallation *Via Dolorosa* nimmt Mark Walllinger die letzten 18 Minuten des Films *Jesus von Nazareth* des italienischen Regisseurs Franco Zeffirelli[8] als Ausgangspunkt. Der Künstler bearbeitet den Film, indem er 90% des Bildes mit einem breiten schwarzen Balken überdeckt und den Ton

ausblendet. Den Betrachtenden bleibt lediglich der Blick auf einen schmalen Bildrahmen. Seit den Anfängen der christlichen Kunst ist die Passionsgeschichte in unzähligen Schilderungen bildlich festgehalten worden; Leidensweg und Kreuzigung sind zentrale Elemente der westlichen religiösen Bildtradition. Für ein Publikum, das mit einer tradierten christlichen Ikonographie sozialisiert worden ist, sind die in *Via Dolorosa* sichtbaren Bildfragmente einfach zu ergänzen; das schwarze Rechteck ist kein blinder Fleck, sondern von imaginärer Transparenz. Wenn etwa an den seitlichen und am unteren Bildrand Teile des Holzkreuzes sichtbar werden, kann die verdeckte Figur des Gekreuzigten intuitiv ergänzt werden. Formal wirkt die Abdeckung des Bildes wie ein überdimensionierter Zensurbalken und lässt – in Verbindung mit der christlichen Thematik – unweigerlich an die grosse kirchliche Bildzensur des Ikonoklasmus denken. Der im Mittelalter ausgetragene und während der Reformation wieder aufkeimende Bilderstreit richtete sich gegen die Anbetung von Heiligenbildern und führte zur Entfernung der religiösen Kunst aus den Kirchen. Statt einem Stück bemalten Holzes zu huldigen, sollten sich die Gläubigen direkt ans Bibelwort halten und daraus bildliche Vorstellungen spiritueller Art entwickeln. Ein Gedanke, der Wallinger vermutlich nicht allzu fern liegt, scheint er doch mit *Via Dolorosa* die Relevanz einer illustrie-

crypt of Milan cathedral since 2005, where it has a very particular impact on questions of faith.

The rectangular black field prompts a further formal comparison, this time with monochrome painting. The moving images lie like a frame around the black rectangle, reminding us of what must be the best-known monochrome picture in the history of art, Kazimir Malevich's *Black Square* (1915). However, while the Russian painter was concerned with creating an image that refers to nothing outside the pictorial reality, Wallinger's black, on the contrary, is part of the projection surface and serves to concentrate the content.

In *The End* (2006), Mark Wallinger goes a step further by dispensing with the picture completely. The biblical story is communicated only by text. The words 'The End', white on black, are followed by a centred list of names scrolling up the screen. This gives rise to the impression that we are seeing the final credits of a film that has just ended. But unlike credits in the cinema, here roles are not listed, only names, as if these people in the (non-existent) film had all played themselves. The names come from the Bible and are listed in the order in which they appear, starting with God, Adam, Eve, Cain and Abel, coming 12 minutes later to Jacob, Mary and Joseph, and finally finishing with Jesus. The list comprises some 1800 individuals whom the artist has extracted from the biblical text and recorded on his roll the first time they are mentioned by name.[9] By this means the Bible story is indirectly retold via the figures that occur in it, though it is open to question how many viewers will be able to reconstruct the narrative. It is easy enough to associate the names of the first family at the beginning of the Old Testament with the story of fratricide, and the names again sound more familiar towards the end of the film when the emergence of Jesus is approaching at the beginning of the New Testament. But when the protagonists are called Ashtaroth, Ram or Coz, only a small number of people will be able to place them precisely. Wallinger is not really concerned with testing our knowledge of the Bible. Rather he wants to make it possible to experience the story, no matter how strange large parts of the Holy Scriptures may seem to a public living in a Christian society. Present-day society has a strong tendency to focus on what divides Islamic, Jewish and Christian/Western culture, but historically things are not so simple: the Old

renden Vergegenwärtigung zu hinterfragen. Bemerkenswert ist, dass diese Arbeit nicht nur im musealen Kontext gezeigt wird, sondern seit 2005 auch als permanente Installation in der Krypta des Mailänder Doms zu sehen ist, also durchaus an einem Ort der religiösen Andacht ihre Wirkung entfalten kann.

Das rechteckige schwarze Feld regt aber noch zu einem anderen formalen Vergleich an, demjenigen mit monochromer Malerei. Das bewegte Bild legt sich wie ein Rahmen um das schwarze Rechteck und erinnert an das wohl bekannteste monochrome Bild der Kunstgeschichte, an Kasimir Malewitschs *Schwarzes Quadrat* (1915). Während es dem russischen Maler jedoch darum ging, ein Bild zu schaffen, das auf nichts ausserhalb der bildlichen Realität verweist, bildet Wallingers schwarze Fläche im Gegensatz dazu eine inhaltliche Projektionsfläche und Verdichtungsmaschine.

Bei *The End* geht Mark Wallinger einen Schritt weiter, indem er nicht nur teilweise, sondern gänzlich auf das Bild verzichtet. Die biblische Geschichte wird nur durch Text vermittelt. Auf einer schwarzen Leinwand erscheint der Schriftzug „The End", gefolgt von einer zentriert über die Leinwand laufenden Namenliste. Dadurch entsteht der Eindruck, dass wir den Abspann eines eben zu Ende gegangenen Films sehen. Im Unterschied zum Abspann im Kino sind hier aber nicht die Rollen mit ihren jeweiligen Darstellern aufgeführt, sondern lediglich Vornamen, so als ob diese Personen im (nicht existierenden) Film alle sich selber gespielt hätten. Die Namen stammen aus der Bibel und erscheinen in der Reihenfolge ihres Auftretens, beginnend mit Gott, Adam, Eva, Kain und Abel, um nach zwölf Minuten bei Jakob, Maria und Joseph anzukommen und schliesslich mit Jesus aufzuhören. Die Liste umfasst rund 1800 Personen, die der Künstler aus dem biblischen Text extrahiert und bei ihrer ersten namentlichen Erwähnung in die Aufzählung aufgenommen hat.[9] Dadurch wird die biblische Geschichte indirekt, über die vorkommenden Figuren, nacherzählt, wobei fraglich ist, wie viele Zuschauer die Erzählung zu rekonstruieren vermögen. Die Namen der ersten Familie zu Beginn des Alten Testaments kann das Publikum sicherlich mit der Geschichte des Brudermordes verknüpfen, und auch gegen Ende der Videoarbeit, wenn zu Beginn des Neuen Testaments das Auftreten von Jesus naht, klingen die Namen wieder vertrauter. Wenn die Protagonisten aber Ashtaroth, Ram oder Coz heissen, werden nur wenige diese genau verorten können. Mark Wallinger geht es aber kaum darum, unsere Bibelkenntnisse zu testen. Vielmehr will er sie erlebbar machen, egal wie fremd einem christlich sozialisierten Publikum weite Teile der Heiligen

Kazimir Malevich
Black Square, 1915

Testament is a scripture shared by Christians, Jews and Muslims alike. Wallinger thus makes it possible to experience the multi-layered cultural and religious diversity of the Bible.

If the aesthetic level in *The End* is pared-down, the soundtrack is exceedingly opulent. We hear Johann Strauss' *Blue Danube* waltz, lively dance music from the time of the Austrian Empire.[10] *The Blue Danube* is regarded as an unofficial Austrian national anthem and in the absence of an official anthem following World War II, it was quite frequently used as a substitute, for instance by the Austrian football team. But it has become familiarly linked with the score of Stanley Kubrick's 1968 science-fiction film *2001: A Space Odyssey*,[11] in which spaceships move through the black universe to the sounds of the waltz. In Wallinger's work it is white words that, as the artist himself put it, move in an infinite black space.[12] *2001: A Space Odyssey* is a fantasy story of the development of humankind in which motifs with religious connotations occur, like a cultic black monolith appearing in mystical rays of light. *The Blue Danube* accompanies a key scene in the film that marks the transition from the primitive to the civilised stage of existence. In this already legendary film clip, the world of primates is directly linked with a spaceship. But the waltz rings out a second time during the film's final credits, where Kubrick intends it to be understood as an ironic comment.[13] In *The End*, the effect of the music is similarly alienating, but the joyous sounds also make complete sense if we bear in mind that the list of names in Wallinger's film ends with the emergence of Jesus and therefore, at least for Christians, with the arrival of the Redeemer.

In two earlier video works Wallinger expresses his cultural curiosity using a different strategy, namely by overlaying an everyday iconography with one that has Christian connotations. In *Threshold to the Kingdom* (2000), the arrival of airline passengers is interpreted as a stepping into the kingdom of heaven, while in *Angel* (1997), travellers on the London underground who pass one another on the station's up and down escalators mutate into the Damned and the Redeemed on the Day of Judgement. Wallinger makes these analogies between everyday scenes and a religious iconic tradition plausible by not just documenting the situations, but deliberately accentuating them by means of aesthetic interventions or an

Schrift vorkommen mögen. Die heutige Gesellschaft hat stark die Tendenz, auf das Trennende zwischen islamischer, jüdischer und christlich-westlicher Kultur zu fokussieren, was sich durch einen Blick zurück relativieren liesse: Das Alte Testament ist die Schrift, die Christen, Juden und Muslime untereinander teilen. So macht Wallinger die kulturelle und religiöse Vielschichtigkeit der Bibel erlebbar.

Ist die ästhetische Ebene bei *The End* äusserst reduziert und ereignislos gestaltet, so ist die Klangebene von grösster Opulenz: Wir hören Johann Strauss' pompösen Walzer *An der schönen blauen Donau*, beschwingte Tanzmusik aus der kaiserlich-königlichen Epoche.[10] Der Donauwalzer gilt als inoffizielle österreichische Nationalhymne und wurde in Ermangelung einer offiziellen Hymne nach dem Zweiten Weltkrieg öfters als Ersatz angestimmt, etwa von der österreichischen Fussballmannschaft. Strauss' Walzer hat aber auch als Filmmusik eine interessante Vorgeschichte. In Kubricks Science-Fiction-Film *2001: A Space Odyssey* von 1968[11] bewegen sich zu den Walzerklängen Raumfähren durchs schwarze All. Bei Wallingers Arbeit sind es weisse Wörter, die sich, wie es der Künstler selber formulierte, in einem unendlichen schwarzen Raum bewegen.[12] *2001: A Space Odyssey* ist eine fantastische Entwicklungsgeschichte der Menschheit, wobei religiös gefärbte Motive wie Wiedergeburt oder eine in mystischen Lichtstrahlen erscheinende kultische schwarze Stele vorkommen. *An der schönen blauen Donau* begleitet eine Schlüsselszene im Film, die den Übergang vom primitiven zum kultivierten Daseinsstadium markiert. In diesem legendären Filmschnitt verbindet sich die Welt der Primaten direkt mit derjenigen der Raumfahrt. Johann Strauss' Walzer erklingt aber noch ein zweites Mal und zwar während dem Filmabspann. Der Kontrast zum eher schwer verdaulichen Film könnte kaum grösser sein, denn die Abspannmusik tut so, als sei gerade ein vergnüglicher, beschwingter Streifen zu Ende gegangen, was bei Kubrick als ironischer Kommentar zu verstehen ist.[13] Bei *The End* wirkt die Musik ähnlich befremdend, und dies nicht nur durch ihre Unbekümmertheit, sondern auch durch die Diskrepanz der kulturellen Prägungen: Heiliges Land und biblische Geschichte hier – Wiener Opernball und Sissi dort. Die fröhlichen Klänge machen aber durchaus auch Sinn, wenn wir bedenken, dass die Namenliste von Wallingers Film mit dem Auftreten Jesu endet und damit, zumindest für die Christen, mit der Ankunft des Erlösers.

In zwei früheren Videoarbeiten geht Wallinger seiner kulturellen Neugierde mit einer anderen Strategie nach, nämlich

enhancement of the pre-existing scenes. In *Threshold to the Kingdom* the intervention consists of slowing the picture down and employing as a soundtrack a piece of church music, Giorgio Allegri's famous interpretation of Psalm 51.[14] Thus the simple act of passing from Customs into the arrival hall through a pair of automatic doors is elevated by a metaphor into a transcendence of reality.[15] In *Angel* this process is achieved through the elaborate task of learning to speak the first five verses of St John's Gospel phonetically, backwards. It featured the first introduction of a theatrical figure: the angel Blind Faith, wearing dark glasses and carrying a white stick. 'In the beginning was the Word and the Word was with God and the Word was God ... ' 'This figure repeats the central logos of Christianity before ascending to heaven up the escalator accompanied by Handel's *Zadok the Priest*.[16] The film runs in reverse. Redeemed or condemned people manoeuvre expertly backwards up and down the escalators. Everything that happens has already happened. What exists outside this exhortation to believe, if not in God's emissary, then in language itself?'[17]

A similar layering of secular and sacred iconography is found in his video installation *The Underworld*, made in

2004. A film of Giuseppe Verdi's *Requiem*[18] is displayed on 21 video monitors that are set up in a circle in a completely dark space, the screens turned inwards, and the devices turned upside down. Each monitor relays the complete work, but each begins at the next of the 21 movements of the requiem. Thus every movement is being played simultaneously. On the visual level this results in an impenetrable multiplication of the event: the soloists, choir, conductor, orchestra and musicians can be seen at the same time. In this context we inevitably interpret the vivid facial expressions of the singers and instrumentalists immersed in their music-making as an expression of pain and anguish. These figures, appearing upside down, turn into lost souls, sweltering in the underworld, who are shouting out the pain from the depth of their beings. The circle becomes the realm of death to which the spectators, as living beings, have no access. As a result of the inward-turned monitors, the circle of pictures can never be assimilated as a whole. The view into the world beyond allows us only to gain an inkling of it; the feeling is one of standing on the edge of the crater of a volcano. The closed circle evokes hopelessness – there is no escape. The circular form inevitably refers to what must be the best-known Western

mit der Überlagerung einer alltäglichen Ikonographie durch eine christlich geprägte. In *Threshold to the Kingdom* (2000) wird die Ankunft von Flugpassagieren als Übertritt ins Himmelreich gelesen, während in *Angel* (1997) Fahrgäste der Londoner Untergrundbahn, die sich auf den aufwärts und abwärts fahrenden Rolltreppen der Station kreuzen, zu Verdammten und Erlösten des Jüngsten Tages mutieren. Diese Analogien zwischen Alltagsszenen und einer religiösen Bildtradition macht Wallinger plausibel, indem er die Situationen nicht nur dokumentiert, sondern mit ästhetischen Eingriffen oder mit einer Anreicherung der vorgefundenen Szenen gezielt zuspitzt. In *Threshold to the Kingdom* besteht der Eingriff in der Verlangsamung des Bildes und in der akustischen Unterlegung mit einem Stück Kirchenmusik, Giorgio Allegris bekannter Vertonung des 51. Psalms.[14] Auf diese Weise wird die simple Handlung des Durchschreitens einer automatischen Zollpforte zur Ankunftshalle durch Metaphorisierung auf die Höhe einer Transzendenz der Wirklichkeit gehoben.[15] Bei *Angel* wird dieser Vorgang mit Hilfe der komplizierten Aufgabe erreicht, die ersten fünf Verse des Johannesevangeliums phonetisch rückwärts auszusprechen zu lernen. Bei dieser Arbeit tritt in Wallingers Schaffen zum ersten Mal eine Theaterfigur auf: Der Engel namens Blind Faith (blindes Vertrauen), der eine dunkle Brille und einen

weissen Stock trägt. „Am Anfang war das Wort und das Wort war bei Gott und das Wort war Gott." „Er wiederholt diesen zentralen Satz des Christentums, bevor er mit musikalischer Begleitung durch Händels *Zadok der Priester* auf der Rolltreppe gen Himmel fährt.[16] Der Film läuft rückwärts. Erlöste oder Verdammte bewegen sich gekonnt rückwärts die Rolltreppe hinauf und hinab. Alles, was sich ereignet, hat sich bereits ereignet. Was ist es denn, das jenseits dieser Ermahnung zum Glauben existiert, wenn nicht im Gottgesandten, dann aber in der Sprache selbst?"[17]

Mit einer solchen Überlagerung von säkularer und sakraler Ikonographie arbeitet Wallinger auch in seiner 2004 entstandenen Videoinstallation *The Underworld*. Die Filmaufnahme einer Aufführung von Giuseppe Verdis *Requiem*[18] liefert die Bild- und Klangebene. Wie der Titel bereits verrät, entwirft Wallinger mit seiner Installation ein Unterweltszenario. *The Underworld* ist eine raffinierte Inszenierung mit vielschichtigen inhaltlichen Bezügen. Die Installation besteht aus 21 Videomonitoren, die in einem vollkommen dunklen Raum im Kreis aufgestellt sind, die Bildflächen gegen innen gerichtet, die Geräte auf den Kopf gestellt. Die Aufführung von Verdis *Requiem* hören und sehen wir 21 Mal, wobei die Wiedergabe auf den einzelnen Monitoren zeitverschoben abläuft. Die

description of the hereafter, Dante's *Divine Comedy*, where hell is described as a funnel shape with concentric circles.[19] What contributes to the frightening, indeed infernal, mood of the work is the ineluctability which is expressed not only formally by the closed circle, but also through the endless repetition of the music, turning the enjoyment of listening into torture. The simultaneity leads to an deafening cacophony: a seething, surging and diminishing carpet of sound underpins the impact of the hellish scenario. The dissolution of real time and the consequent severance of the event from an earthly context engender a rather alarming disorientation.

With *The Underworld* Wallinger has created a kind of sequel to a work produced 16 years earlier. *Heaven* (1988) consists of a birdcage in which a fish lure is suspended in the place of the bird. Fish are the symbol of the first Christians: Christ is described as a fisher of men, but the lure is an image of false and deadly promise – instead of giving sustenance and hence life, it brings death. It is significant that it is a golden cage, proverbially standing for easy circumstances in life, yet at the same time representing a prison. The symmetrical, three-aisled structure of the cage is reminiscent of the architecture of

sacred buildings. Thus the work is more a sarcastic symbolisation of a misguided conception of heaven. At the same time this visualisation displays such Surreal playfulness that the sarcasm is disarmed. For the distortion of realities suggestive of Surrealism is also a reminder of a well-known work by Duchamp, *Why Not Sneeze Rose Sélavy?* (1921/1964).[20] Along with lumps of sugar and a thermometer, Duchamp likewise puts a dead water creature into his birdcage – the skeleton of a cuttlefish.

If it has appeared from our deliberations so far that Mark Wallinger does art *about* religion rather than *religious art*, then this conclusion has to be looked at relatively in the case of *State Britain* (2007), for the installation can (also) be read as a religious work for reasons related to both content and form. Without going into this complex work in detail – I refer readers to the well-argued text by Michael Diers (p. 89–96) – I would like finally to consider *State Britain* in terms of my thematic stance.

As is well known, *State Britain* is a replica of the admonitory display that the peace activist Brian Haw had constructed opposite the Houses of Parliament in London.[21] The protest wall contains many motifs that can be

Aufnahme ist in 21 Zeitsequenzen unterteilt und wird so abgespielt, dass von einem Bildschirm zum nächsten stets ein Zeitsprung entsteht. Daraus entsteht der Eindruck, das Bild drehe sich konstant im Kreis. Auf der visuellen Ebene ergibt sich eine unübersichtliche Multiplizierung des Geschehens: Solisten, Chor, Dirigent, Orchester und Musiker sind gleichzeitig sichtbar. Die expressive Mimik der in ihrem Musizieren aufgehenden Sängerinnen und Instrumentalisten interpretieren wir in diesem Kontext unweigerlich als Ausdruck von Schmerz und Pein. Die verkehrt erscheinenden Figuren werden zu verlorenen, in der Unterwelt schmorenden Seelen, die sich ihren Schmerz aus der Brust schreien. Der Kreis wird zum Reich des Todes, in das die Betrachtenden als Lebende keinen Zutritt haben. Durch die nach innen gewendeten Monitore kann das Geschehen im Bilderkreis nie als Ganzes erfasst werden, der Blick ins Jenseits lässt nur ein Erahnen zu; es entsteht das Gefühl, als ob wir am Rande eines Vulkankraters stehen würden. Das geschlossene Rund evoziert von der Innenseite aus betrachtet auch Ausweglosigkeit – es gibt kein Entrinnen. Die Kreisform verweist unweigerlich auf die wohl bekannteste abendländische Schilderung des Jenseits, auf Dantes *Divina Commedia*, in der die Hölle als eine Trichterform mit konzentrischen Kreisen beschrieben wird.[19] Was zur beängstigenden, ja infernalen Stimmung des Werkes

beiträgt, ist die Unausweichlichkeit, die sich nicht nur formal durch den geschlossenen Kreis ausdrückt, sondern auch durch die endlose Wiederholung der Musik, wodurch der Hörgenuss zu einer Qual wird. Die Gleichzeitigkeit führt zu einer ohrenbetäubenden Kakophonie, ein brodelnder, an- und abschwellender Klangteppich unterstützt die Wirkung des Höllenszenarios. Die Auflösung der realen Zeit und damit die Herauslösung des Geschehens aus einem weltlichen Kontext mündet in eine eher beängstigende Desorientierung.

Mit *The Underworld* hat Mark Wallinger eine Art Gegenstück zu einer 16 Jahre früher entstandenen Arbeit mit dem Titel *Heaven* (1988) geschaffen. *Heaven* besteht aus einem Vogelkäfig, in dem an Stelle eines gefiederten Haustiers ein Fischköder liegt. Der eigentlich in den Luftraum des Käfigs passende Vogel wird durch ein Wassertier ausgewechselt, das lebende Tier wird von einer leblosen Tierattrappe ersetzt. Der Köder dient wiederum dazu, grössere Fische mit dem falschen Versprechen auf ein leckeres Mal anzulocken und durch den versteckten Haken zu töten. Fische sind das Symbol der ersten Christen, Christus wird als Fischer bezeichnet, der Köder ist ein Bild für eine falsche Versprechung: Statt Nahrung und damit Leben zu spenden, bringt er den Tod. Kaum zufällig ist es ein goldener Käfig, der sprichwörtlich für eine angenehme

assigned to a Christian context. Thus among the count-less objects, placards and pictures from which it is assembled we recognize a whole series of crosses as well as various banners inscribed with texts like 'Paz vaya con dios', 'Father forgive them for they know not what they do 2006 AD. Children forgive us for now we do' and 'Christ is risen indeed!'. These religious motifs relate back to the personal background of Brian Haw, an evangelical Christian, or as Wallinger put it, a Christian Socialist,[22] whose protest is presumably strongly rooted in a religiously based moral outrage. For more than six years now he has camped in front of the British Parlia-ment as a kind of personified bad conscience of those politically responsible. And even when a large part of his protest wall was cleared away in May 2006, he did not budge from the spot. With his protest he wants to bear witness to the horrors that are happening in Iraq in the name of official British policy. In this connection the crosses can be understood as a reminder of those who have died in the war, and hence as sort of cemetery crosses. A comparison with the commemorative sites those left behind construct where fatal traffic accidents have occurred, creating open-air altars with flowers, crosses, candles and pictures, comes forcibly to mind.

Typologically the protest wall can be compared with an altar, and this is made still clearer by the integration of Wallinger's installation into the almost sacred-seeming architecture of the Duveen Galleries in Tate Britain. Its function corresponds to that of a decorated church altar. In church the story of the sufferings of Christ or other saints is made visible to the faithful in an often dramatic way. This is intended not only to keep the memory of the martyrdoms of the saints alive, but is above all about empathy with their suffering, *compassio*. Admittedly the pictorial level of *State Britain* is not com-parable with the elaborately worked out iconic pro-gramme of a church altar, but the invitation to participate which also plays a central role here, is similar. Instead of the figures of tortured or martyred saints we see pic-tures of disfigured and maimed children, victims of the Iraq war. They are pictures that reproduce the suffering in a graphic way that does not come across in the usual war reporting by the media; some of them are almost unbearable, and they are totally comparable with Grünewald's depiction of the martyred Christ,[23] an altar-piece with an extremely penetrating depiction of the physical suffering of Jesus.

Lebenssituation steht, die jedoch zugleich ein Gefängnis dar-stellt. Die symmetrische, dreischiffige Struktur des Gitters erinnert an die Architektur von Sakralbauten. Die Arbeit ist somit eine eher sarkastische Symbolisierung einer fehlgelei-teten Vorstellung des Himmels. Gleichzeitig ist diese Visua-lisierung von einer solch surrealen Spielfreude, dass der Sarkasmus wieder aufgebrochen wird. Die surreal anmutende Verdrehung der Realitäten gemahnt denn auch an eine bekannte Arbeit von Marcel Duchamp: *Why Not Sneeze Rose Sélavy?* (1921 / 1964).[20] Dabei legt Duchamp in seinen Vogel-käfig nebst Zuckerstücken und einem Thermometer ebenfalls ein totes Wassertier, ein Sepiaskelett.

Wenn sich aus den bisherigen Überlegungen ergeben hat, dass Mark Wallinger vielmehr Kunst *über* Religion als *reli-giöse Kunst* macht, dann muss dieser Schluss im Falle von *State Britain* (2007) relativiert werden, denn die Installation kann aus inhaltlichen und formalen Gründen (auch) als ein religiöses Werk gelesen werden. Ohne ausführlich auf diese komplexe Arbeit einzugehen – ich verweise auf den fundier-ten Text von Michael Diers (S. 89–96) – möchte ich meine Themenstellung abschliessend auf *State Britain* anwenden. *State Britain* ist bekanntlich eine Replik des Mahnmals, das der Friedensaktivist Brian Haw vor dem Londoner Parlaments-

gebäude aufgebaut hatte.[21] Die Protestwand enthält zahlrei-che Motive, die einem christlichen Kontext zuzuordnen sind. So erkennen wir unter den unzähligen Objekten, Schrifttafeln und Bildern, aus denen sie sich zusammensetzt, eine ganze Reihe von Kreuzen sowie verschiedene Schriftbanner mit Tex-ten wie „Paz vaya con dios", „Father forgive them for they know not what they do 2006 AD. Children forgive us for now we do" oder „Christ is risen indeed!". Diese religiösen Motive gehen auf den persönlichen Hintergrund von Brian Haw zurück, einem evangelikalen Christen, oder, wie es Mark Wallinger for-mulierte, einem christlichen Sozialisten[22], dessen Protest vermutlich stark in einer religiös begründeten moralischen Empörung wurzelt. Seit mehr als sieben Jahren campiert er nun schon vor dem britischen Parlament als eine Art personifi-ziertes schlechtes Gewissen der politisch Verantwortlichen. Und auch als im Mai 2006 ein Grossteil seiner Protestwand abgeräumt wurde, wich er nicht von der Stelle. Mit seinem Protest will er Zeugnis ablegen für die Gräuel, die im Namen der offiziellen britischen Politik im Irak geschehen. Die Kreuze können in diesem Zusammenhang als eine Erinnerung an die Kriegstoten und somit als eine Art Friedhofskreuze verstanden werden. Auch ein Vergleich mit Erinnerungsstätten, die Hin-terbliebene am Ort von tödlichen Verkehrsunfällen aufbauen, wo sie mit Blumen, Kreuzen, Kerzen und Bildern kleine

Marcel Duchamp
Why Not Sneeze Rose Sélavy? 1921 / 1964

Thomas Hirschhorn
Ingeborg Bachmann-Altar, 1998
Kunsthaus Zürich, 1998

I would like to compare Wallinger's 'altar' with a group of works by Thomas Hirschhorn. The Swiss artist Hirschhorn describes his works as altars which are variously dedicated to the memory of writers such as Ingeborg Bachmann or Raymond Carver, and formally they come very close to *State Britain*.[24] Thomas Hirschhorn links the devotional altar with a social statement, in a similar way to Wallinger. However, unlike *State Britain*, Hirschhorn's altars are productions for the form and content of which the artist is himself responsible, whereas Wallinger has transferred a copy of a real street altar into a museum context.

Alongside the multi-layered references linking themes of social policy and identity in Wallinger's work, questions of religious faith have featured strongly and he never falls into the trap of oversimplifying such complex subjects. His is a conceptually orientated artistic strategy, full of rich material for intellectual debate, but in treating questions of faith, he is also an artist who never loses sight of the importance of such issues to basic human experience, and is sensitive to the intimate level on which they operate.

Freiluftaltäre bilden, drängt sich auf. Typologisch lässt sich die Protestwand mit einem Altar vergleichen, was durch die Einbindung von Wallingers Installation in die fast sakral anmutende Architektur der Duveen Galleries in der Tate Britain noch verdeutlicht wurde. Ihre Funktion entspricht derjenigen eines ausgeschmückten Kirchenaltars. In der Kirche wird den Gläubigen die Leidensgeschichte Christi oder anderer Heiliger in oftmals dramatischer Weise anschaulich gemacht. Damit soll nicht nur die Erinnerung an die Martyrien der Heiligen wach gehalten werden, sondern es geht vor allem um das Mitleiden, um die „Compassio". Zwar ist die Bildebene von *State Britain* nicht mit dem elaborierten Bildprogramm eines kirchlichen Altars vergleichbar, ähnlich ist aber die Einladung zur Anteilnahme, die auch hier eine zentrale Rolle spielt. Anstatt gequälter oder gemarterter Heiligenfiguren sehen wir Bilder von entstellten und verstümmelten Kindern, Opfern des Irakkriegs. Es sind Bilder, die das Leiden in einer Drastik wiedergeben, wie sie in der üblichen Kriegsberichterstattung der Medien nicht vorkommt, Bilder, die teils kaum erträglich sind und die sich durchaus mit Grünewalds Darstellung des gemarterten Christus[23] vergleichen lassen, einem Altarwerk mit einer äusserst eindringlichen Schilderung des physischen Leids Jesu.

Wallingers „Altar" lässt sich auch mit Arbeiten von Thomas Hirschhorn vergleichen. Dieser bezeichnet seine Werke als Altäre, die jeweils der Erinnerung an Autorinnen oder Autoren wie Ingeborg Bachmann oder Raymond Carver gewidmet sind und *State Britain* formal sehr nahe kommen.[24] Thomas Hirschhorn verbindet den Andachtsaltar mit einem gesellschaftlichen Statement, ähnlich wie Wallinger. Im Gegensatz zu *State Britain* sind Hirschhorns Altäre jedoch formal und inhaltlich vom Künstler selbst verantwortete Inszenierungen, während Wallinger die Kopie eines realen Strassenaltars in den Museumskontext transferiert hat.

Neben den vielschichtigen Bezügen, mit denen in Wallingers Werk sozialpolitische Themen und Identitätsfragen miteinander verknüpft werden, sind auch religiöse Fragestellungen stark in den Vordergrund getreten, doch tritt er bei der Behandlung solch komplexer Zusammenhänge niemals in die Falle der übertriebenen Vereinfachung. Seine künstlerische Vorgehensweise ist konzeptuell orientiert und birgt reichhaltigen Stoff für intellektuelle Debatten, doch erweist er sich in Fragen des Glaubens auch als ein Künstler, der die Bedeutung solcher Themen als menschliche Grunderfahrung nie aus dem Blick verliert. Vielmehr erspürt er mit grossem Feingefühl die intime Ebene, auf der sie sich ereignen.

1 Yve-Alain Bois, 'Piece Movement. On Mark Wallinger's *State Britain*', in *Artforum*, New York, April 2007, p. 248–251.

2 See for example, Michail Bulkakov, 'Pontius Pilatus', in *Mark Wallinger. Ecce Homo*, exh. cat., Secession, Vienna 2003, p. 5f.; Adrian Searle, 'Eine aussergewöhnliche Gestalt', in ibid., p. 37–41; Michael Diers, 'Sehet, welch ein Mensch', *Warum! Bilder diesseits und jenseits des Menschen*, exh. cat., Martin-Gropius-Bau, Berlin 2003, p. 317–321.

3 Charlotte Higgins, 'It's a good day for bears', in *The Guardian*, London, 5 December 2007, p. 10–12.

4 A whole series of Wallinger's works imply a kind of role-play, with the artist always slipping himself into the figures in question, whether it is the bear in *Sleeper* or the blind man in *Angel*. For the first time in *Ecce Homo* he takes another person as a model and does not enact the Christ figure himself. Many artists before him have incorporated Christ into their work: the examples range from Albrecht Dürer by way of James Ensor to Jonathan Meese.

5 In an interview Mark Wallinger makes a reference to the Yugoslav War. See Yve-Alain Bois, Guy Brett, Margaret Iversen, Julian Stallabrass, 'An Interview with Mark Wallinger', in *October*, Cambridge (MA), no. 123, Winter 2008, p. 197.

6 On this see Alan Krell, *The Devil's Rope: A Cultural History of Barbed Wire*, Reaktion Books, London 2003.

7 On this see Stefania Morellato, 'An Interview with Mark Wallinger', *Mark Wallinger. Easter*, Hangar Bicocca, Milan 2005, p. 71.

8 Franco Zeffirelli (*1923), *Jesus of Nazareth*, 1977, 271 minutes, with Robert Powell and Anne Bancroft.

9 The only figure to be named three times is the devil, who crops up under different names.

10 Johann Strauss (1825–1899), *An der schönen blauen Donau*, 1867.

11 Stanley Kubrick (1928–1999), *2001: A Space Odyssey*, 1968, 143 minutes, with Keir Dullea and Gary Lockwood.

12 Artist in conversation with the author, 18 April 2008.

13 On this see Julia Heimerdinger, *Neue Musik im Spielfilm*, Pfau Verlag, Saarbrücken 2007, p. 36–46.

14 Giorgio Allegri (1582–1652), *Miserere*, 1630s.

15 The important socio-political aspect of this work is dealt with by Janneke de Vries in her contribution to this catalogue, see p. 105–112.

16 George Frideric Handel (1685–1759), *Zadok the Priest*, 1727.

17 Excerpt from an unpublished text by the artist, dated 1987.

18 The well-known Mass for the dead was performed and recorded at the Usher Hall in Edinburgh in 1982 with Claudio Abbado conducting and top-flight singers such as Jessye Norman or José Carreras.

19 Dante Alighieri (1256–1321), *La Divina Commedia*, 1307–1321. In his time William Blake, who is very much admired by Mark Wallinger, worked intensively with *The Divine Comedy* in a comprehensive cycle of watercolours.

20 Marcel Duchamp (1887–1968), *Why Not Sneeze Rose Sélavy?* (1921/64), birdcage, 152 marble cubes in the form of sugar lumps, thermometer, cuttlefish skeleton, 12.4 × 22.2 × 16.2 cm, National Gallery of Canada, Ottawa .

21 In relation to this, the fact that the contents of the assemblage were determined not by Mark Wallinger but by Brian Haw is hardly

1 Yve-Alain Bois, in: *Artforum*, New York, April 2007: „one of the most remarkable political works of art ever".

2 Siehe u. a. Michail Bulgakow, „Pontius Pilatus", in: *Mark Wallinger. Ecce Homo*, Ausst. Kat. Secession, Wien 2003, S. 5f.; Adrian Searle, „Eine aussergewöhnliche Gestalt", in: *Mark Wallinger. Ecce Homo*, Ausst. Kat. Secession, Wien 2003, S. 37–41; Michael Diers, „Sehet, welch ein Mensch", in: *Warum! Bilder diesseits und jenseits des Menschen*, Ausst. Kat. Martin-Gropius-Bau, Berlin 2003, S. 317–321.

3 Charlotte Higgins, „It's a good day for bears", in: *The Guardian*, London, 5. Dezember 2007, S. 10–12.

4 Eine ganze Reihe von Wallingers Arbeiten impliziert eine Art Rollenspiel, wobei der Künstler immer selber in die jeweiligen Figuren schlüpft, sei es der Bär in *Sleeper* oder der Blinde in *Angel*. Für *Ecce Homo* nimmt er erstmals eine andere Person als Modell und mimt die Christusfigur nicht selber. Zahlreiche Künstler vor ihm haben in ihrer Arbeit Christus verkörpert, die Beispiele reichen von Albrecht Dürer über James Ensor bis zu Jonathan Meese.

5 Mark Wallinger macht in einem Gespräch einen Hinweis auf den Jugoslawienkrieg, vgl. Yve-Alain Bois, Guy Brett, Margaret Iversen, Julian Stallabrass, „An Interview with Mark Wallinger", in: *October*, Cambridge (MA), Nr. 123, Winter 2008, S. 197.

6 Siehe dazu: Alan Krell, *The Devils Rope: A Cultural History of Barbed Wire*, London 2003.

7 Siehe dazu: Stefania Morellato, „An Interview with Mark Wallinger", in: *Mark Wallinger. Easter*, Hangar Bicocca, Mailand 2005, S. 71.

8 Franco Zeffirelli (*1923), *Jesus of Nazareth*, 1977, 271 Minuten, mit Robert Powell und Anne Bancroft.

9 Die einzige Figur, die dreimal genannt wird, ist der Teufel, der mit unterschiedlichen Namen auftritt.

10 Johann Strauss (1825–1899), *An der schönen blauen Donau*, 1867.

11 Stanley Kubrick (1928–1999), *2001: A Space Odyssey*, 1968, 143 Minuten, mit Keir Dullea und Gary Lockwood.

12 Gespräch mit der Autorin vom 18. April 2008.

13 Siehe dazu: Julia Heimerdinger, *Neue Musik im Spielfilm*, Pfau Verlag, Saarbrücken 2007, S. 36–46.

14 Giorgio Allegri (1582–1652), *Miserere*, 1630er Jahre.

15 Den wichtigen gesellschaftlich-politischen Aspekt dieses Werks behandelt Janneke de Vries in ihrem Katalogbeitrag S. 105–112.

16 Georg Friedrich Händel (1685–1759), *Zadok the Priest*, 1727.

17 Zitat aus einem unpublizierten Text des Künstlers von 1987.

18 Die bekannte Totenmesse wurde 1982 in der Usher Hall in Edinburgh unter der Leitung von Claudio Abbado mit hochkarätigen Sängern wie Jessye Norman oder José Carreras aufgeführt und aufgezeichnet.

19 Dante Alighieri (1256–1321), *La Divina Commedia*, 1307–1321. Der von Mark Wallinger hoch geschätzte William Blake hat sich seinerseits in einem umfassenden Aquarellzyklus intensiv mit der *Divina Commedia* beschäftigt.

20 Marcel Duchamp (1887–1968), *Why Not Sneeze Rose Sélavy?* (1921/64), Vogelkäfig, 152 Marmorwürfel in Form von Zuckerwürfeln, Thermometer, Sepiaskelett, 12.4 × 22.2 × 16.2 cm, National Gallery of Canada, Ottawa .

21 Die Tatsache, dass die Inhalte der Assemblage nicht von Mark Wallinger, sondern von Brian Haw bestimmt wurden, ist in diesem Zusammenhang wenig relevant, denn der Unterschied besteht eigentlich nur darin, dass der Friedensaktivist die einzelnen Elemente des Werks ausgesucht

relevant, for the difference really lies only in the fact that the peace activist sought out or created the individual elements of the work, while the artist selected and then displayed the protest display as a whole.

22 Artist in conversation with the author, 18 April 2008.

23 Matthias Grünewald (1475–1528), *Isenheim Altar*, 1508–1515, Musée d'Unterlinden, Colmar.

24 Thomas Hirschhorn (*1957), *Ingeborg Bachmann-Altar*, 1998, installation for the *Freie Sicht aufs Mittelmeer* exhibition, Kunsthaus Zürich.

oder geschaffen hat und der Künstler das Protestmahl als Ganzes ausgewählt und dann ausgestellt hat.

22 Gespräch mit der Autorin vom 18. April 2008.

23 Matthias Grünewald (1475–1528), *Isenheimer Altar*, 1508–1515, Musée d'Unterlinden, Colmar.

24 Thomas Hirschhorn (*1957), *Ingeborg Bachmann-Altar*, 1998, Installation für die Ausstellung *Freie Sicht aufs Mittelmeer*, Kunsthaus Zürich.

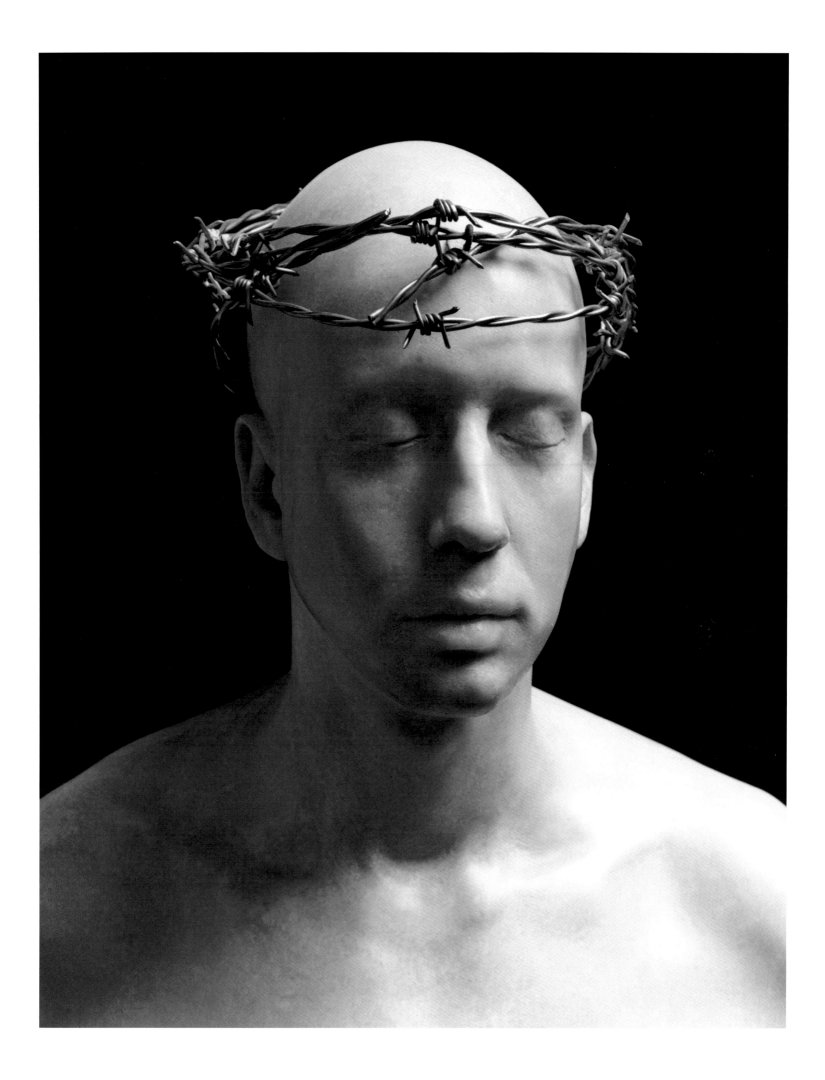

Ecce Homo, 1999
Trafalgar Square, London 1999 / 2000

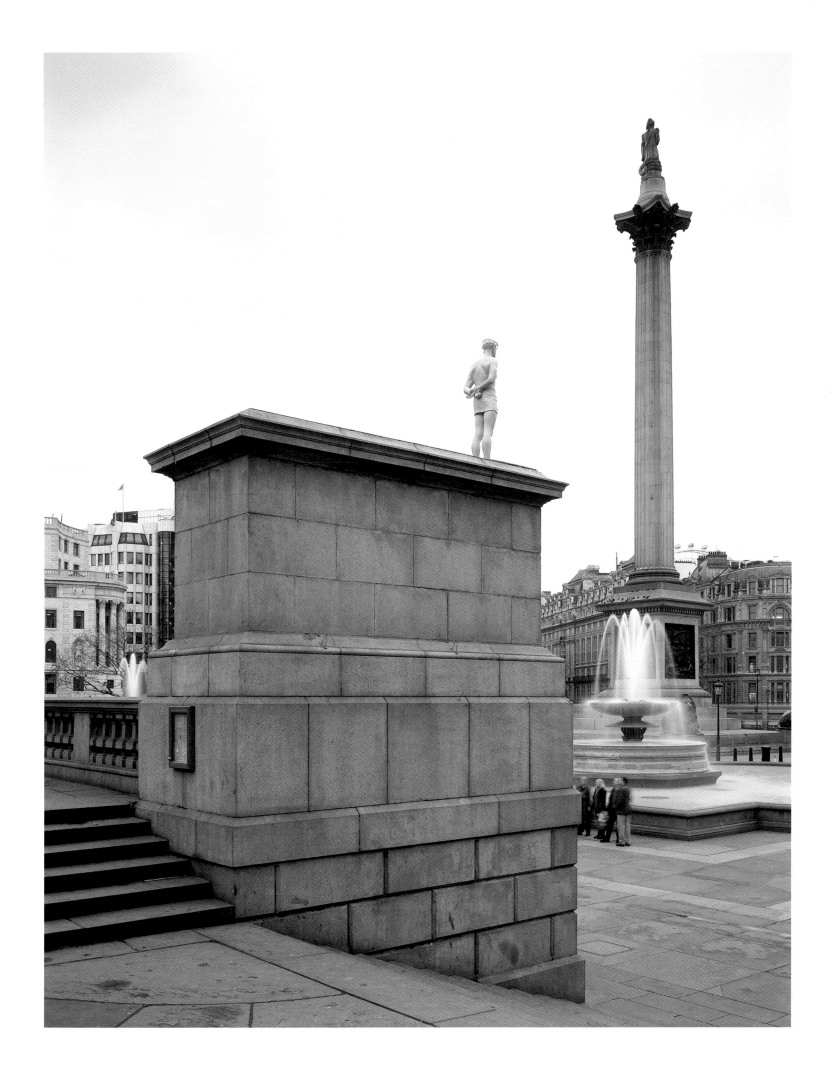

THE END

The End, 2006
Anthony Reynolds Gallery, London 2006

```
GOD
ADAM
EVE
CAIN
ABEL
ENOCH
IRAD
MEHUJAEL
METHUSAEL
LAMECH
ADAH
ZILLAH
JABAL
JUBAL
TUBAL-CAIN
NAAMAH
SETH
ENOS
CAINAN
MAHALALEEL
JARED
ENOCH
METHUSELAH
LAMECH
NOAH
```

```
SAUL
BAAL-HANAN
ACHBOR
HADAR
MEHETABEL
MATRED
MEZAHAB
TIMNAH
ALVAH
JETHETH
ELAH
PINON
MIBZAR
MAGDIEL
IRAM
POTIPHAR
HIRAR
SHUAH
ER
ONAN
SHELAH
TAMAR
ZERAH
ZAPHNATH-PAANEAH
ASENATH
POTI-PHERAH
MANASSEH
EPHRAIM
HANOCH
PHAILU
HEZRON
CARMI
JEMUEL
JAMIN
OHAD
JACHIN
```

```
SHEREZER
REGEM-MELECH
MALACHI
ZARA
ESROM
ABIUD
ELIAKIM
AZOR
SADOC
ACHIM
ELIUD
ELEAZAR
MATTHAN
JACOB
JOSEPH
MARY
JESUS
```

The End, 2006

← *Via Dolorosa*, 2002
Duomo di Milano

The Word in the Desert I, 2000

The Word in the Desert III, 2000

The Word in the Desert V, 2000

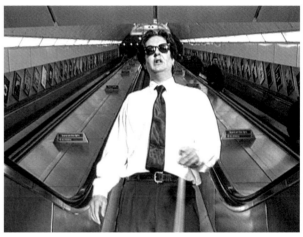

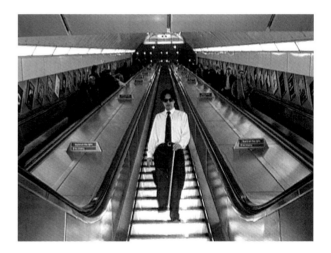

Angel, 1997

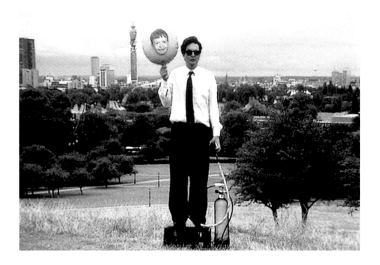

Hymn, 1997

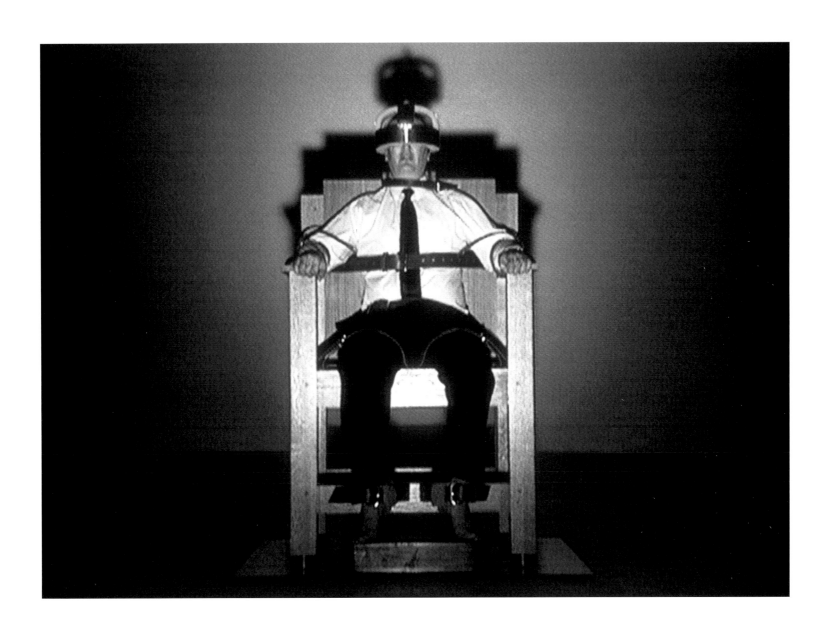

Prometheus, 1999

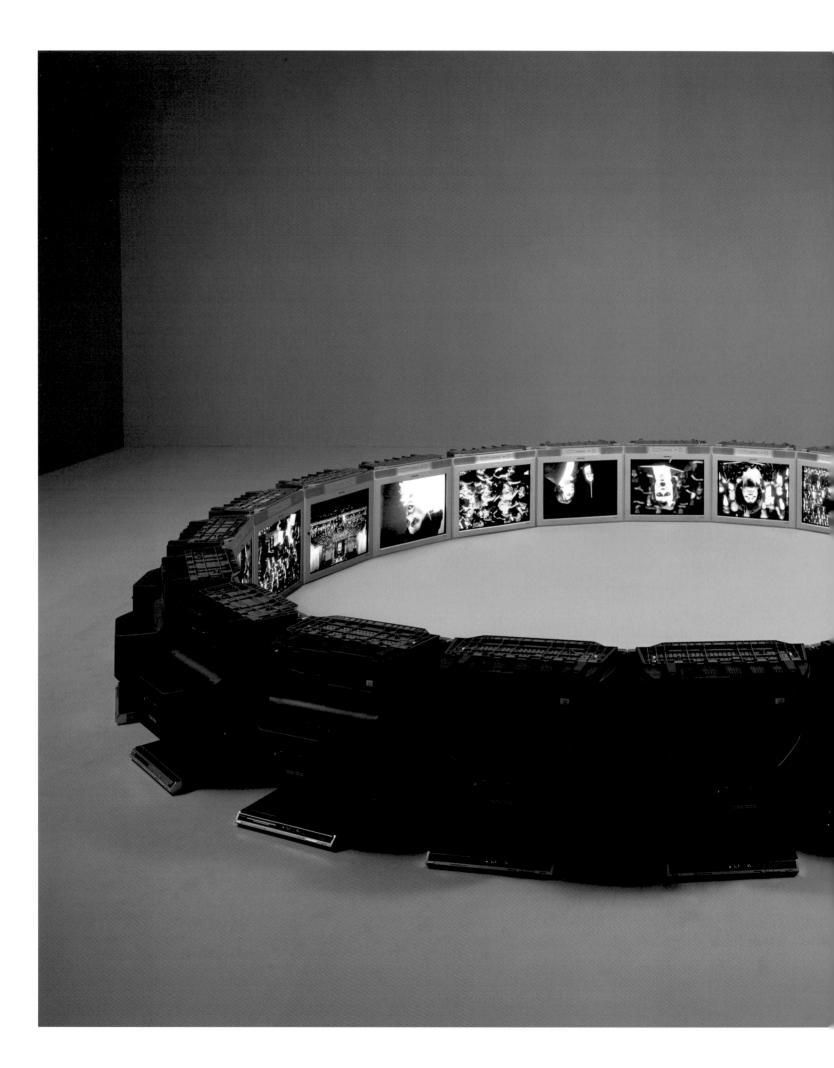

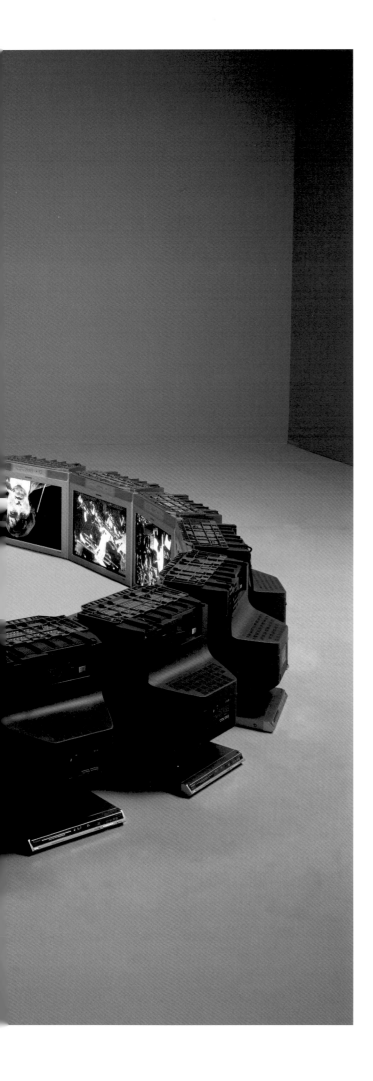

The Underworld, 2004
Hangar Bicocca, Milan 2005

Heaven, 1988

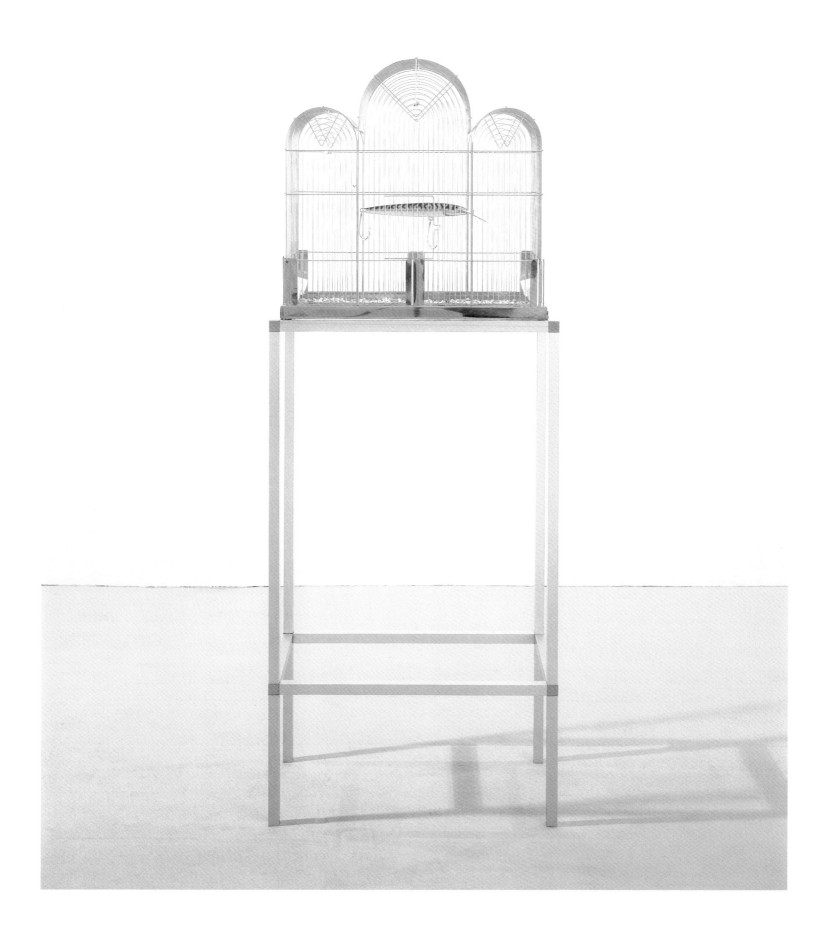

A ist für alles, 2005
Anthony Reynolds Gallery, London 2006

Autopsy, 1996

On an Operating Table, 1998

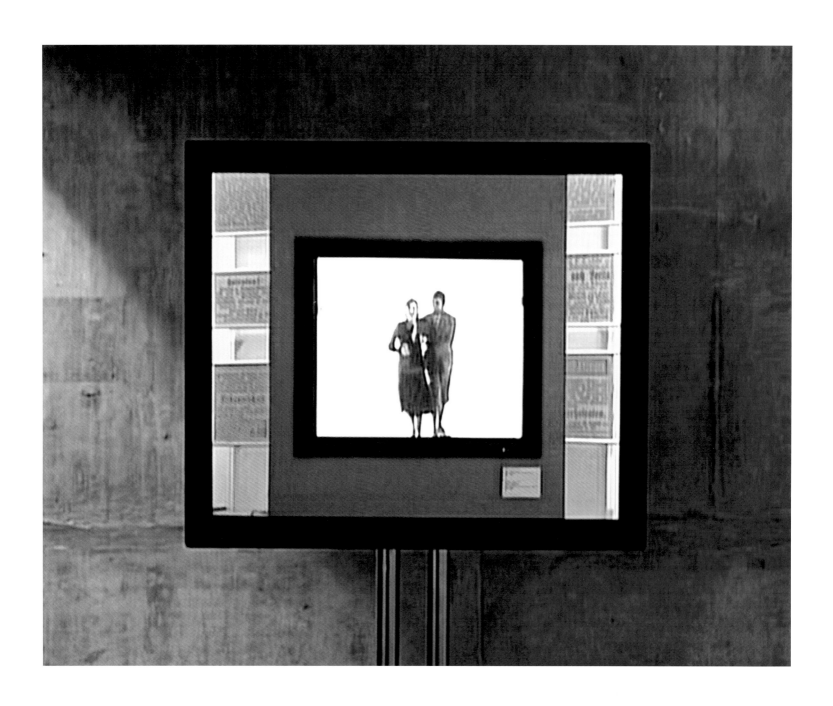

Third Generation (Ascher Family), 2003

IN THE EXCLUSION ZONE OF ART

Notes on *State Britain*
by Mark Wallinger

Michael Diers

Danse macabre – In the early hours of Tuesday, 23 May 2006, a squad of 78 policemen moved into Parliament Square in London to clear away the protest wall of the peace activist Brian Haw, erected on the edge of the street from posters, signs and flags over a length of some 40 metres, leaving only mattresses, tarpaulins and a few personal items. After many attempts over the years and now on the basis of the Serious Organised Crime and Police Act 2005, the authorities had finally succeeded in considerably restricting the right to demonstrate of this carpenter from Worcestershire who had been camping on the grass across from the Palace of Westminster day in, day out, since 2 June 2001.[1] By installing an exclusion zone with a radius of 1000 metres around the Square, political demonstrations could henceforth be banned in the government district.[2] However, as Haw had already been installed there before the law was passed, he was able to procure exceptional consent permitting him to continue his action, subject to certain conditions. Thus in future he was not allowed to extend his installation beyond a length of three metres, and moreover he could now only intermittently use the megaphone that had regularly rung in the ears of politicians and government officials in the Houses of Parliament across the road. Despite

IM BANNKREIS DER KUNST

Notizen zu *State Britain*
von Mark Wallinger

Michael Diers

Totentanz – Am Dienstag, den 23. Mai 2006, rückte in den frühen Morgenstunden ein Trupp von 78 Polizisten am Londoner Parliament Square an, um die dort am Strassenrand aus Plakaten, Transparenten und Flaggen in einer Länge von rund vierzig Metern errichtete ephemere Anklagemauer des Friedensaktivisten Brian Haw bis auf wenige Reste, darunter Matratzen, Planen und persönliche Gegenstände, abzuräumen. Nach jahrelangem Hin und Her war es den Behörden auf der Grundlage eines eigens geschaffenen Gesetzes („Serious Organised Crime and Police Act") nach mehreren Anläufen gelungen, das Demonstrationsrecht des seit dem 2. Juni 2001 tagaus, tagein gegenüber dem Palace of Westminister auf dem Rasen campierenden Zimmermanns aus Worcestershire erheblich einzuschränken.[1] Indem man eine Bannmeile mit einem Radius von 1000 Metern rund um den prominenten Platz einrichtete, liessen sich fortan politische Demonstrationen im Regierungsbezirk verbieten.[2] Da Haw jedoch bereits vor diesem Erlass hier zugegen war, konnte er eine Ausnahmegenehmigung erwirken, die es ihm unter Auflagen gestattete, seine Aktion fortzuführen. So durfte er seine Installation künftig nicht über eine Breite von drei Metern ausdehnen und ferner das Megaphon, das den Politikern und Regierungsbeamten in den Houses of Parliament vis-a-vis regelmässig in den Ohren geklungen hatte, nur mehr von Zeit zu Zeit nutzen. Trotz solcher

such measures, and above all in spite of the destruction of the protest wall that had developed over the course of five years, and that had been renewed again and again, shielded from the weather by plastic sheets, and had ultimately consisted of some 600 individual elements, Haw is still standing fast in the same place today to pillory the government's policy in Iraq and Afghanistan.[3]

The departure point for the peace campaign by the evangelical Christian, Haw, had originally been humanitarian rather than political. Children in particular had already had to suffer under the UN sanctions imposed against Iraq in 1990, as demonstrated not least by the sharp rise in the mortality rate. As a result of the war waged since 2003, their living conditions had become much harsher. Pictures of children who had been killed or wounded by war therefore stood, and stand, at the centre of the rhetorical and visual arguments and agitation of Haw's long-term protest; and a constant flow of new contributions from friends and those who feel solidarity with his cause continue to be integrated into it.

Originally the diverse panorama of textual and pictorial tableaux of varying size, detail and trenchancy had been

spread out in the form of an extensive frieze, the central words of which, addressed to pedestrians and drivers ('You lie, kids die', 'Genocide of Iraq Infants, Innocents! U.S.A/G.B. – Stop Now!', 'Baby Killers', 'The Murdered Children', 'Christ is risen indeed'), were primarily directed against the coalition of American and British troops, specifically against their representatives George W. Bush and Tony Blair. The latter was apostrophised as a liar in a play on his name: 'B-liar'. Other banners argued in favour of the right to public engagement, saying: 'Protest is our right', 'Freedom to protest', 'Free Speech' and also, short and concise, 'Support Brian'.

The centre of the loosely arranged sequence of panels was formed by a line stretched out between two rainbow-coloured peace flags on which children's clothes, spattered with red blood, were hung out as if to dry. Among prominent contributors to the iconostasis was the English graffiti artist Banksy, whose depiction of two soldiers secretly painting a red peace sign on a wall can be understood as an emblematic comment on the hoped-for effect of Haw's project. Two other pictograms arranged in the manner of street signs referred to interest in oil as a decisive reason for the military intervention, and castigated

Massgaben und vor allem trotz der Zerstörung seines im Verlauf von fünf Jahren ständig gewachsenen, immer wieder erneuerten und vor Wind und Wetter durch Folien geschützten, zuletzt aus rund 600 Einzelteilen bestehenden Protestzauns harrt Haw bis heute an Ort und Stelle aus, um die Irak- und Afghanistan-Politik der Regierung anzuprangern.[3]

Ausgangspunkt der Friedenskampagne des evangelikalen Christen waren von Anfang an weniger politische denn humanitäre Gesichtspunkte. Unter den bereits 1990 verhängten UN-Sanktionen gegen den Irak hatten insbesondere Kinder zu leiden, wie unter anderem die deutlich erhöhte Sterblichkeitsrate auswies. Durch den ab 2003 geführten Krieg hatten sich deren Lebensbedingungen schliesslich noch einmal brisant verschärft. Bilder getöteter oder kriegsversehrter Kinder standen und stehen daher im Mittelpunkt der rhetorischen und visuellen Argumentation und Agitation des Haw'schen Dauer-Protestes, in den auch weiterhin immer wieder Beiträge solidarischer Passanten und Freunde integriert werden.

Ursprünglich war das vielfältige Panorama aus Text- und Bildtableaus unterschiedlicher Grösse, Detailliertheit und Prägnanz in der Form eines raumgreifenden Frieses ausgespannt, dessen zentrale, an Fussgänger und Autofahrer adressierte

Parolen („You lie, kids die", „Genocide of Iraq Infants, Innocents! U.S.A./G.B. – Stop Now!", „Baby Killers", "The Murdered Children", „Christ is risen indeed") in erster Linie gegen die Allianz der US-amerikanischen und britischen Streitkräfte, namentlich gegen deren Vertreter George W. Bush und Tony Blair gerichtet waren. Letzterer wurde wortspielend als B-Liar, demnach als Lügner apostrophiert. Andere Schlagzeilen plädierten für das Recht auf öffentliches Engagement, indem es hiess: „Protest is our right", „Freedom to protest", „Free Speech" oder auch kurz und bündig „Support Brian".

Das Zentrum der locker gereihten Tafelfolge bildete eine zwischen zwei regenbogenfarbenen Friedensfahnen ausgespannte Leine, auf der wie zum Trocknen blutrot gefleckte Kinderkleider aufgehängt waren. Prominentester Beiträger zur Ikonostase war der englische Graffiti-Künstler Banksy, dessen Darstellung zweier Soldaten, die heimlich ein signalrotes Peace-Zeichen an eine Wand pinseln, als emblematischer Kommentar auf die erhoffte Wirkung des Haw'schen Projektes zu verstehen war. Zwei andere, in der Art von Strassenschildern angelegte Piktogramme verwiesen auf das Interesse am Erdöl als ausschlaggebendem Grund für die militärische Intervention oder geisselten die Einschränkung der Redefreiheit. In der Vertikalen skandierten einige weitere Flaggen und

restrictions on freedom of speech. Vertically, a few more flags and a cross, nailed together from slats of wood with a photo portrait of Haw stuck onto it, added rhythm to the overall display. On the ground, a variety of objects and utensils, including flowerpots, cardboard crosses and miniature paper coffins, as well as a lot of dolls and teddies ('bears against bombs') alluded to the cruel and pointless death of innocent children.

The impression of passing along a modern *danse macabre* arose not only from the subject treated and its shocking, gruesome details, but also from the impressive scale of the display, comparable in its extent to the painted wall of a mediaeval cemetery, as well as from the combination of image and text such as had constituted that richly traditional genre, and not least from the sharply accusatory tone characteristic of the display as a whole. This tone had already been evident in the late Middle Ages, in towns in particular, as a criticism of the 'mighty of the world' in the form of *danses macabres*, and described as 'democratic agitation'.[4]

Trompe-l'œil – With his work *State Britain* (2007), Mark Wallinger imposingly commemorated Haw's monument to peace.[5] By having it painstakingly reconstructed full-size in all its detail, a task that involved many months and major financial outlay, partly on the basis of photographs that he himself had taken shortly before the act of state iconoclasm, Wallinger recreated as a sculpture what would otherwise have survived at best in documentary images.[6] We are able to comprehend this artistic replica of a non-artistic installation – when first exhibited it could be seen in the pillared halls of the Duveen Galleries in Tate Britain which run elegantly through the entire building – first of all as a political acknowledgement, perhaps even as a form of reparation. An ephemeral protest display which the State had felt obliged to break up a few months earlier was not only publicly reasserted by art as a mimetic reproduction within a period of six months, but as the same time ennobled by being put on permanent exhibition. This was an act of artistic protest against political thoughtlessness and consequently itself a political act that went hand in hand with a renewed contravention of the law in question, because Tate Britain, as the artist immediately pointed out, lies half inside the said exclusion zone. As a result, and this is the point, its presentation in the museum, which was divided into two parts by the

ein aus Latten gezimmertes Kreuz mit einem angehefteten Fotoporträt Haws das Gesamttableau. Am Boden verwiesen diverse Objekte und Utensilien, darunter Blumentöpfe, Pappkreuze und papierene Miniatursärge sowie zahlreiche Puppen und Teddybären („bears against bombs") auf den grausamen und sinnlosen Tod unschuldiger Kinder.

Der Eindruck, im Vorübergehen einen modernen Totentanz abzuschreiten, ergab sich nicht nur aufgrund des verhandelten Gegenstandes und dessen schockierenden und makabren Einzelheiten, sondern auch durch die beeindruckende Gesamtlänge der Anschlagwand, die in ihrer Ausdehnung einer bemalten mittelalterlichen Kirchhofsmauer vergleichbar war; sodann aber auch aus der für die traditionsreiche Gattung konstitutiven Kombination von Bild und Text, und nicht zuletzt durch den für das Ensemble als Ganzes charakteristisch scharfen Anklageton, wie er im Sinne einer Kritik der „Mächtigen der Welt" bereits im ausgehenden Mittelalter, namentlich in Städten, durch die Instanz der Totentänze als „demokratische Regung" verlautet war.[4]

Trompe-l'œil – Mit seiner Arbeit *State Britain* (2007) hat Mark Wallinger dem zerstörten Haw'schen Friedensmonument ein imposantes Denkmal gesetzt.[5] Indem er es im Massstab 1:1

in sämtlichen Details in monatelanger Arbeit mit grossem finanziellem Aufwand, unter anderem anhand fotografischer Aufnahmen, die er selber kurz vor dem ikonoklastischen Staatsakt gemacht hatte, minutiös rekonstruieren liess, hat er als Skulptur nachgeschaffen, was sonst allenfalls in dokumentarischen Bildern überlebt hätte.[6] Man wird diese künstlerische Replik einer ausserkünstlerischen Installation, die anlässlich ihrer ersten Ausstellung in der säulengeschmückten, den Gesamtbau elegant querenden Duveen Galleries der Tate Britain zu sehen war, zunächst als politische Würdigung, vielleicht sogar als eine Form der Wiedergutmachung begreifen können. Eine ephemere Protestkulisse, die der Staat wenige Monate zuvor noch meinte auflösen zu müssen, wurde durch die Kunst qua mimetischer Reproduktion binnen Halbjahresfrist nicht nur öffentlich wieder hervorgekehrt, sondern zugleich nobilitierend auf Dauer gestellt. Ein Akt künstlerischen Protestes gegen politische Unbesonnenheit und dadurch selbst ein politischer Akt, der mit einem erneuten Verstoss gegen das nämliche Gesetz einherging, weil auch das Gebäude der Tate Britain, wie der Künstler flugs ermittelt hatte, zur Hälfte in besagtem Bannkreis liegt. Folglich, so die Pointe, verletzte die Präsentation im Museum, die von der imaginären Grenze in zwei Teile zerschnitten wurde, ebenfalls die staatliche Hoheit über den politischen

imaginary border, likewise undermined state supremacy over political space. Now the freedom of art was suddenly in conflict with the ban on demonstrations, so that the dispute settled after a fashion in Parliament Square seemed to be flaring up precisely one thousand metres away.

Presumably nobody seriously expected that the police might also seize the installation at Tate Britain, but in the play of ideas, that is the approach, the two works, which based on external appearance were similar to the point of interchangeability, were also extremely closely related politically. As a result, what Wallinger had initially endeavoured to achieve primarily on the material level was repeated on the ideological level: the actual reproduction of a political installation as a work of art, a kind of elevation as art in the sense of a simultaneous updating, continuation and historicisation. In its wordplay, the title *State Britain* reflects this conflict by conjugating the condition of the State with the administration of the museum as an institution (Tate Britain), and furthermore posing the general question about the state of affairs where art is concerned (the state of art).

Illusory manoeuvre – Mark Wallinger did not come across Brian Haw and his protest for the first time in spring 2006 because of the night-time raid in the fog by the police. The action of Brian Haw, who had spent years as an obsessive campaigner, standing up for his beliefs, inevitably appeared remarkable in many respects to an artist whose work right from the start had often been concerned with aspects of public life, especially with questions of political representation.[7] Not only was the form of the demonstration using text and picture posters and appeals on a loudspeaker reminiscent of the heyday of political art as it had taken shape in the course of the student movement in the 1970s, and as it had been reflected for example in the work of Joseph Beuys, but at first glance the everyday materials used and the character of Haw's street altar – resembling collage, assemblage and installation – could also be linked to contemporary works of art, including those of Thomas Hirschhorn. In its consistency and many of the means used, the lived-out form of politically committed protest that Haw embodied was connected to an ambitious political conception of art, without the widespread concept of 'street art' having to be applied to it.

Raum. Jetzt widerstritt plötzlich die Freiheit der Kunst dem Demonstrationsverbot, sodass sich der am Parliament Square mehr schlecht als recht geschlichtete Streit genau 1000 Meter entfernt zu erneuern schien.

Vermutlich hat niemand ernsthaft damit gerechnet, die Polizei könnte die Installation in der Tate Britain ebenfalls kassieren, aber im Gedankenspiel, sprich dem Konzept nach, waren beide Werke, die einander dem äusseren Schein nach zum Verwechseln ähnlich sind, auch politisch aufs Engste assoziiert. Dadurch wiederholte sich auf der ideellen Ebene, was Wallinger zunächst vor allem auf der materiellen Ebene angestrengt hatte: die faktische Reproduktion einer politischen Installation als künstlerisches Werk, eine Art Aufhebung qua Kunst im Sinne einer gleichzeitigen Aktualisierung, Fortschreibung und Historisierung. Der Titel *State Britain* spiegelt im Wortspiel diesen Konflikt, indem er den Zustand des Staates mit der Verfassung der Institution Museum (Tate Britain) konjugiert und darüber hinaus die allgemeine Frage nach dem (Zu-)Stand der Dinge in Sachen Kunst (state of the art) stellt.

Täuschungsmanöver – Mark Wallinger ist auf Brian Haw und seinen Protest nicht erst im Frühling 2006 durch die Nacht- und Nebelaktion der Polizei gestossen. Einem Künstler, des-

sen Werk sich von Anbeginn häufig mit Aspekten des öffentlichen Lebens, insbesondere mit Fragen der politischen Repräsentation befasst,[7] musste die Aktion des seit Jahren als querköpfiger Klausner konsequent die Kritik lebenden Brian Haw in vieler Hinsicht bemerkenswert erscheinen. Nicht nur erinnerte die Form der Demonstration mittels Text- und Bildplakaten und Lautsprecherappellen an die Hochzeit einer politischen Kunst, wie sie sich im Zuge der Studentenbewegung in den 1970er Jahren ausgeprägt und zum Beispiel im Werk von Joseph Beuys niedergeschlagen hatte. Die verwendeten Alltagsmaterialien sowie der Collage-, Assemblage- und Installations-Charakter des Haw'schen Strassenaltars liessen sich auf den ersten Blick auch mit Werken der zeitgenössischen Kunst, darunter Arbeiten von Thomas Hirschhorn, in Verbindung setzen. Die gelebte Form engagierten Protestes, die Haw verkörperte, stand in ihrer Konsequenz wie in vielen der eingesetzten Mittel mit einer ambitioniert politischen Auffassung von Kunst in Zusammenhang, ohne dass man den inzwischen grassierenden Begriff „Street Art" dazu heranziehen müsste.

Dass der Staat glaubte, sich dieses Protestes mit allen Mitteln erwehren zu müssen, hat das politische Selbstverständnis des Künstlers Mark Wallinger nicht wenig berührt.

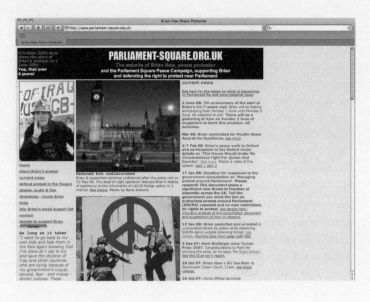

Brian Haw, Homepage

London, map with exclusion zone/
Karte mit Bannmeile

The fact that the state felt it had to fend off the protest using all its resources struck quite a chord with Wallinger, the politically aware artist. After all, a few years earlier in Trafalgar Square, London's most public of public spaces, he had used a life-size, naturalistic sculpture of a young man whose head was adorned with a crown of gilded barbed wire, in a reference updating the *Ecce Homo* scene in the Bible, to remind people that democracy in fact also had to include the right of minorities to express their opinions freely.[8] As in the case of the meticulous reproduction of Haw's protest display which was thereby transformed into a political still life or history picture, the sculpture, through its enhanced truth to life, emphasised the fine line which can be traced in aesthetic terms dividing art and reality. This strategy of facsimile-based metamorphosis is distinguished by the deliberate blurring of the transition from one level to the other in order to illuminate the precise difference between the two spheres more acutely. The largely (materially) identical reproduction of Haw's world of posters and objects differentiates this *trompe-l'œil* process from a related technique of eye-deceiving repetition, as for example, in Warhol's wooden *Brillo Boxes*, or Fischli/Weiss' painted polyurethane sculpture.

In the case of *State Britain*, Wallinger reproduces, to use a tautological expression from the field of advertising, something 'authentic to the original', in order to keep alive in the public mind that critical doubt that never lets the public be quite certain whether it is now dealing with leftovers and relics, or in fact with a work of art that barely visibly shifts the things of the world, including political matters, one millimetre away from what was preordained, and thereby derails them.

I attest brain – The opening image of the 'peace protestor' web site lavishly illustrated with texts and images and maintained by Brian Haw's friends, shows a view of the Houses of Parliament glowing in the evening light. On the other side of the street we see the peace encampment, reduced in size to comply with the law, flanked by two flags. On its left the hero of Parliament Square is sitting on a folding chair; in the foreground some plastic sheets and tarpaulins are lying carefully folded and stacked. 'Reduced but undiminished' is the caption under the photograph which quite unsentimentally stakes out the contrast between the hut and the palace and at the same time contrasts two chronometers – here Big Ben on its tower which measures the

Schliesslich hatte er wenige Jahre zuvor auf dem öffentlichsten aller öffentlichen Plätze in London, auf dem Trafalgar Square, mit einer lebensgrossen, veristischen Skulptur eines jungen Mannes, dessen Haupt eine Stacheldrahtkrone zierte, in aktualisierender Anspielung auf die biblische Szene des *Ecce Homo* daran erinnert, dass Demokratie gerade auch das Recht der Minderheit auf freie Meinungsäusserung einschliessen müsse.[8] Wie im Fall der akribischen Reproduktion der Haw'schen Protestlandschaft, die dadurch in ein politisches Stillleben oder Historienbild verwandelt wurde, betonte auch die „Credo"-Skulptur von 1999 durch ihre gesteigert hohe Lebensechtheit den schmalen Grat, der sich in ästhetischer Hinsicht zwischen Kunst und Wirklichkeit ziehen lässt. Den Übergang von der einen zur anderen Ebene bewusst zu verschleifen, um im Sinne einer verschärften Wahrnehmung gerade die Differenz beider Sphären herauszustellen, zeichnet diese Strategie faksimilierender Metamorphose aus. Die weitgehend (material-)identische Reproduktion der Haw'schen Plakat- und Objektwelt unterscheidet dieses Trompe-l'œil-Verfahren von einer verwandten Technik augentäuschender Wiederholung, wie sie zum Beispiel durch Warhols aus Holz gefertigte *Brillo Boxes* oder Fischli/Weiss' farbig gefasste Polyurethan-Skulpturen vertreten wird. Wallinger reproduziert im Fall von *State Britain*, mit einem tautologischen Aus-

druck der Werbewirtschaft gesagt, „originalauthentisch", um jenen kritischen Zweifel beim Publikum wachzuhalten, der es nie ganz sicher darüber sein lässt, ob es sich nun um Relikte und Reliquien oder doch um ein Kunstwerk handelt, das kaum sichtbar die Dinge der Welt, darunter auch die politischen, um einen Millimeter vom Vorgegebenen abrückt und damit aus den Fugen bringt.

I attest brain – Das Eingangsbild der von Freunden Brian Haws betreuten, reich text- und bildgestützten Website des „peace protestor" zeigt eine im Abendlicht erstrahlende Ansicht der Houses of Parliament. Auf der anderen Strassenseite sieht man den vorschriftsmässig reduzierten, von zwei Fahnen bewehrten Friedenskiosk. Links davon hat der Held des Parliament Square auf einem Campingstuhl Platz genommen, im Vordergrund liegen akkurat gefaltet und gestapelt einige Folien und Planen. „Reduced but undiminished" lautet die Bildunterschrift des Fotos, das ganz unsentimental auf den Kontrast von Hütte und Palast setzt und zugleich zwei Zeitmesser kontrastiert – hier die Turmuhr des Big Ben, welche den Lauf der Zeit nach Stunden und Minuten, dort der Protestler, der seine Aktion fortlaufend nach jener Anzahl von Tagen und Nächten bemisst, die er seither mahnwachend vor Ort verbracht hat.[9] Wenige Clicks weiter stösst man über

course of time by hours and minutes, there the protes-
tor who measures his action continuously by the number
of days and nights he has spent on the spot in his unre-
lenting vigil.[9] A few clicks further on via the straightfor-
ward indication 'images on other sites', and we come to
a link that takes us to the homepage of Tate Britain
where we encounter Haw's previous complete installa-
tion in Wallinger's variant by means of photographs
and videos, like a journey into prehistory: however, as
we know from the action in front of the Palace of
Westminster, political reality continues at present to
stand at its side.

den nüchternen Verweis „images on other sites" auf einen
Link, der den Besucher zur Homepage der Tate Britain führt,
wo ihm die vormalige Haw'sche Gesamtinstallation in der
Variante Wallingers anhand von Fotografien und Videos wie
eine Reise in die Vorzeit begegnet, der jedoch, wie er durch
die Aktion vor dem Palace of Westminster weiss, die politi-
sche Realität weiterhin aktuell zur Seite steht.

The author would like to thank Madeleine Schuppli and Barbara von Flüe for their support. The literature used, other than works specifically referred to in the notes, is: Mark Wallinger, *State Britain*, ed. Clarrie Wallis, exh. cat., Tate Britain, London 2007. – Yve-Alain Bois, 'Piece Movement. On Mark Wallinger's *State Britain*', in *Artforum*, New York, April 2007, p. 248–251. – Yve-Alain Bois, Guy Brett, Margaret Iversen and Julian Stallabrass, 'An Interview with Mark Wallinger', in *October*, Cambridge (MA), no. 123, 2008, p. 185–204. – Paul Bonaventura, 'Mark Wallinger: State Britain', in *Parkett*, Zurich, no. 79, 2007, p. 6–9. – For further literature see also Wikipedia, the free encyclopedia under 'State Britain'.

1 Brian Haw, born 1949 and the father of seven children, has been interested in political questions since his youth. Thus as early as the 1970s he undertook to mediate in his own way in the Irish conflict, later on to make himself useful as a social aid in Cambodia, and to intervene in his own country on behalf of disadvantaged children. His protest in Parliament Square has resulted in him becoming a public figure well beyond England, and even before the destruction of his monumental protest display the media repeatedly reported on his activities (information as in Wikipedia, the free encyclopedia [en.wikipedia.org/wiki/Brian_Haw], under Brian Haw; as at 2 May 2008). On a web site managed by his friends the cause of his protest and the ideas behind it as well as its chronology and many contributions to the widely ramified publicity debate can be read or viewed (www.parliament-square.org.uk).

2 The law was enacted in 2005. In March 2008 it was modified decisively: 'Managing Protest around Parliament: The Government proposes the repeal of sections 132–138 of the Serious Organised Crime and Police Act 2005. Repeal of these sections will remove the requirement to give notice of demonstrations in the designated area around Parliament. It will also remove the offence for such demonstrations to be held without the authorisation of the Metropolitan Police Commissioner.' The Governance of Britain – Constitutional Renewal, March 2008

3 See web site.

4 Information from Gert Kaiser (ed.), *Der Tanzende Tod. Mittelalterliche Totentänze*, Insel Taschenbuch, Frankfurt/Main 1983, p. 37.

5 *State Britain* brought the artist himself the 2007 Turner Prize.

6 As Haw's posters were loaded into a container during the police raid in May 2006 (see facts and photos on the Haw web site), it is not impossible that the installation has 'survived' in a state-run room of court exhibits. – The Mike Smith Studio in London which specialises in contemporary art subjects, made the reproductions, commissioned by the artist.

7 See in general the *Mark Wallinger. Credo*, exh. cat., Tate Liverpool, London 2000, and Michael Diers, 'Mark Wallinger', *Warum! Bilder diesseits und jenseits des Menschen*, ed. Matthias Flügge and Friedrich Meschede, exh. cat., Martin-Gropius-Bau Berlin, Hatje Cantz Verlag, Ostfildern-Ruit 2003, p. 316–321.

8 'Democracy is about the right of minorities to have free expression, not the majority to browbeat and marginalise.' Mark Wallinger, quoted in Ian Hunt, 'Protesting Innocence', *Mark Wallinger. Credo*, p. 16.

9 At present, i.e. on completion of this text on 4 May 2008, according to the web site, it comes to exactly 2528 days (and nights).

Der Verfasser dankt Madeleine Schuppli und Barbara von Flüe für ihre Unterstützung. Benutzte Literatur, sofern sie in den Anmerkungen nicht eigens nachgewiesen ist: Clarrie Wallis (Hg.), *State Britain*, Ausst. Kat., Tate Britain, London 2007; Yve-Alain Bois, „Piece Movement. On Mark Wallinger's *State Britain*", in: *Artforum*, New York, April 2007, S. 248–251; Yve-Alain Bois, Guy Brett, Margaret Iversen, Julian Stallabrass, „An Interview with Mark Wallinger", in: *October*, Cambridge (MA), Nr. 123, 2008, S. 185–204; Paul Bonaventura, „Inspirierende Empörung", in: *Parkett*, Zürich, Nr. 79, 2007, S. 10–13. Für weitere Literatur siehe auch Wikipedia, the free encyclopedia s. v. „State Britain".

1 Brian Haw, geboren 1949, Vater von sieben Kindern, ist seit seiner Jugend an politischen Fragen interessiert. So hat er bereits in den 1970er Jahren auf seine Weise unternommen, im Irland-Konflikt zu vermitteln, sich später als Sozialhelfer in Kambodscha nützlich zu machen oder sich für benachteiligte Kinder in seiner Heimat einzusetzen. Sein Protest am Parliament Square hat ihn weit über England hinaus zu einer öffentlichen Person werden lassen, über welche die Medien auch vor der Zerstörung seiner monumentalen Protestlandschaft immer wieder berichtet haben (Angaben lt. Wikipedia [en.wikipedia.org/wiki/Brian_Haw], s.v. Brian Haw; Stand vom 2. Mai 2008). Auf einer von Freunden betreuten Webseite lassen sich sowohl Anlass und Idee als auch die Chronologie seines Protestes und zahlreiche Beiträge der weit verzweigten publizistischen Debatte nachlesen oder ansehen (www.parliament-square.org.uk).

2 Das 2005 erlassene Gesetz wurde im März 2008 in entscheidenden Punkten geändert: „Neuer Umgang mit Protesten im Parlamentsviertel: Die Regierung schlägt die Aufhebung der Paragraphen 132–136 des Gesetzes zur Bekämpfung organisierter Schwerkriminalität (Serious Organised Crime and Police Act) aus dem Jahr 2005 vor. Durch die Aufhebung dieser Paragraphen entfällt die Notwendigkeit, Demonstrationen in der Bannmeile um das Parlament zuvor anmelden zu müssen. Entfallen wird ausserdem der Strafbarkeitscharakter solcher Demonstrationen, wenn sie ohne die Erlaubnis der Londoner Polizei veranstaltet werden." Die britische Regierungsführung – Erneuerung der Verfassung, März 2008

3 Siehe Website (wie Anm. 1).

4 Angaben nach Gert Kaiser (Hg.), *Der Tanzende Tod. Mittelalterliche Totentänze*, Insel Taschenbuch, Frankfurt/Main 1983, S. 37.

5 Dem Künstler selber wiederum hat *State Britain* den Turner Prize des Jahres 2007 eingetragen.

6 Da die Haw'schen Plakate während der Polizeiaktion im Mai 2006 in einen Container verladen worden sind (siehe die Angaben und Fotos auf der Haw'schen Webseite, wie Anm. 1), ist es nicht ausgeschlossen, dass die Installation in einer staatlichen Asservatenkammer „überlebt" hat. Die Reproduktionen fertigte im Auftrag des Künstlers das auf Fragen der zeitgenössischen Kunst spezialisierte Londoner Studio Mike Smith an.

7 Vgl. dazu allgemein *Mark Wallinger. Credo*, Ausst. Kat., Tate Liverpool, London 2000, sowie Michael Diers, „Mark Wallinger", in: *Warum! Bilder diesseits und jenseits des Menschen*, hg. von Matthias Flügge und Friedrich Meschede, Ausst. Kat., Martin-Gropius-Bau Berlin, Hatje Cantz Verlag, Ostfildern-Ruit 2003, S. 316–321.

8 „Democracy is about the right of minorities to have free expression, not the majority to browbeat and marginalise." Mark Wallinger, zitiert nach Ian Hunt, „Protesting Innocence", in: *Mark Wallinger. Credo* (wie Anm. 7), S. 16.

9 Das sind derzeit, d. h. bei Abschluss des vorliegenden Textes am 4. Mai 2008, laut Website (wie Anm. 1) exakt 2528 Tage (und Nächte).

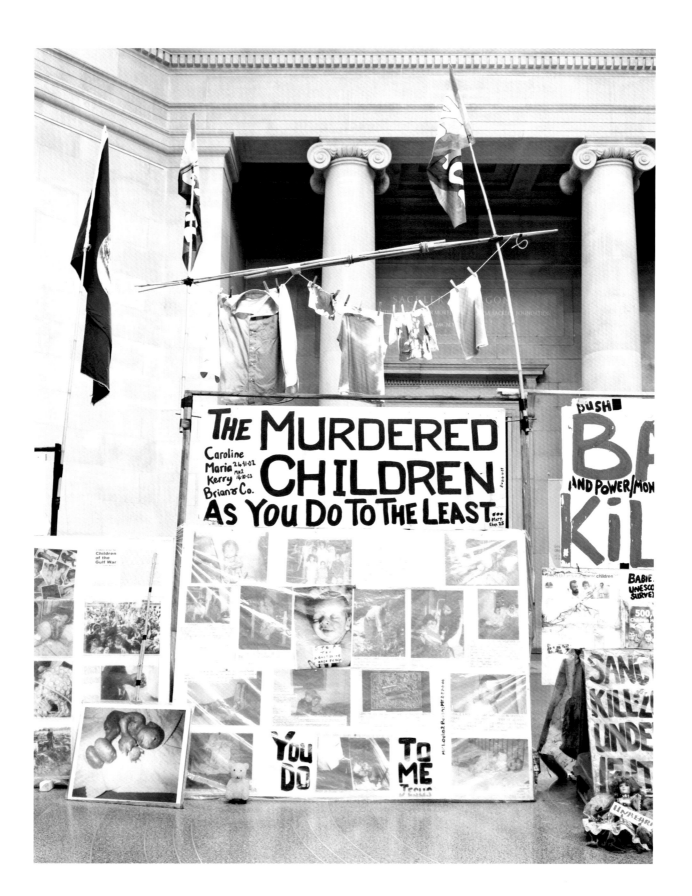

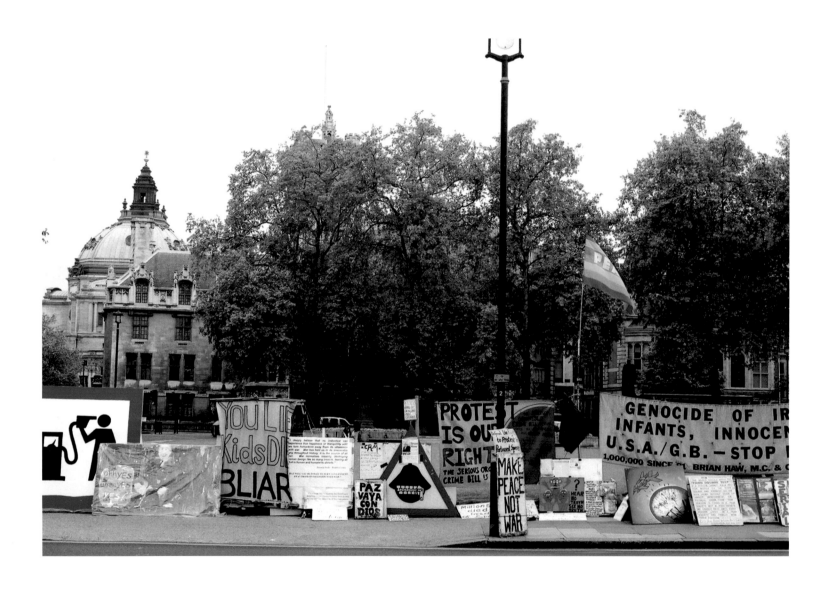

Brian Haw's protest, Parliament Square, London 2006

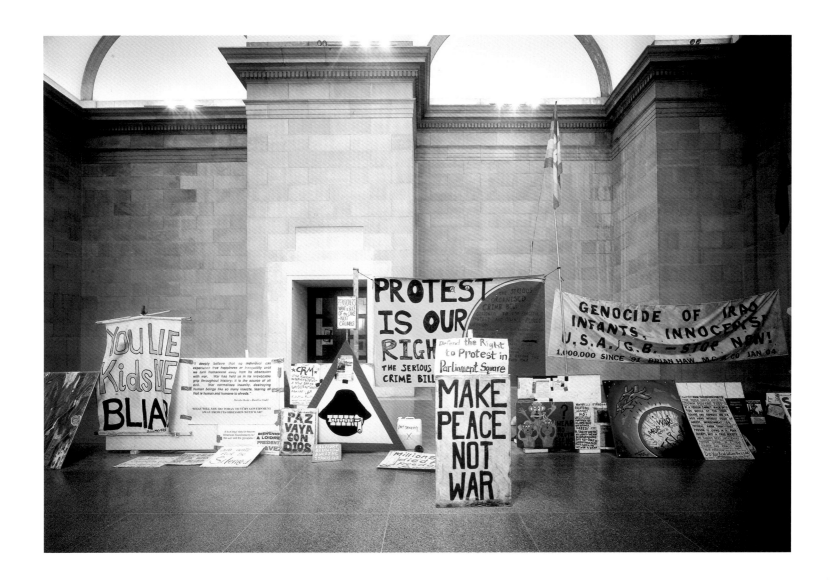

State Britain, 2007
Tate Britain, London 2007

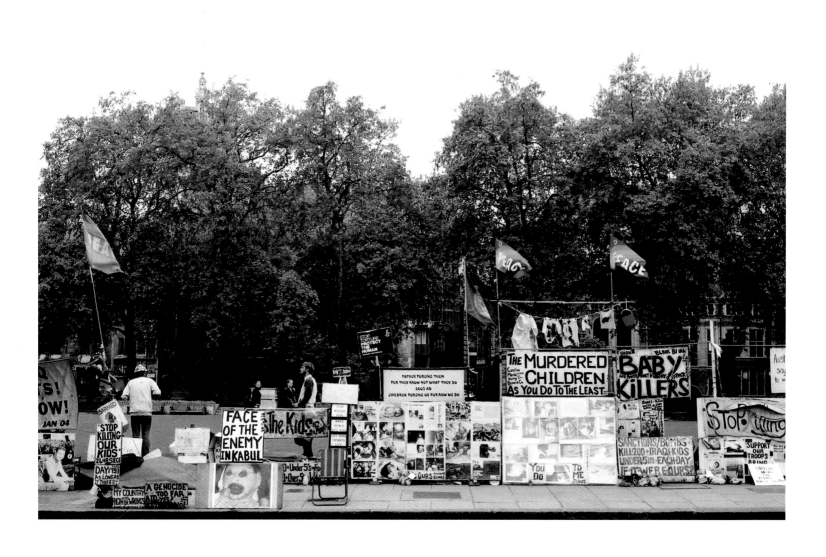

Brian Haw's protest, Parliament Square, London 2006

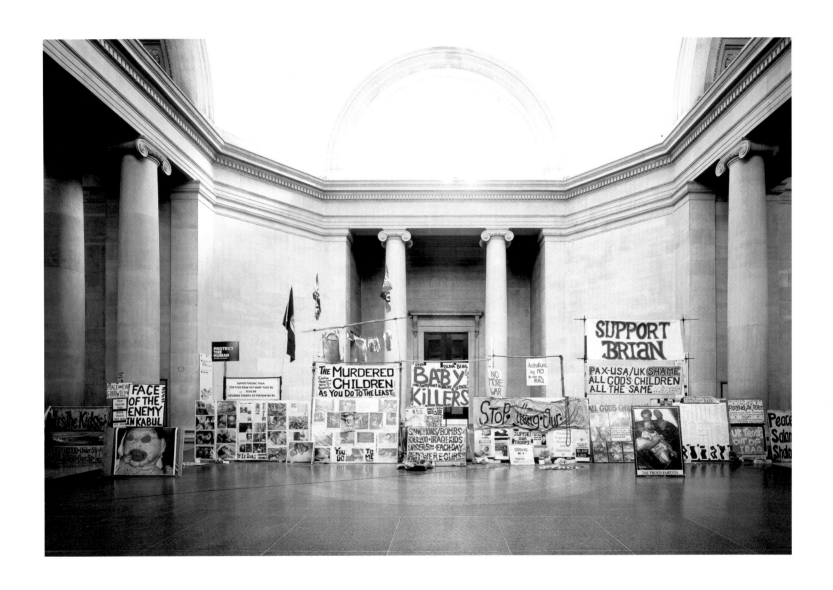

State Britain, 2007
Tate Britain, London 2007

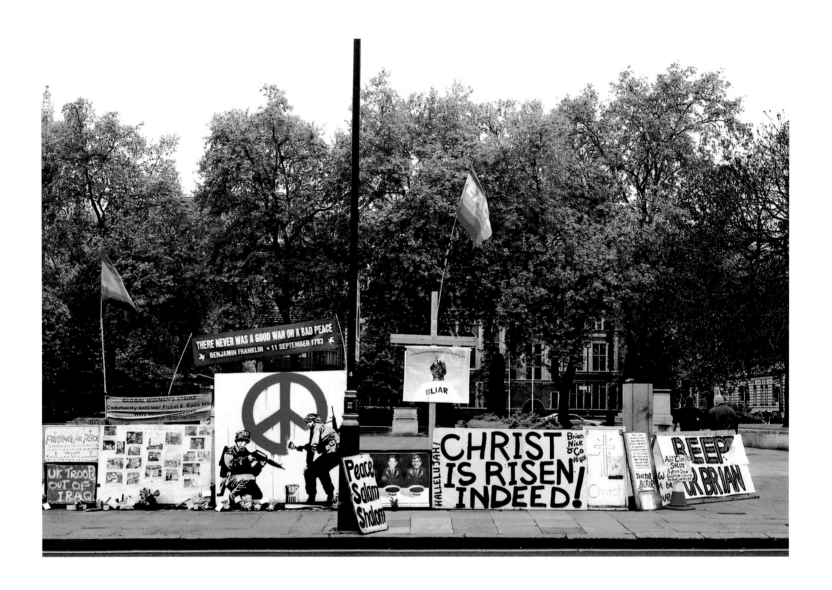

Brian Haw's protest, Parliament Square, London 2006

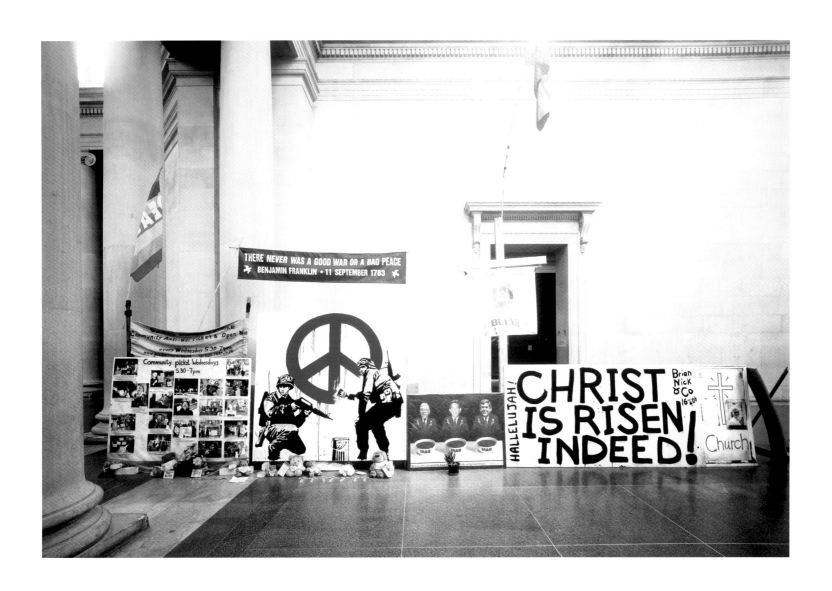

State Britain, 2007
Tate Britain, London 2007

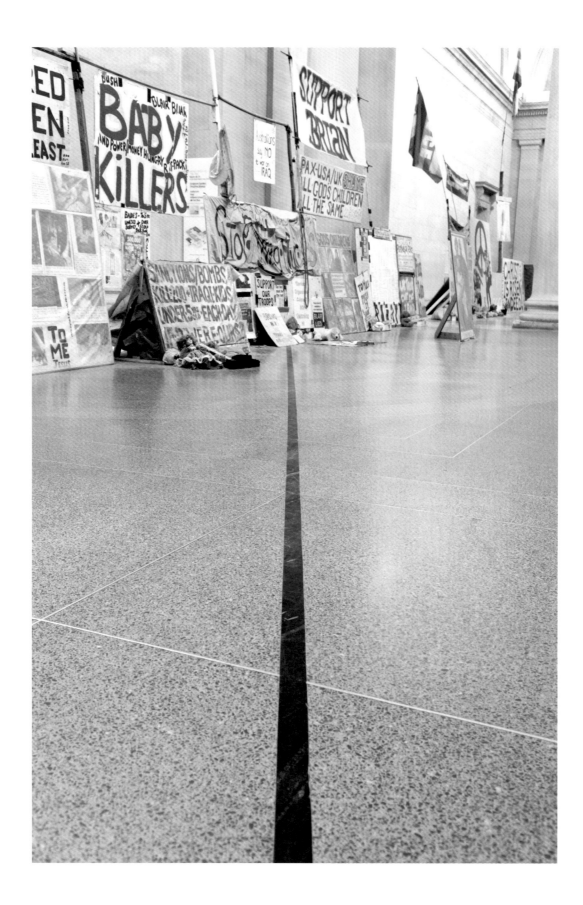

State Britain, 2007
Tate Britain, London 2007

THE KNOWN INVISIBLE

Janneke de Vries

Human beings reconstruct their surroundings mainly via visual perception. What we have before our eyes recognisably exists. We can question it with respect to its quality, but not with regard to its presence. But sometimes perception can be replaced by knowledge. On occasion it is enough for us to know that something is there to recognise its existence. Perhaps we could here speak of the known invisible, in a reversal of Rosalind Krauss' *Optical Unconscious*. Viewed positively, it has something to do with the liberation of thoughts from the optical given fact. It could be interpreted negatively as blind submission to information that has been alleged to us. And it is all the more astonishing when this phenomenon occurs in fine art – the field in which presence is initially communicated via visual perception.

The work *Zone*, which Mark Wallinger developed in summer 2007 for the Münster Sculpture Projects, is one such remarkable case. It entailed the artist encircling the inner city of Münster with a fine, transparent thread almost five kilometres long. At a minimum height of 4.5 metres, the line travelled along the façades of houses above the heads of the passers-by, crossed streets, avoided lampposts, was suspended in parks and gardens

DAS GEWUSSTE UNSICHTBARE

Janneke de Vries

Der Mensch erschliesst sich seine Umwelt zum grossen Teil über die visuelle Wahrnehmung. Was wir vor Augen haben, ist anerkanntermassen existent. In Frage stellen können wir es hinsichtlich seiner Qualität, aber nicht in Bezug auf seine Anwesenheit. Doch manchmal kann die Wahrnehmung durch das Wissen ersetzt werden. Gelegentlich reicht es, zu wissen, dass etwas da ist, um seine Existenz anzuerkennen. Vielleicht könnte man hier, in Umkehrung von Rosalind Krauss' *Optical Unconscious*, vom gewussten Unsichtbaren sprechen. Das hat, positiv, etwas mit einer Befreiung der Gedanken vom optisch Gegebenen zu tun. Negativ liesse es sich als blinde Fügung unter das auffassen, was einem an Informationen vorgegeben wird. Und es ist umso erstaunlicher, wenn sich dieses Phänomen in der Bildenden Kunst ereignet – dem Bereich, in dem sich Präsenz im ersten Moment über die visuelle Wahrnehmung vermittelt.

Die Arbeit *Zone*, die Wallinger im Sommer 2007 für die Skulptur Projekte Münster entwickelt hat, ist so ein erstaunlicher Fall. Dafür hat der Künstler die Innenstadt Münsters mit Hilfe einer dünnen, transparenten Schnur in einer Länge von fast fünf Kilometern eingekreist. In 4.5 Metern Mindesthöhe zog sich die Schnur über den Köpfen der Passanten an Häuserfassaden entlang, überquerte Strassen, wich Laternenpfählen aus, hangelte sich in Grünanlagen von Baum zu Baum und überwand

from tree to tree, and crossed over the lake. The centre of the circle so described was located on a traffic island opposite the Sculpture Projects main office. The course of Wallinger's encirclement was marked on the map indicating the position of all the works participating in the Sculpture Projects. The project and artist likewise appeared on the list of participants in the exhibition. The catalogue described the work. So there were many confirmations of its presence. But it was almost impossible to see the virtually transparent line. With knowledge of its existence, one of the fixing clamps on the façades of the houses could sometimes be discerned, or a fleeting glimpse of the line crossing from one side of a street to another could be caught, when by chance a sunbeam was reflected on the material, causing it to glimmer. But after craning your neck and peering up for a certain amount of time, you finally gave up and just accepted the line's presence as an actual fact. As a consequence people generally followed Zone with the help of the map, without being able to assimilate the work visually – conscious in a strangely intense way of the fact that it was accompanying them through the town. For a long time now invisibility has not necessarily meant a lack of presence.

Furthermore, the difficulties of assimilating Zone visually in conjunction with the precise placing of the work on the town map led to a paradox. The actual presence was replaced by a symbol. The aid to finding the directions when walking around the work was not the signified itself, but its sign. It also gave the majority of visitors a system for viewing all the other works that were scattered across the Münster townscape: they were automatically divided into those that were located inside the Wallinger circle, and those that were outside it. This division determined the rhythm and chronological sequence of viewing: people first looked at everything inside the circle, then rode around everything outside it on bicycles – or the other way round. In this way a work, which could hardly be discerned in material terms, dominated the visual apprehension of the other materially present artworks.

The almost invisible demarcation of a boundary that Zone delineated between outside and inside followed the method used in constructing the Orthodox Jewish 'eruv'– a symbolic boundary line that extends private space into urban space, so circumventing the prohibitions prescribed for the Sabbath. For instance, on the

Teile des Aasees. Das Zentrum der auf diese Weise beschriebenen Kreisform befand sich auf einer Verkehrsinsel gegenüber dem Hauptbüro der Skulptur Projekte. Auf dem Plan, der die Lage aller an den Skulptur Projekten beteiligten Arbeiten verzeichnete, war der Verlauf von Wallingers Umkreisung vermerkt. Auf der Teilnehmerliste der Ausstellung waren Projekt und Künstler ebenfalls aufgeführt. Der Katalog beschrieb die Arbeit. Zahlreiche Bestätigungen ihrer Anwesenheit also. Sehen aber konnte man die transparente Schnur kaum. Mit dem Wissen um ihre Existenz liess sich manchmal eine der Befestigungsklampen an Häuserfassaden ausmachen oder ein flüchtiger Blick auf die sich von einer Strassenseite zur anderen ziehende Schnur erhaschen, wenn zufällig ein Sonnenstrahl das Material reflektieren und aufblitzen liess. Nachdem man aber eine gewisse Zeit den Kopf in die Höhe gereckt hatte, gab man schliesslich mit steifem Hals auf und nahm das Vorhandensein der Schnur als faktische Gegebenheit hin. Meist also lief man Zone mit Hilfe des Lageplans ab, ohne die Arbeit visuell fassen zu können – wobei man sich auf seltsam intensive Weise ihrer Begleitung durch den Stadtraum bewusst war. Unsichtbarkeit meint eben noch lange nicht mangelnde Präsenz.

Darüber hinaus führten die Schwierigkeiten, Zone visuell zu greifen, gemeinsam mit der genauen Verortung der Arbeit in

der Stadtkarte zu einem Paradoxon. Die faktische Präsenz wurde ersetzt durch deren Symbol. Orientierungshilfe beim Ablaufen der Arbeit war nicht das Bezeichnete selbst, sondern dessen Zeichen. Mehr noch: Die schriftliche Verzeichnung von Zone gab der Mehrzahl der Besucherinnen und Besucher eine Systematik im Erfassen aller anderen, im Münsteraner Stadtraum verteilten Arbeiten vor, indem automatisch eine Unterteilung vorgenommen wurde in die Werke, die innerhalb des Wallinger-Kreises lagen, und die, die sich ausserhalb befanden. Diese Unterteilung bestimmte Rhythmus und chronologische Abfolge in der Betrachtung, indem man zunächst alles innerhalb des Kreises besuchte, um dann mit dem Fahrrad alles ausserhalb abzufahren – oder umgekehrt. Auf diese Weise dominierte eine Arbeit, die materiell kaum auszumachen war, die visuelle Erfassung anderer materiell präsenter Werke.

Die nahezu unsichtbare Abgrenzung, die Zone zwischen einem Aussen und seinem Innen vornahm, folgte der Konstruktionsmethode des orthodox-jüdischen „Eruvs" – einer symbolischen Grenzziehung, die den Privatraum in den urbanen Raum hin erweitert und so Verbote des Sabbats umgeht. Das Tragen von Gegenständen etwa ist am Sabbat nur im privaten Rahmen erlaubt. Wird aber der Privatbereich durch die im Talmud beschriebene Installierung eines „Eruvs" in den

Skulptur Projekte Münster 07,
map with / Karte mit Zone, 2007

Sabbath, the carrying of objects is allowed only in the private context. But if the private sphere is expanded into public space by the installation of an 'eruv' as described in the Talmud, a prayer book can be carried when walking to the synagogue, for example. An 'eruv' was installed just last year in a district of northwest London. In fact the White House in Washington and the European Parliament in Strasbourg lie within such invisible boundaries. The 'eruv' is the positive mirror image of a ghetto insofar as it symbolises a productive extension of the urban space through the drawing of a boundary, a free space that can be interpreted in new ways, whereas the ghetto stands for the confinement and exclusion of those who must remain within its boundaries on the orders of people outside.

The conception of the drawing of boundaries as a means of exercising political or territorial power is added to the ways of interpreting Zone when Wallinger himself refers to the meaning of the English 'pale' as another form of zone.[1] 'Pales' had been set up since the 14th century as areas of home rule in enemy territory, as regions where power prevailed without restriction. The expression 'beyond the pale' is still used in English today: literally it

meant that everything beyond the sphere of influence of English supremacy was to be regarded as unacceptable. The extent to which the installation of power-asserting, territorial demarcation lines is still part of political culture today was shown in 2005 when the British government announced a kilometre-wide exclusion zone around Parliament Square, thereby erecting a de facto 'pale'. As a result, the long-standing protest wall erected by Brian Haw was finally dismantled as an unauthorised political demonstration within the boundaries of the restricted area – only to be promptly reconstructed in Tate Britain as State Britain by Mark Wallinger.[2]

The questions of the drawing of territorial boundaries in an attempt to secure political power and its justification, formulated in a more coded way in Zone and more openly in State Britain, run through many of Wallinger's works as fundamental motifs. They can already be found in Oxymoron (1996), in which the artist replaced the blue and red of the Union Jack with their complementary colours, orange and green, thus obtaining the colours of the Irish flag and transposing the rhetorical figure of the oxymoron into a political dimension.

öffentlichen Raum hinein verlängert, kann z. B. das Gebetbuch auf dem Gang in die Synagoge mitgeführt werden. Erst im vergangenen Jahr wurde in einer Gegend in Nordwest-London ein „Eruv" errichtet. Und dass das Weisse Haus in Washington oder das Europäische Parlament in Strassburg innerhalb einer solchen unsichtbaren Grenze liegen, dürfte nur Wenigen bekannt sein. Der „Eruv" ist damit insofern das positive Spiegelbild eines Ghettos, als er eine durch Grenzziehung erreichte, produktive Erweiterung des städtischen Raumes symbolisiert, einen Freiraum für neue Lesarten. Wohingegen das Ghetto für Beschränkung und Ausgrenzung derjenigen steht, die sich, von den ausserhalb Befindlichen verordnet, innerhalb seiner Grenzen aufzuhalten haben.

Die Auffassung einer Grenzziehung als Mittel politischer oder territorialer Macht kommt zu den Lesarten von Zone hinzu, wenn Wallinger selbst auf die Bedeutung des englischen „Pale" als einer weiteren Zonenform hinweist.[1] „Pales" wurden seit dem 14. Jahrhundert als heimische Herrschaftsgebiete im feindlichen Ausland durchgesetzt, als Bereiche, in denen die eigene Macht uneingeschränkt galt. Im Englischen existiert bis heute die Redewendung „beyond the pale" (deutsch „Jenseits von Gut und Böse"), die genau genommen davon spricht, dass alles hinter dem Einflussbereich des bri-

tischen Königreiches als inakzeptabel anzusehen sei. Wie sehr die Einsetzung machtbestätigender, territorialer Abgrenzungen noch heute zur politischen Kultur zählen, zeigte sich 2005, als die britische Regierung eine Bannmeile im Umkreis von einem Kilometer um das Parlament verabschiedete und damit faktisch einen „Pale" errichtete. Daraufhin wurde der Protestzaun von Brian Haw als unerlaubte politische Demonstration innerhalb der Grenzen der Bannmeile schliesslich abgebaut – um sofort von Mark Wallinger in der Tate Britain als State Britain wieder aufgebaut zu werden.[2]

Die Fragen nach territorialer Grenzziehung als Versuch politischer Machtsicherung und deren Berechtigung, die in Zone verschlüsselter, in State Britain unverblümter formuliert werden, ziehen sich als Grundmotive durch viele von Wallingers Arbeiten. Sie finden sich bereits 1996 in Oxymoron, als der Künstler das Blau-Rot des Union Jack mit den im Farbkreis komplementär gesetzten Farben Orange und Grün ersetzte, damit die Farben der irischen Fahne erhielt und so die rhetorische Figur eines Oxymorons (eines unüberbrückbaren Gegensatzes) in eine politische Dimension überführte.

Arbeiten wie Threshold to the Kingdom (2000) oder Sleeper (2004) erweitern diese Aspekte um die konkrete Frage nach

Works like *Threshold to the Kingdom* (2000) and *Sleeper* (2004) further expand upon questions of political and intellectual inclusion and exclusion. In *Threshold to the Kingdom*, for example, the fixed camera position films the automatic doors at the international arrivals hall at London's City Airport, observing the entry of passengers into the United Kingdom from the no-man's-land of the Customs Hall. In slow motion, the people seem to float across the threshold, elevating them from the status of outsiders into that of those who belong. They are accompanied by Allegri's *Miserere*, a setting of the 51st Psalm that was originally reserved solely for services within the Vatican walls; only when the child prodigy Mozart had visited the Vatican and transcribed it from memory was it made accessible to the public at large. Thus the soundtrack, too, takes up the question of an enclosed elite as a theme. The title of the work adds a further religious level to the political one, by expanding the earthly kingdom into a heavenly one. Even the security official sitting in the concourse behind a counter with a huge no smoking symbol is turned into a strangely secular St Peter figure.

Four years later *Sleeper*, formulated and consistently developed the themes already considered in *Threshold to the Kingdom*, and can be seen formally – in the economy of the means deployed – and in terms of content as a direct bridge to *Zone*. As the culmination of a two-year stay in Berlin, *Sleeper* consists of a filmed performance in which Wallinger wanders through the illuminated Neue Nationalgalerie in a bear costume. It is the record of one of the ten consecutive nights that he inhabited the empty museum. Nothing much happens: the bear does not perform any charming little tricks to entertain the nocturnal visitors outside, nor does he hide himself or read to while away the time. He moves very unspectacularly through the vast glazed space of this architectural icon of Modernism – sometimes settles down, only immediately to get up again and walk up and down along the lines on the floor, abruptly run off, disappear from the picture via a staircase for minutes at a time, lean against the external pane of glass exhausted, and again wander off. Time is stretched out tenaciously like chewing gum. Occasionally people come to the window to make contact with the strange animal in the temple of art. The bear never seems lonelier and more isolated than at such moments. What comes across as formally

politischer und intellektueller Ein- und Ausgrenzung. In *Threshold to the Kingdom* z. B. filmt die unbewegte Kamera die elektronische Tür in der Halle internationaler Ankünfte im City Airport in London, um den Eintritt der Passagiere aus dem Niemandsland des Zollbereichs in das Britische Königreich zu beobachten. In Zeitlupe scheinen die Gefilmten gleichsam schwebend die Schwelle zu überschreiten, die sie aus dem Status der Aussenstehenden in den der Dazugehörigen erhebt – seltsam konterkariert von ihren gleichgültigen Gesichtsausdrücken, die dem feierlichen Anlass wenig angemessen erscheinen. Begleitet werden sie von Allegris *Miserere*, einer Vertonung des 51. Psalms, die ursprünglich den internen Gottesdiensten des Vatikans vorbehalten war, nach einem Besuch des Wunderkindes Mozart jedoch von diesem aus dem Gedächtnis niedergeschrieben und so der Öffentlichkeit zugänglich gemacht wurde. Auch die Tonebene also thematisiert die Frage nach einer sich ausgrenzenden Elite. Der Titel der Arbeit, der die Szenerie als „Schwelle zum Königreich" einordnet, fügt der politischen Ebene zusätzlich eine religiöse hinzu, indem er das irdische in ein himmlisches Königreich erweitert und damit den in der Flughalle hinter einem Tresen mit riesigem Nichtraucheremblem sitzenden Angestellten zu einer merkwürdig diesseitigen Petrusfigur macht.

Sleeper formuliert vier Jahre später die in *Threshold to the Kingdom* bereits angelegten Themen konsequent weiter und ist formal – in der Sparsamkeit der Mittel – wie inhaltlich als direkte Brücke zu *Zone* zu sehen. Während eines zweijährigen Aufenthalts in Berlin entstanden, besteht *Sleeper* aus der Verfilmung einer Performance, in der Wallinger in einem Bärenkostüm durch die erleuchtete Neue Nationalgalerie streifte. Der Film gibt eine der zehn aufeinander folgenden Nächte wieder, in denen er das leere Museum durchwanderte. Mehr geschieht nicht: Der Bär vollbringt keine reizenden Kunststückchen, um die nächtlichen Besucherinnen und Besucher draussen zu unterhalten, noch versteckt er sich oder liest, um sich die Zeit zu vertreiben. Er bewegt sich denkbar unspektakulär durch die gläsernen Räume dieser architektonischen Ikone des Modernismus – lässt sich manchmal nieder, um gleich wieder aufzustehen und die Linien auf dem Boden abzulaufen, unvermittelt loszurennen, minutenlang über eine Treppe aus dem Bild zu verschwinden, sich erschöpft gegen eine Aussenscheibe zu lehnen und erneut loszustromern. Die Zeit dehnt sich zäh wie Kaugummi. Gelegentlich kommen Menschen an die Scheibe, um Kontakt zu dem seltsamen Tier im Kunsttempel aufzunehmen. Nie wirkt der Bär einsamer und isolierter als in solchen Momenten. Was hier formal zurückgenommen daherkommt, löst eine Vielzahl

withdrawn triggers a multiplicity of associations which can only be hinted at here: the bear as the symbol of the city of Berlin is contained in them, as is its ambiguity as a touching cuddly toy and an aggressive beast of prey. There is the history of a city that once cut off its east part from its west by means of a wall. The history of Berlin as the capital of agents and espionage in the Cold War – and from this time comes the term, 'sleeper' for an agent who was dormant while waiting for a signal to act. Also the exposure of the individual in his glass cage, with restricted opportunities for making any contact with the outside world. Even so, the nocturnal onlookers again and again made attempts to alleviate the captive's isolation in spite of the thick panes of glass. Pots of honey were deposited by the door, and on one extraordinary occasion a second bear appeared outside to greet his incarcerated brother, then disappeared again unrecognised into the night …

Using simple sources as a key to revealing multi-layered levels of meaning defines not only the artistic strategy of *Zone*, *Oxymoron*, *Threshold to the Kingdom* and *Sleeper* in particular, but also characterises many other works by Wallinger. This may seem surprising in view of the frequently described pathos and monumentality of many of his works. And yet the quiet and withdrawn, things subtly altered using minimal resources, have a significant place in the oeuvre of this artist. Time and again he takes what he finds present – in the case of *Zone*, for example, the Münster townscape and the history of the drawing of boundaries in religious and political communities – and unpicks it in a way that adds new, unforeseeable dimensions to what already exists.

This is also true in the case of *Fly*, a video dating from 2000. Displayed on a monitor, like a window, it shows a blue sky dotted with occasional clouds. In the centre of the shot is a fly, small, but too big to ignore. It sits there motionless, caught between two panes of glass and long since dried out. Beckett's Clov in *Endgame* comes to mind: 'I'll go now to my kitchen, ten feet by ten feet by ten feet, and wait for him to whistle me.'[3] There was quite obviously a whistle, but the fly is still waiting – equally absent and present in its defined territory of the windowpane. Occasionally other flies land on the surface and move to and fro searching. The clouds in the sky pass by and constantly change shape, birds cross the screen in the background, distant planes climb up or

von Assoziationen aus, die an dieser Stelle nur angedeutet werden können: Der Bär als Stadtsymbol Berlins ist darin enthalten, sowie seine Zwiespältigkeit als rührendes Kuschel- und aggressives Raubtier. Die Geschichte einer Stadt, die einst ihren Ost- und Westteil via Grenzziehung durch eine Mauer voneinander isolierte. Auch die Geschichte Berlins als Hauptstadt der Agenten und der Spionage im Kalten Krieg – einer Zeit übrigens, aus der die Bezeichnung von sich in untätiger Alarmbereitschaft befindlichen Agenten als „Sleeper" stammt. Und auch das Ausgesetztsein des Individuums in seinem gläsernen Käfig sowie die eingeschränkten Möglichkeiten zu jeder nach aussen gerichteten Kontaktaufnahme. Wiederholt unternahmen übrigens nächtliche Betrachterinnen und Betrachter Versuche, die Isolation des Gefangenen trotz dicker Glasscheiben zu mildern. Mehrere Gläser Honig wurden vor der Tür abgestellt. Und einmal kam gar ein Bär von aussen heran, um seinen abgeschotteten Bruder im Innern zu grüssen und dann unerkannt wieder im Dunkel zu verschwinden…

Mit einfachen Mitteln vielschichtige Bedeutungsebenen zu eröffnen, umschreibt nicht nur die künstlerische Strategie speziell von *Zone*, *Oxymoron*, *Threshold to the Kingdom* oder *Sleeper*, sondern zeichnet auch eine Vielzahl weiterer Werke von Wallinger aus. Angesichts des häufig beschriebenen Pathos und der Monumentalität vieler seiner Arbeiten mag das überraschen. Und doch hat das Leise und Zurückgenommene, das mit wenigen Mitteln überraschend Veränderte seinen festen Platz im Schaffen dieses Künstlers. Immer wieder nimmt er, was er vorfindet – im Fall von *Zone* z. B. den Münsteraner Stadtraum und die Geschichte der Grenzziehungen in religiösen und politischen Gemeinschaften – und kombiniert es auf eine Weise, die dem bereits Vorhandenen neue, unvorhersehbare Ebenen hinzufügt.

So auch im Fall von *Fly*, einem Video aus dem Jahr 2000. Wiedergegeben auf einem Monitor zeigt es wie durch ein Fenster einen blauen, mit gelegentlichen Wolken betupften Himmel. Im Zentrum der Aufnahme, klein, aber zu gross, um sie ignorieren zu können: eine Fliege. Bewegungslos hockt sie dort, offensichtlich zwischen zwei Fensterscheiben festgehalten und längst vertrocknet. Becketts Clov aus *Endspiel* kommt einem in den Sinn: „Ich gehe in meine Küche, drei Meter mal drei Meter mal drei Meter, warten, bis er mir pfeift."[3] Gepfiffen wurde ganz augenscheinlich, aber warten tut die Fliege immer noch – abwesend und anwesend gleichermassen in ihrem definierten Bereich des Fensterglases. Andere Fliegen landen auf der Oberfläche und bewegen sich suchend hin- und her, als sei das Wesen in ihrem Zentrum

prepare to land, the soundtrack – an indecipherable medley of simultaneous radio broadcasts – does not let up for a second. The question of the presence or absence of the dead fly quite obviously plays no kind of role. It can be there, or not. The course of the world is not influenced by it, life goes on. Life in the face of death – seldom has such a profound theme been conveyed so emphatically and pointedly in such a laconic way.

In *Upside Down and Back to Front, the Spirit Meets the Optic in Illusion* (1997), Wallinger again displays his courage in tackling big themes, the traces they leave in the seemingly commonplace, the process of turning on its head, quite literally, the known and our traditional conceptions of it, using minimal means. A bottle of clear liquor with a measure stands upright on a mirror, instead of hanging upside down above the counter, as in a bar. The labels with the description 'spirit' (ambiguously suggesting both 'alcohol' and 'soul') are in mirrored writing and upside down. The contents are described as 100% pure and absolute, with its source – the birthplace of the artist. There is no lavish intervention that alters things beyond that, 'only' the turning upside down of the given fact, the unaccustomed view of the known,

which is able to open up new perspectives. What exists is decoded in the reflection in the surface the bottle stands on. What is real lies in the mirror image and can only be seen if we know about its existence. What is real perhaps lies even beyond what is visually apprehensible – as 'spirit' in fact, as something spiritual dissolving in the optical illusion.

Accordingly it really seems sometimes to be enough to know of things without seeing them. On occasion it seems to be possible to free oneself from what is optically alleged in order to be able to play freely with thoughts. That is how memory works. Or transience. As do the social mechanisms that determine people's lives together, and in fact the collective memory that is deeply rooted within us though we are as yet unable to decode exactly where it comes from in detail. And finally the boundaries that travel invisibly through our heads and the world. The known invisible can obviously take shape in art without having to become materially visible. Which would bring us back to the beginning –'In the beginning was … '[4]

nicht vorhanden. Die Wolken am Himmel ziehen vorbei und verändern beständig ihre Formen, Vögel kreuzen die Aufnahme im Hintergrund, ferne Flugzeuge steigen auf oder setzen zur Landung an, die Tonspur – eine unentwirrbare Geräuschmelange parallel laufender Radiosendungen – hält keine Sekunde inne. Die Frage der An- oder Abwesenheit der toten Fliege spielt ganz offensichtlich keinerlei Rolle. Sie kann da sein oder auch nicht. Der Weltenlauf lässt sich damit nicht beeinflussen, das Leben geht weiter. Leben im Angesicht des Todes – selten wurde ein so grosses Thema auf so lakonische Weise so nachdrücklich und pointiert umgesetzt.

Seinen Mut zu grossen Themen, ihr Aufspüren im scheinbar Alltäglichen, das Vorgehen, Bekanntes und unsere herkömmlichen Vorstellungen von ihm mit minimalen Mitteln wortwörtlich auf den Kopf zu stellen, führt Wallinger auch in *Upside Down and Back to Front, the Spirit Meets the Optic in Illusion* (1997) vor. Eine Schnapsflasche mit Portionierer steht hier aufrecht auf einer Spiegelfläche, anstatt wie in einer Bar kopfüber über dem Tresen zu hängen. Die Etiketten mit der Bezeichnung „Spirit" (doppeldeutig für „Schnaps" und „Geist") sind spiegelverkehrt und auf dem Kopf stehend beschriftet. Der Inhalt wird als „100% pur" und der Abfüllort als der Geburstort des Künstlers angegeben. Kein aufwendi-

ger Eingriff, der die Dinge darüber hinaus veränderte. „Nur" die Umkehrung des Gegebenen, der ungewohnte Blick auf das Bekannte, der neue Perspektiven zu eröffnen in der Lage ist. Was ist, wird in der Spiegelung in der Standfläche entschlüsselt. Das Eigentliche liegt im gespiegelten Abbild und kann nur gesehen werden, wenn man um sein Vorhandensein weiss. Das Eigentliche liegt vielleicht sogar jenseits des visuell Greifbaren – eben als „Spirit", als sich in der optischen Illusion auflösendes Geistiges.

Demnach scheint es also wirklich manchmal auszureichen, von den Dingen zu wissen, ohne sie zu sehen. Es scheint gelegentlich möglich zu sein, sich vom optisch Vorgegebenen zu lösen, um frei mit den Gedanken spielen zu können. Erinnerung funktioniert so. Oder Vergänglichkeit. Genauso wie die gesellschaftlichen Mechanismen, die das Zusammenleben des Menschen bestimmen. Überhaupt die ganze Sache mit dem kollektiven Gedächtnis, das tief in uns verwurzelt ist, ohne dass wir noch genau entschlüsseln könnten, woher es sich im Einzelnen speist. Und schliesslich die Grenzen, die sich unsichtbar durch unsere Köpfe und die Welt ziehen. Das gewusste Unsichtbare – in der Kunst kann es offenbar Gestalt annehmen, ohne materiell sichtbar werden zu müssen. Womit wir wieder am Anfang wären – *in the beginning was...*[4]

1 See Brigitte Franzen, Kasper König, Carina Plath (ed.), *skulptur projekte münster 07*, exh. cat., Verlag der Buchhandlung Walther König, Cologne 2007, p. 257–263.

2 On *State Britain* see the essay by Michael Diers in this catalogue, p. 89–96.

3 Samuel Beckett, *Endspiel*, Bibliothek Suhrkamp, Frankfurt/Main 1974, p. 10.

4 The first line of St John's Gospel which Wallinger uses in the video projections *On an Operating Table* (1998) and *Angel* (1997).

1 Siehe Brigitte Franzen, Kasper König, Carina Plath (Hg.), *skulptur projekte münster 07*, Ausst. Kat., Verlag der Buchhandlung Walther König, Köln 2007, S. 257–263.

2 Zu *State Britain* vgl. den Text von Michael Diers in diesem Katalog, S. 89–96.

3 Samuel Beckett, *Endspiel*, Bibliothek Suhrkamp, Frankfurt/Main 1974, S. 11.

4 Die erste Zeile des Johannes-Evangeliums, die Wallinger in den Videoprojektionen *On an Operating Table* (1998) und *Angel* (1997) einsetzt.

Zone, 2007
Skulptur Projekte Münster 07, 2007

Zone, 2007
Skulptur Projekte Münster 07, 2007

Spacetime, 2003
Kunstverein Braunschweig, 2007

Spacetime, 2003
Kunstverein Braunschweig, 2007

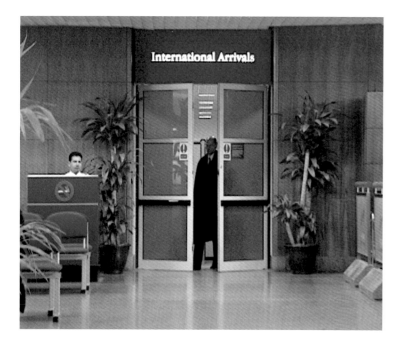
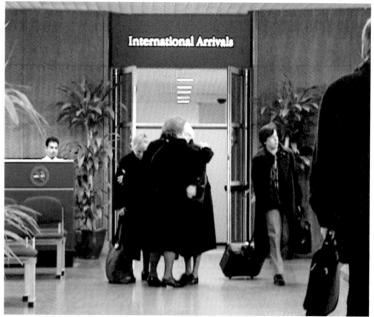
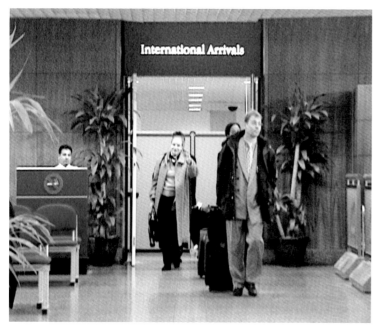
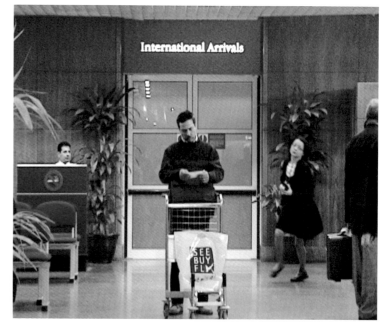

Threshold to the Kingdom, 2000

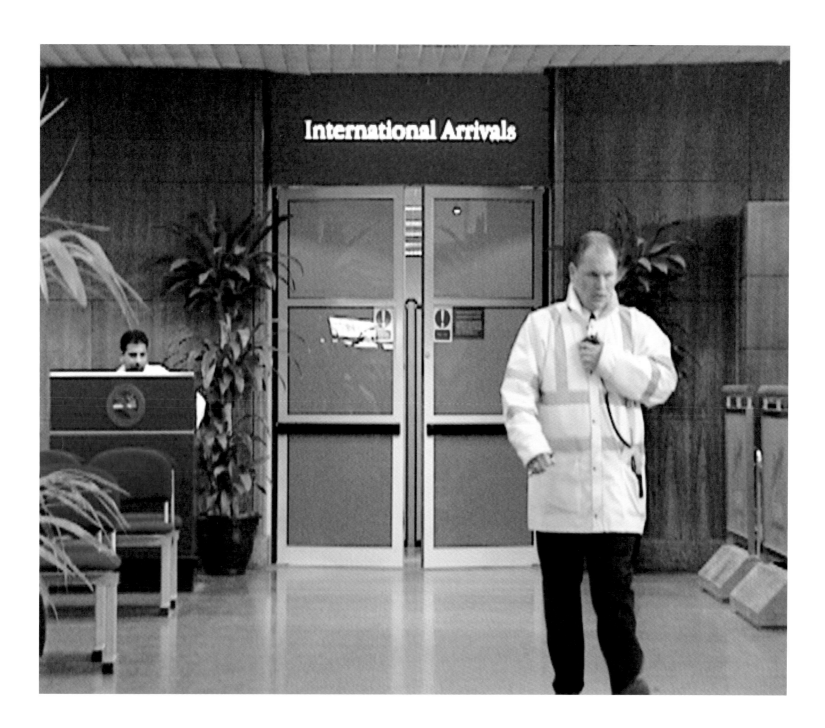

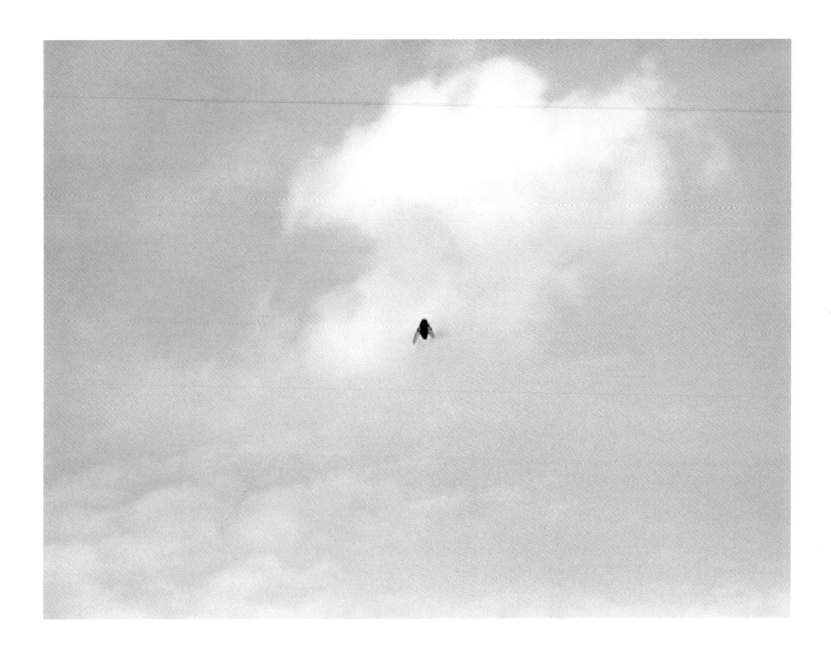

Fly, 2000

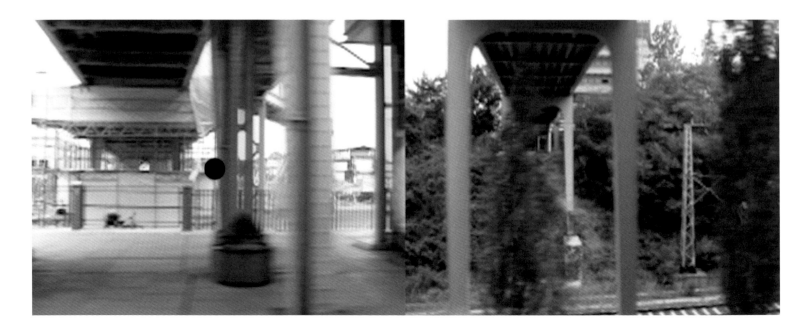

Façade, 2001
British Pavilion, Biennale di Venezia, 2001

Okerstein (1001–1072), 2007
Kunstverein Braunschweig, 2007

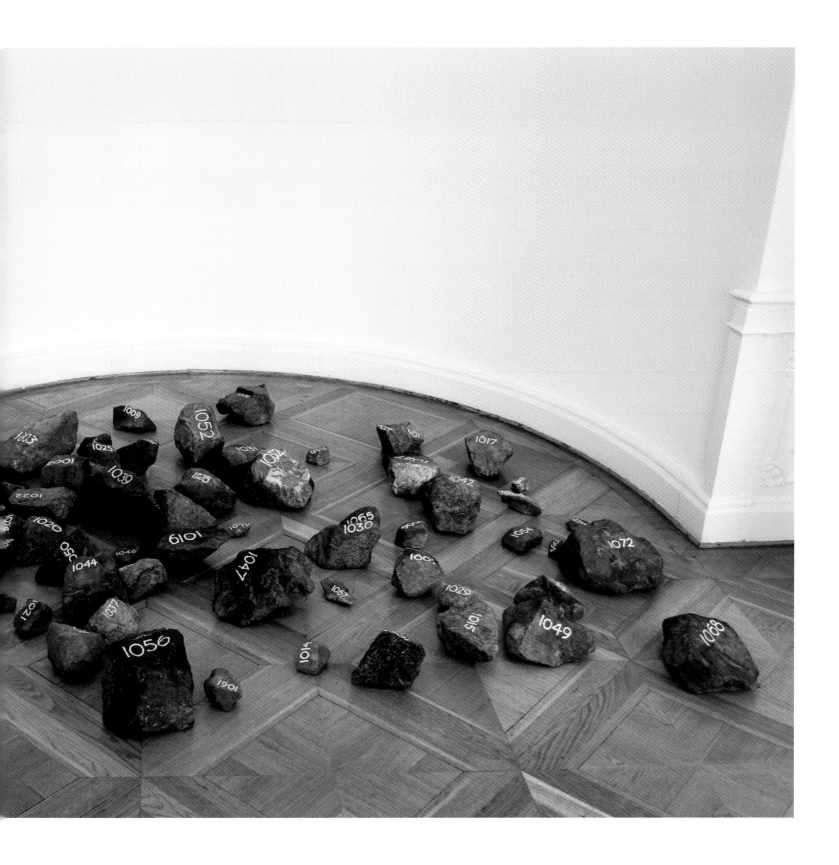

Folk Stones, 2008
Folkstone Triennial, 2008

Sleeper, 2004 →→
Performance, Neue Nationalgalerie, Berlin 2004

Sleeper

As a bear I don't claim any special knowledge. Only that which I have experienced and how it led me here. Growing up in the shadow of the wall was not about proximity. Imagine casting a stone into water and finding that the ripples expanding in concentric rings, never diminish. Berlin was part of my subconscious before I ever set foot here.

A sleeper may be planted years in advance – of all the double agents buried during the Cold War, not all of them were sprung. The secret of a successful hibernation is a matter of provisions and a plausible disguise. At night I am examined for authenticity, during the day I pass unnoticed. The bears in the zoo are the last of their kind, as they are no longer allowed to breed. When the last one dies will they raze the whole sorry zoo to the ground like they did with Spandau Prison after the death of the idiot Hess? Alone in the centre of this vast space I gaze toward Potsdamer Platz like the guilty conscience of the building. A bad sleeper. Sometimes I feel adrift, as if I have woken up in the middle of this story.

A transparent building is intimidating. It can only exist in a society that doesn't fear its shattering. In the Neue National galerie we are open, we have nothing to hide – art is for all to experience. When the wall came down, there it was, naked. And looking at the Fernsehturm, you can't help thinking, how appropriate; this is what you get when a culture of surveillance and paranoia commissions a representative national icon. One gigantic lookout tower.

The bear costume is an obvious disguise, I know. (Too much effort would appear ingratiating, I thought.) It is both bear, and clearly not bear. Children, for all their fear of the unknown, can play with this fear. They switch from play to reality effortlessly, exist in two realms simultaneously. (Tonight I have been trailed by two small girls who tease me through the glass. I breathe a little cloud on to the pane. They fan out a pack of playing cards and bid me pick one. I point and they turn over a picture of Harry Houdini.) The portal to the other side, the underworld or wonderland is the mirror as represented in Orphee or Alice. You have to pass through your own image to reach an imagined world. Risking enchantment.

As a child I was traumatised by a vision of the other side. The Singing Ringing Tree, made in a fully imagined world in Babelsberg, tells the story of a selfish princess who sends a long-suffering prince on a quest for a magical tree. He reaches the border of another kingdom which is protected by a ravine and a sheer rock face and guarded by a dwarf. The prince explains his quest for the magical tree, and the dwarf offers it to him on one condition. If the princess does not love him by sunset, he must return to live in the magic kingdom. The prince is so confident that he jokes. He says that if he fails he will be a turned into a bear …

What does it dream? This empty building full of limpid darkness, like the promise of a well, a reservoir of silent thought? How often does one look at the moon and think that a man has walked there? On the other side of the wall the Palast der Republik is choking with asbestos.

In Babelsberg, tongue-tied over their short history and in grief at their estranged brothers and sisters, they turned to the long past for some unexpurgated truth. The two realms of Germany were like twins separated as children and raised in completely contrary ways. To cross irrevocably from one realm to another or to be divided, without appeal. This is what I have learnt and it seems very cruel. Germany invented the unconscious, which is not normally credited with respecting borders.

What if I died in here?

Being alone in a museum was a delicious recurring dream of mine, to transgress among objects of such inestimable value. But an empty museum, what would that be, exactly? But then, I have met many people who preferred the Jewish Museum empty of exhibits. Why? Something to do with Freud and the return of the repressed, I suppose. Because what do we dream until we know what we have done? The characters in fairy tales are hapless innocents – they do not yet inhabit a moral universe.

Bauhaus is our house, Gretel.

What are we allowed to dream? The past rises up with all its vivid detail to mock our progress at every turn. The long past of our own fear. Inside the bear's head I am aware of my own breathing. Looking out of the jaws at my narrow view, my progress from stimulus to distraction gains some kind of animal momentum – to watch and be watched as a foreign, alien, strange, endearing, imprisoned, animal.

Don't feed the bears.

Marx wrote that history weighed like a nightmare upon the brains of the living. Without the notion of a God to console, history may seem random and uncontrolled. Joyce talks about the nightmare of history as the unbearable contingency of being: the accident of birth that would take more than a lifetime to understand. He chose exile from god and nationality. The rest, the past which lies unrecorded, are what myth and folktales retain, the long past where no details change; where things remain real and answer to their names.

The Neue Nationalgalerie declares that the modern world, so cruelly interrupted, will resume its business from such and such a date.

Tonight, the moon shone brighter than the lights of the Sony Centre.

Did I tell you about the other bear? On the seventh night a bear appeared, identical in every detail, looking through the glass. The security cameras picked it up.

My German brother.

Mein Doppelgänger.

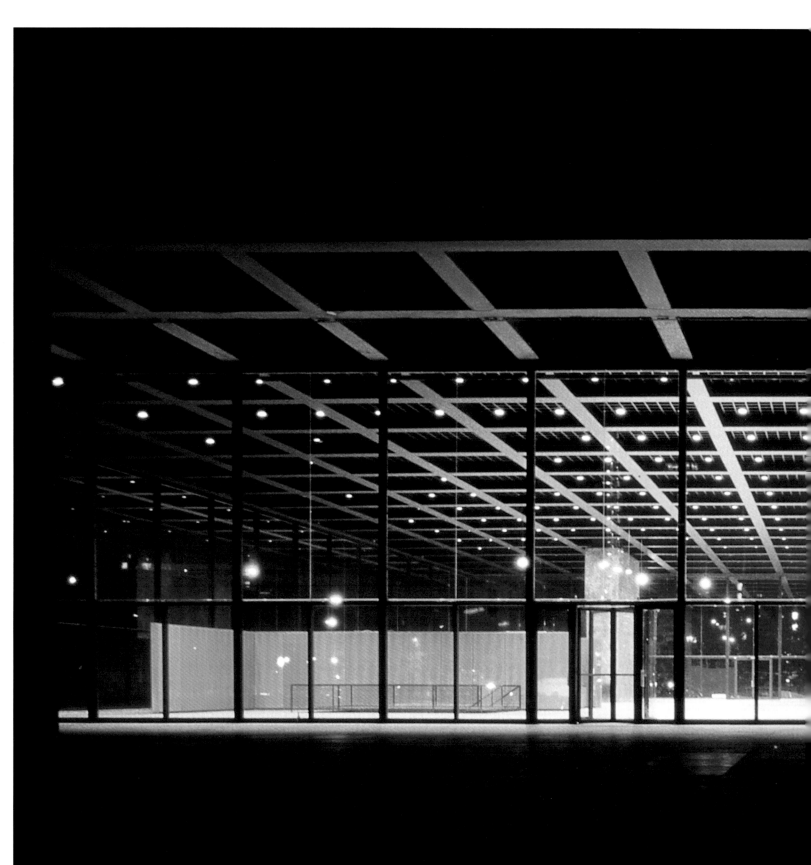

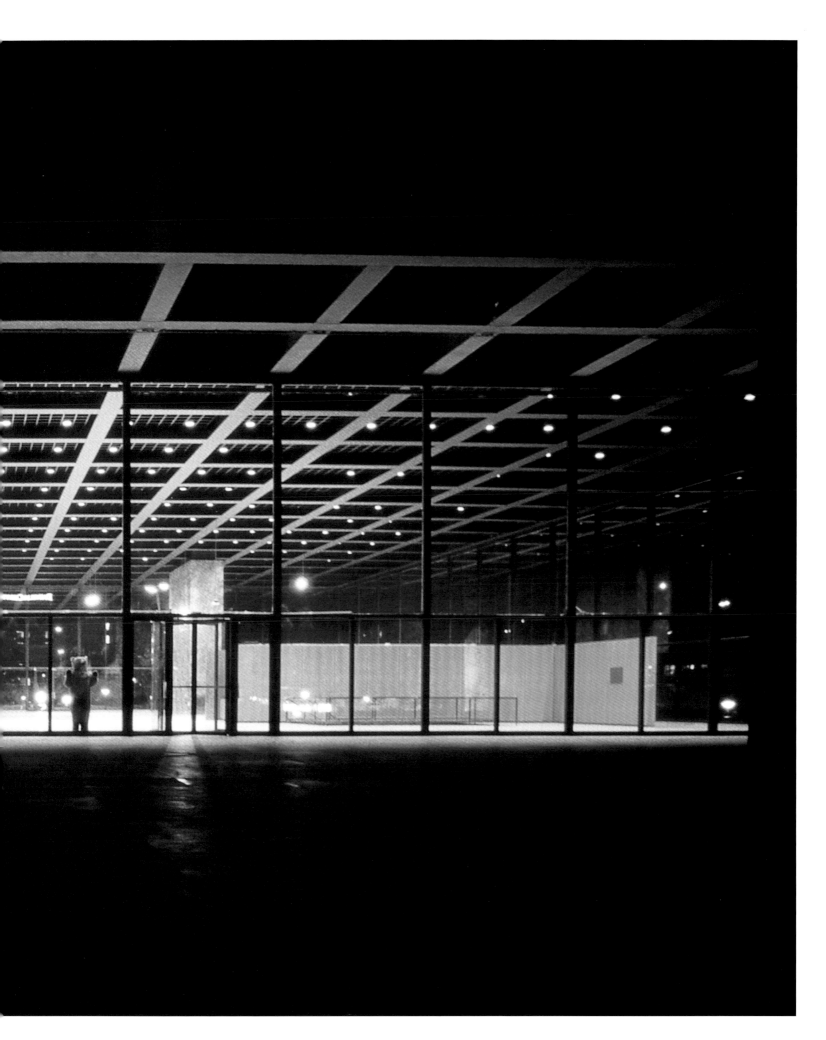

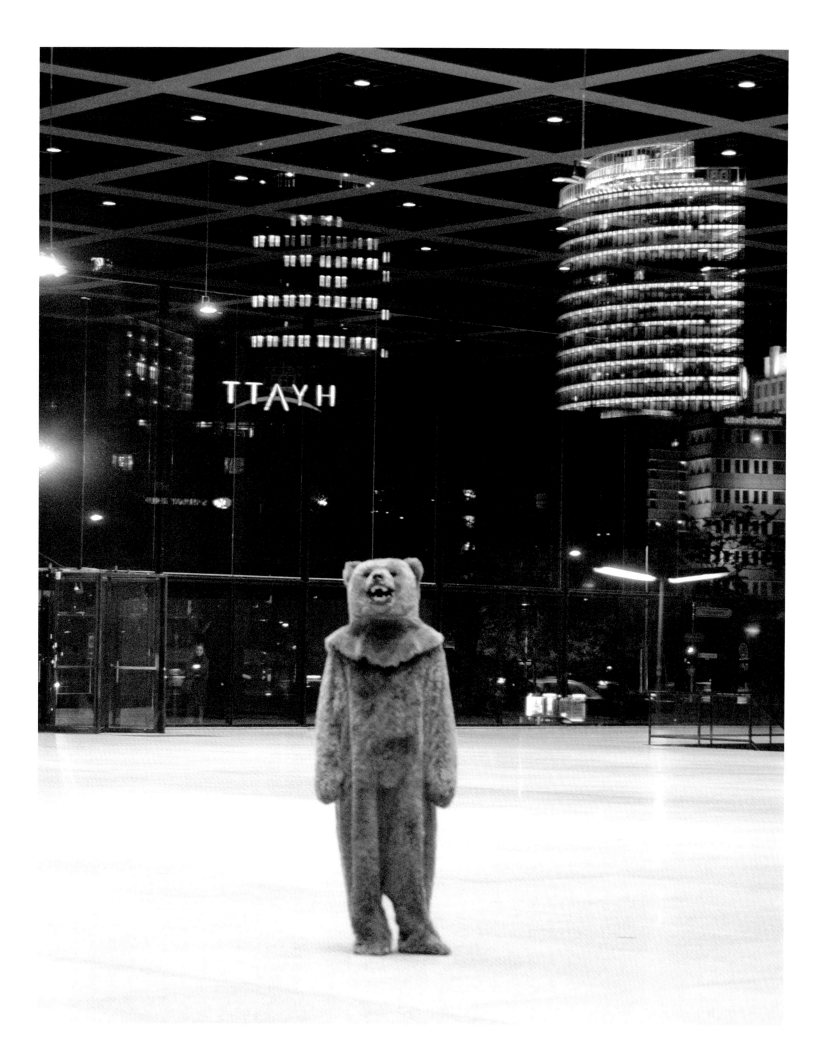

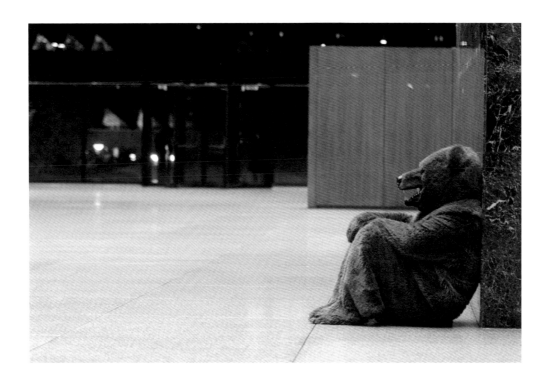

Sleeper, 2004
Performance, Neue Nationalgalerie, Berlin 2004

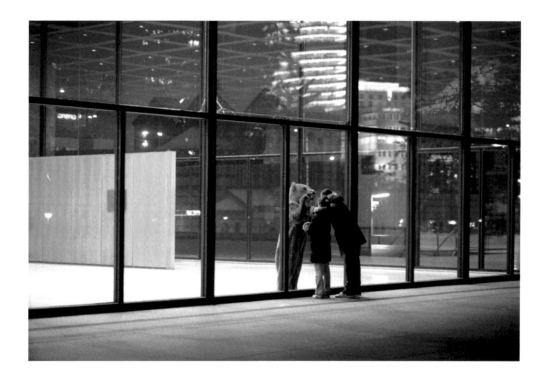

Sleeper, 2004
Performance, Neue Nationalgalerie, Berlin 2004

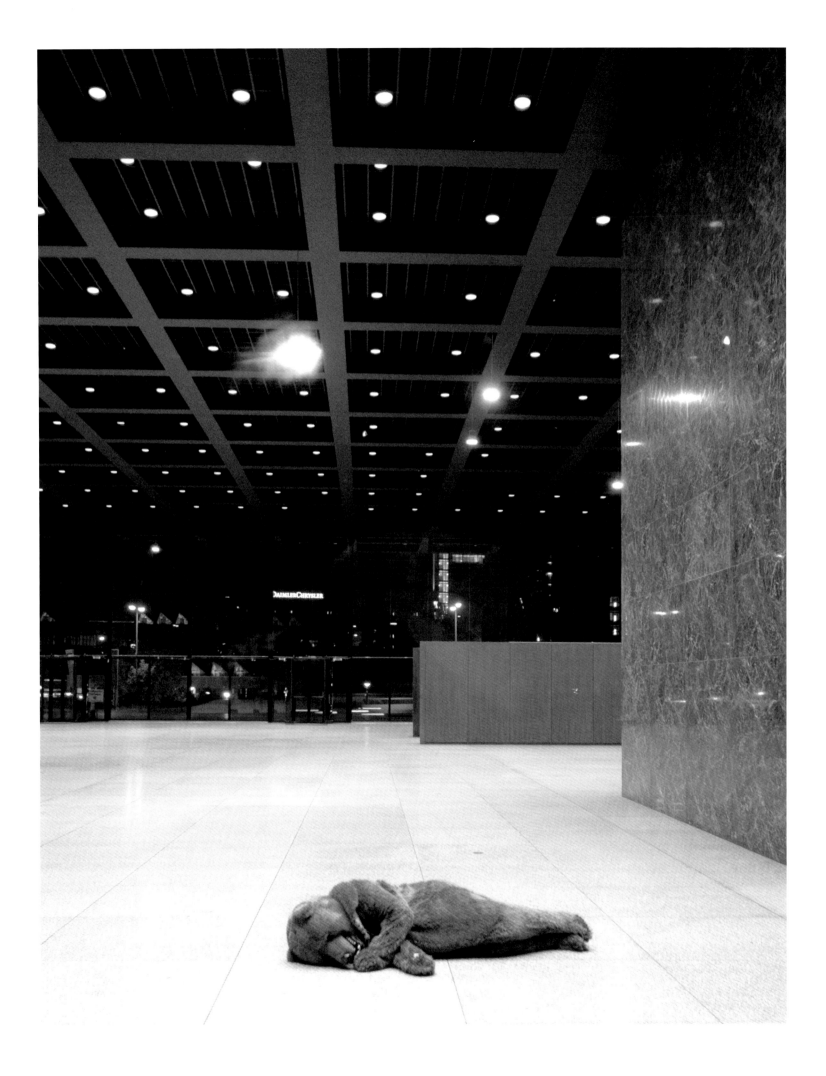

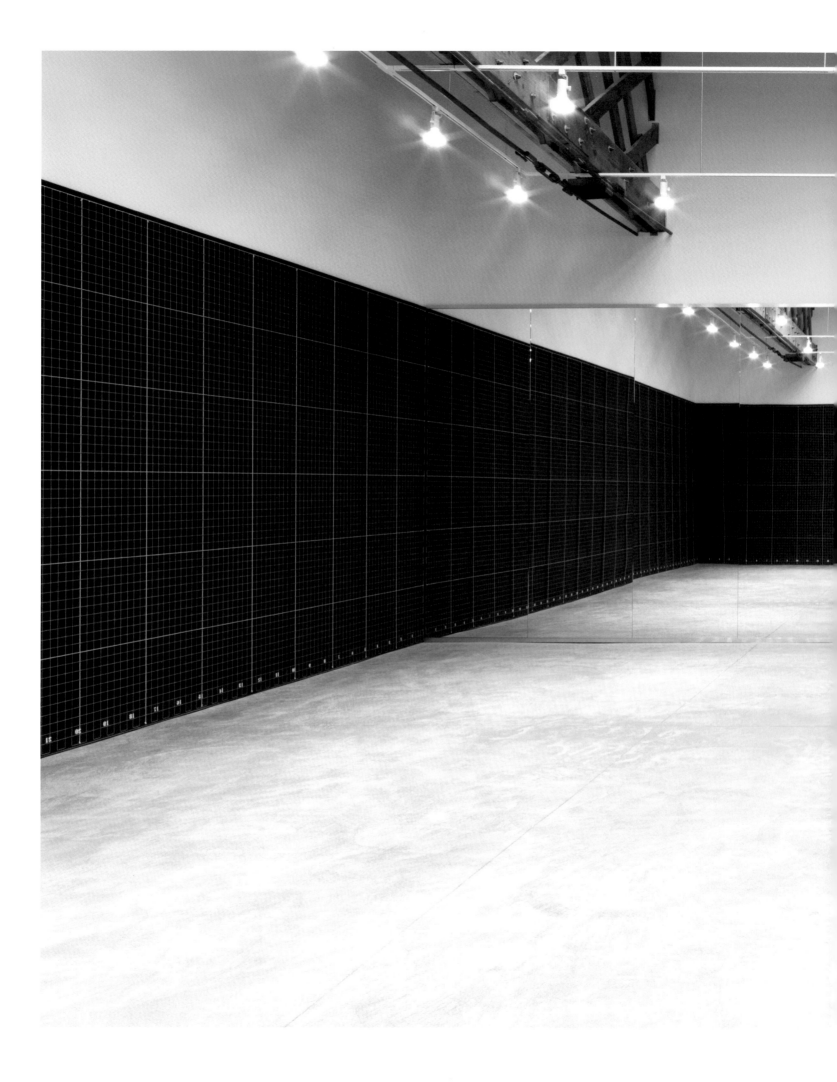

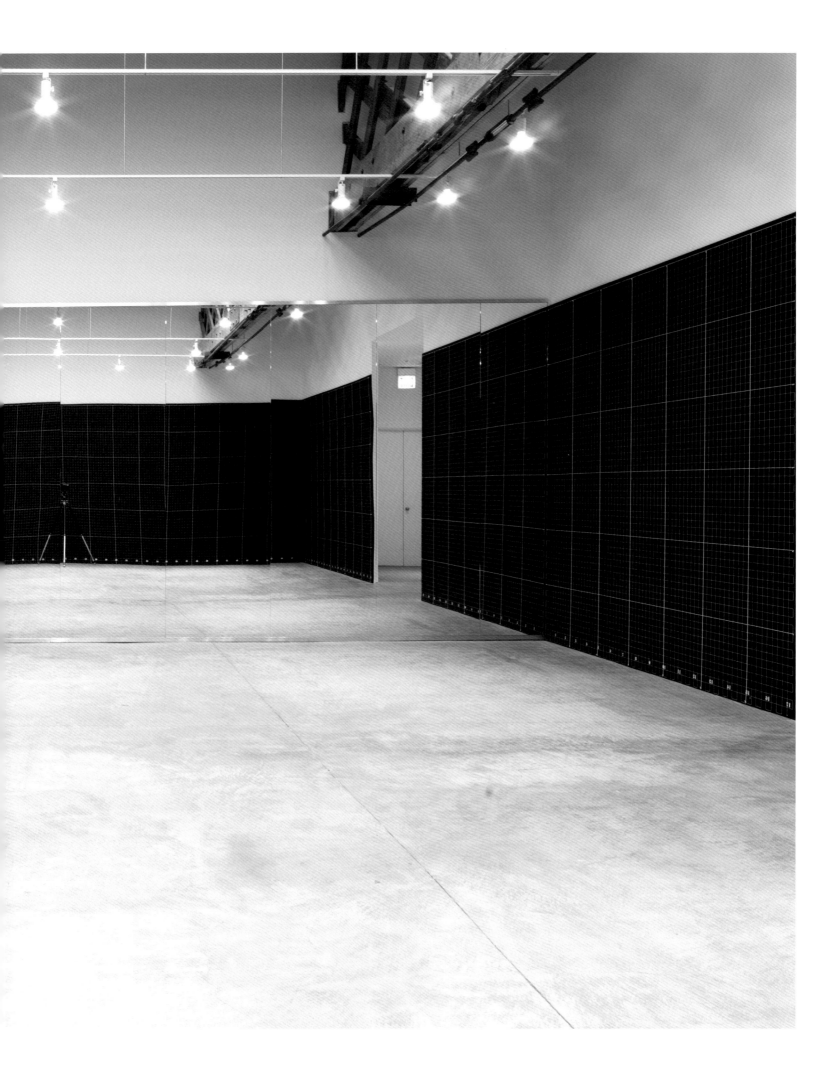

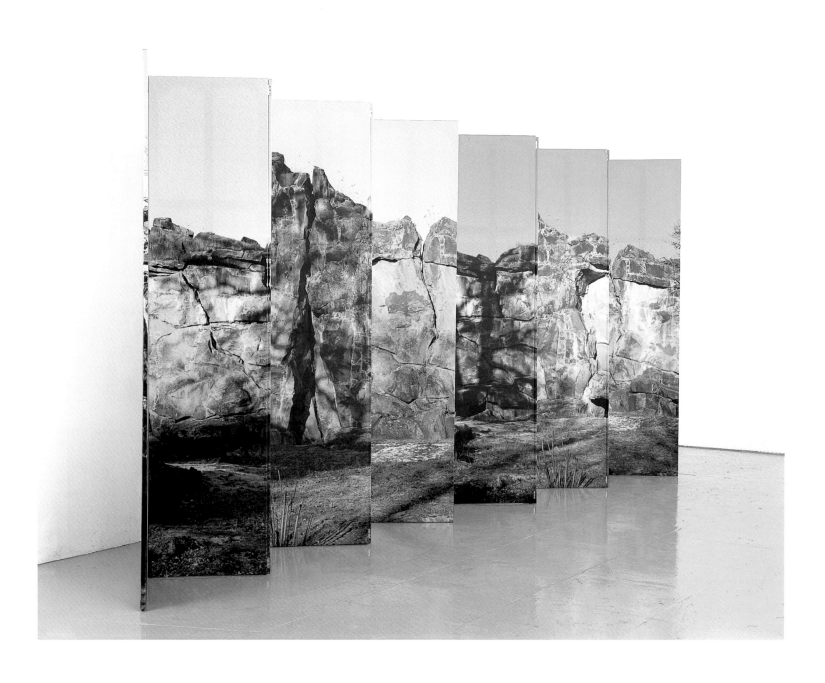

← *The Human Figure in Space*, 2007
Donald Young Gallery, Chicago 2007

Painting the Divide (Berlin Zoo), 2005

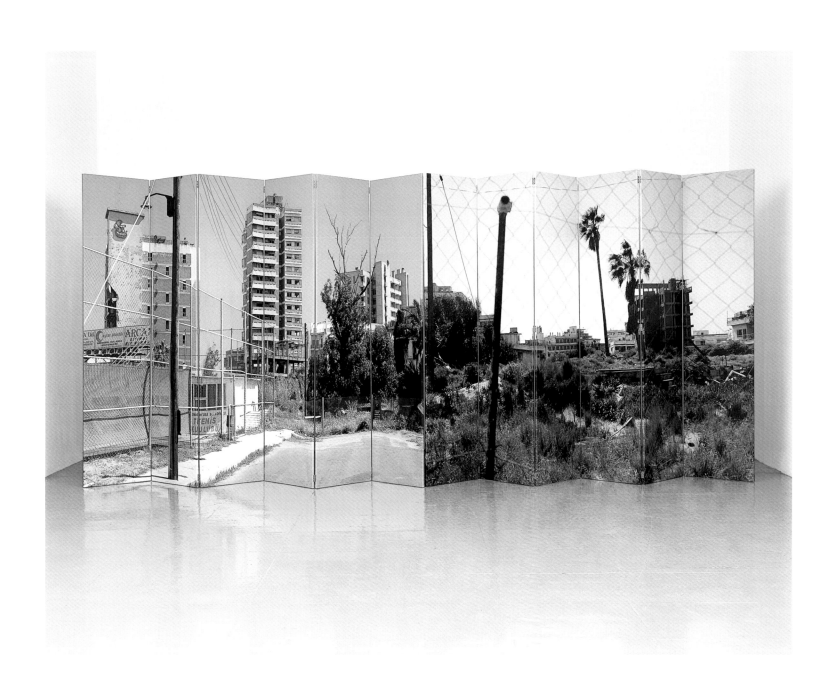

Painting the Divide (Famagusta), 2005

Painting the Divide (Jerusalem), 2005

LIST OF WORKS
BIOGRAPHY
BIBLIOGRAPHY
AUTHORS' BIOGRAPHIES

WERKLISTE
BIOGRAFIE
BIBLIOGRAFIE
AUTORENBIOGRAFIEN

LIST OF WORKS

WERKLISTE

A = Exhibition / Ausstellung Aargauer Kunsthaus Aarau
B = Exhibition / Ausstellung Kunstverein Braunschweig

Tattoo, 1987
Paint on PVC ground sheet, three parts, each 274 × 213 cm
Farbe auf PVC Deckplane, 3-teilig, je 274 × 213 cm
Dolly J. Fiterman Collection, Minneapolis

A Heaven, 1988
Brass birdcage, fish lure, gravel, aluminium, 175 × 68 × 37 cm
Messing-Vogelkäfig, Fischköder, Kies, Aluminium, 175 × 68 × 37 cm
Arts Council Collection, Hayward Gallery, London

A Passport Control, 1988
6 colour photographs, each 132 × 101.5 cm
6 Farbfotografien, je 132 × 101.5 cm
Ferens Art Gallery, Hull Museums, (UK)

Half Brother (Diesis - Keen), 1994–1995
Oil on canvas, 230 × 300 cm
Öl auf Leinwand, 230 × 300 cm
Private collection Mark Deweer, Otegem (BE)

A/B Autopsy, 1996
Wood, books, 115 × 122 × 61 cm
Holz, Bücher, 115 × 122 × 61 cm
Courtesy Anthony Reynolds Gallery, London

A The Importance of Being Earnest in Esperanto, 1996
Installation for projected video (sound), 100 chairs, dimensions variable
Installation für Videoprojektion (Ton), 100 Stühle, Masse variabel
Emanuel Hoffmann-Stiftung, Basel, Depositum in der Öffentlichen Kunstsammlung Basel

A/B Oxymoron, 1996
Flag, 229 × 458 cm
Flagge, 229 × 458 cm
Kirkland Collection, London

A Man United, 1996
Knitted acrylic scarf, 22.5 × 1525 cm
Gestrickter Acrylschal, 22.5 × 1525 cm
Courtesy Anthony Reynolds Gallery, London

A/B Angel, 1997
Projected video installation (sound), 7:30 min.
Installation mit Videoprojektion (Ton), 7:30 Min.
Ed. 10, 1 AP
Courtesy Anthony Reynolds Gallery, London

B Hymn, 1997
Video (sound), 4:52 min.
Video (Ton), 4:52 Min.
Ed. 2, 1 AP
Courtesy Anthony Reynolds Gallery, London

Seeing is Believing, 1997
Screen printed light boxes, three parts, each 127 × 127 × 20 cm
Siebdruck auf Lichtboxen, 3-teilig, je 127 × 127 × 20 cm
Ed. 2, 1 AP
Courtesy Anthony Reynolds Gallery, London

A/B Upside Down and Back to Front, the Spirit Meets the Optic in Illusion, 1997
Glass, water, plastic, paper, mirror on plinth, 148 × 80 × 80 cm
Glas, Wasser, Plastik, Papier, Spiegel auf Sockel, 148 × 80 × 80 cm
Courtesy Anthony Reynolds Gallery, London

B On an Operating Table, 1998
Projected video (sound), 13 min.
Videoprojektion (Ton), 13 Min.
Ed. 3, 1 AP
Courtesy Anthony Reynolds Gallery, London

A Ecce Homo, 1999
Marbled resin, gold leaf, barbed wire, life size
Kunstharzgebundener Marmor, Blattgold, Stacheldraht, Lebensgrösse
Ed. 3, 1 AP
Courtesy Anthony Reynolds Gallery, London

Prometheus, 1999
Projected video installation, continuous video loop (sound)
Installation mit Videoprojektion, Loop (Ton)
Ed. 10, 1 AP
Courtesy Anthony Reynolds Gallery, London

Cave, 2000
4-channel video installation (sound), each 600 × 300 cm, 14 min.
4-Kanal-Videoinstallation (Ton), je 600 × 300 cm, 14 Min.
Ed. 2, 1 AP
Courtesy Anthony Reynolds Gallery, London

Credo, 2000
Digital print, 225 x 150 cm
Digital Druck, 225 x 150 cm
Ed. 5, 1AP
Courtesy Anthony Reynolds Gallery, London

A/B Fly, 2000
Video on monitor (sound), 11:30 min.
Video auf Bildschirm (Ton), 11:30 Min.
Ed. 10, 1 AP
Courtesy Anthony Reynolds Gallery, London

The Word in the Desert I, 2000
Colour photograph, 190 × 130 cm
Farbfotografie, 190 × 130 cm
Ed. 5, 1 AP
Courtesy Anthony Reynolds Gallery, London

B The Word in the Desert III, 2000
Colour photograph, 190 × 154 cm
Farbfotografie, 190 × 154 cm
Ed. 5, 1 AP
Courtesy Anthony Reynolds Gallery, London

B *The Word in the Desert V*, 2000
 Colour photograph, 190 × 154 cm
 Farbfotografie, 190 × 154 cm
 Ed. 5, 1 AP
 Courtesy Anthony Reynolds Gallery, London

A/B *Threshold to the Kingdom*, 2000
 Projected video installation (sound), 11:20 min.
 Installation mit Videoprojektion (Ton), 11:20 Min.
 Ed. 10, 1 AP
 Courtesy Anthony Reynolds Gallery, London

 Façade, 2001
 Scanachrome print on vinyl, life size
 Scanachrome auf Vinyl, Lebensgrösse
 Courtesy Anthony Reynolds Gallery, London

A/B *Ghost*, 2001
 Scanachrome on translucent PVC, light box, 295 × 249 × 18 cm
 Scanachrome auf durchsichtigem PVC, Lichtbox, 295 × 249 × 18 cm
 Ed. 2, 1 AP
 Kirkland Collection, London

A *Time and Relative Dimensions in Space*, 2001
 Stainless steel, MDF, electric light, 281.5 × 135 × 135 cm
 Stahl, MDF, elektrisches Licht, 281.5 × 135 × 135 cm
 Courtesy Anthony Reynolds Gallery, London

A/B *Forever and Ever*, 2002
 Aluminium, vinyl, 200 × 500 × 700 cm
 Aluminium, Vinyl, 200 × 500 × 700 cm
 Emanuel Hoffmann-Stiftung, Basel, Depositum in der
 Öffentlichen Kunstsammlung Basel

 Via Dolorosa, 2002
 DVD projection (silent), black square painted on wall, 18:08 min.
 DVD-Projektion (ohne Ton), schwarzes Quadrat auf Wand gemalt,
 18:08 Min.
 Ed. 3, 1 AP
 Courtesy carlier | gebauer, Berlin; Anthony Reynolds Gallery,
 London

B *Spacetime*, 2003
 2 colour photographs on Alu-Dibond, each 180 × 300 × 4 cm;
 metal road sign on post, 280 × 100 × 85 cm, installation
 2 Farbfotografien auf Alu-Dibond, je 180 × 300 × 4 cm;
 Strassenschild, 280 × 100 × 85 cm, Installation
 Ed. 2, 1 AP
 Courtesy carlier | gebauer, Berlin

 Third Generation (Ascher Family), 2003
 Video, 37:58 min.
 Video, 37:58 Min.
 Ed. 3, 1 AP
 Courtesy carlier | gebauer, Berlin; Anthony Reynolds Gallery, London

A/B *Sleeper*, 2004
 Video projection (silent), 2:31 hrs
 Video-Projektion (ohne Ton), 2:31 Std.
 Ed. 3, 1 AP
 Courtesy carlier | gebauer, Berlin; Anthony Reynolds Gallery,
 London; Donald Young Gallery, Chicago

A *The Underworld*, 2004
 Video installation for 21 monitors (sound)
 Videoinstallation mit 21 Bildschirmen (Ton)
 Ed. 2, 1 AP
 Daskalopoulos Collection, Athens

B *What Time Is the Station Leaving the Train?*, 2004
 2-channel video installation (silent), 2 black spots painted on
 wall, dimensions variable, 60:16 min.
 2-Kanal-Videoinstallation (ohne Ton), 2 schwarze Punkte auf
 Wand, Masse variabel, 60:16 Min.
 Ed. 3, 1 AP
 Courtesy Galerie Krinzinger, Wien; Anthony Reynolds Gallery,
 London

 A ist für alles, 2005
 Mies van der Rohe leather divan (sound), 60 min.
 Mies van der Rohe Lederdiwan (Ton), 60 Min.
 Ed. 3
 Courtesy Galerie Krinzinger, Wien; Anthony Reynolds Gallery,
 London

 Easter, 2005
 16 flags, each 600 × 300 cm; 16 flagpoles, each 350 cm long
 16 Fahnen, je 600 × 300 cm; 16 Fahnenmasten, je 350 cm lang
 Courtesy Anthony Reynolds Gallery, London

 Painting the Divide (Berlin Zoo), 2005
 2 six-part hinged folding screens, digital colour print on canvas,
 wooden stretchers, each 240 × 60 × 14 cm (folded)
 2 sechsgliedrige Wandschirme, digitaler Farbdruck auf Leinwand,
 Holzkeilrahmen, je 240 × 60 × 14 cm (gefaltet)
 Ed. 3, 1 AP
 Courtesy Galerie Krinzinger, Wien; Anthony Reynolds Gallery,
 London

 Painting the Divide (Famagusta), 2005
 2 six-part hinged folding screens, digital colour print on canvas,
 wooden stretchers, each 240 × 60 × 14 cm (folded)
 2 sechsgliedrige Wandschirme, digitaler Farbdruck auf Leinwand,
 Holzkeilrahmen, je 240 × 60 × 14 cm (gefaltet)
 Ed. 3, 1 AP
 Courtesy Galerie Krinzinger, Wien; Anthony Reynolds Gallery,
 London

 Painting the Divide (Jerusalem), 2005
 2 six-part hinged folding screens, digital colour print on canvas,
 wooden stretchers, each 240 × 60 × 14 cm (folded)
 2 sechsgliedrige Wandschirme, digitaler Farbdruck auf Leinwand,
 Holzkeilrahmen, je 240 × 60 × 14 cm (gefaltet)
 Ed. 3, 1 AP
 Courtesy Galerie Krinzinger, Wien; Anthony Reynolds Gallery,
 London

The End, 2006
35 mm film projection (sound), 11:40 min.
35-mm-Filmprojektion (Ton), 11:40 Min.
Ed. 5, 1 AP
Courtesy carlier | gebauer, Berlin; Anthony Reynolds Gallery, London

A *Landscape with The Fall of Icarus*, 2007
5-channel video (silent), dimensions variable
5-Kanal-Video (ohne Ton), Masse variabel
Ed. 5, 1 AP
Courtesy Donald Young Gallery, Chicago

B *Okerstein (1001-1072)*, 2007
72 stones, lacquer pen, dimensions variable
72 Steine, Lackstift, Masse variabel
Edition Kunstverein Braunschweig

Self portrait (Freehand 3), 2007
Acrylic on canvas, 92 × 92 cm
Acryl auf Leinwand, 92 × 92 cm
Emanuel Hoffmann-Stiftung, Basel, Depositum in der
Öffentlichen Kunstsammlung Basel

Self portrait (Copperplate Gothic Bold, Shortened), 2007
Acrylic on canvas, 213 × 152 cm
Acryl auf Leinwand, 213 × 152 cm
Emanuel Hoffmann-Stiftung, Basel, Depositum in der
Öffentlichen Kunstsammlung Basel

Self portrait (Engravers MT), 2007
Acrylic on canvas, 122 x 91.5 cm
Acryl auf Leinwand, 122 x 91.5 cm
Private Collection, London

Self portrait (Wide Latin), 2007
Acrylic on canvas, 183 × 213.5 cm
Acryl auf Leinwand, 183 × 213.5 cm
Emanuel Hoffmann-Stiftung, Basel, Depositum in der
Öffentlichen Kunstsammlung Basel

A *State Britain*, 2007
Installation, mixed media, 43 m
Installation, verschiedene Materialien, 43 m
As originally conceived and commissioned for the Duveens
Commission at Tate Britain, 2007
Courtesy Anthony Reynolds Gallery, London

A *The Human Figure in Space*, 2007
3 miles of kite string, mirrors, stenciled numbers, dimensions
variable
3 Meilen Drachenschnur, Spiegel, schablonierte Zahlen, Masse
variabel
Courtesy Donald Young Gallery, Chicago

Zone, 2007
Dyneema fishing line, plastic and metal clamps, approx. 5000 m,
5 m above ground
Dyneema-Angelschnur, Plastik- und Metallhaken, ca. 5000 m, 5 m
über dem Boden
Skulptur Projekte Münster 07

Folk Stones, 2008
19 240 stones, paint, sand, cement, CORE-TEN-steel, overall
dimension 9 × 9 m
19 240 Steine, Farbe, Sand, Zement, CORE-TEN-Stahl,
Gesamtmass 9 × 9 m
Commission by the Folkstone Triennial, Collection The Roger
De Haan Charitable Trust

BIOGRAPHY

Born 1959 in Chigwell, UK. From 1978 to 1981 attended Chelsea School of Art, from 1983 to 1985 Goldsmith's College in London. 1998 residence in Rome, Henry Moore Scholarship. From 2001 to 2002 DAAD Fellowship in Berlin. 2002 Honorary Fellowship of the London Institute. 2003 Honorary Doctorate of the University of Central England. 2007 Winner of the Turner Prize, London. Lives and works in London.

BIOGRAFIE

Geboren 1959 in Chigwell, Grossbritannien. Von 1978 bis 1981 Besuch der Chelsea School of Art, von 1983 bis 1985 des Goldsmith's College in London. 1998 Aufenthalt in Rom, Henry Moore Stipendium. 2001 bis 2002 DAAD Stipendium in Berlin. 2002 Honorary Fellowship von der London Institute. 2003 Ehrendoktorwürde der University of Central England. 2007 Gewinner des Turner Prize, London. Lebt und arbeitet in London.

SOLO EXHIBITIONS (SELECTION)

EINZELAUSSTELLUNGEN (AUSWAHL)

2008	Aargauer Kunsthaus, Aarau *	
	State Britain, MAC / VAL Musée d'art contemporain du Val-de-Marne, Vitry-sur-Seine	
2007	*The Human Figure in Motion*, Donald Young Gallery, Chicago	
	Kunstverein Braunschweig *	
	State Britain, Tate Britain, London *	
	The End, carlier	gebauer, Berlin
2006	*The End*, Anthony Reynolds Gallery, London	
	Threshold to the Kingdom, Convent of St. Agnes of Bohemia, National Gallery, Prague	
2005	Museo de Arte Carillo Gil, Mexico City	
	Easter, Hangar Bicocca, Milan *	
	W-E, Galerie Krinzinger, Vienna	
2004	*Sleeper*, Neue Nationalgalerie, Berlin	
	The Underworld, carlier	gebauer, Berlin
	Presence 4: Mark Wallinger, The Speed Art Museum, Louisville, Kentucky	
	Anthony Reynolds Gallery, London	
2003	*Populus Tremula*, Tate Britain, London	
	The Sleep of Reason, The Wolfsonian, Miami Beach, Florida	
	Via Dolorosa, Städtische Galerie im Lenbachhaus, Munich *	
	Spacetime, carlier	gebauer, Berlin
2002	*Cave*, Millenium Forum, Derry, Ireland	
	Seeing Things, Minoriten-Galerien im Priesterseminar, Graz	
	Promised Land, Tensta Konsthall, Spanga, Sweden	
	Glynn Vivian Art Gallery, Swansea, UK	
2001	*No Man's Land*, Whitechapel Art Gallery, London	
	British Pavilion, Biennale di Venezia, Venice *	
	Time and Relative Dimensions in Space, University Museum of Natural History, Oxford	
2000	*Credo*, Tate Gallery, Liverpool *	
	Ecce Homo, Secession, Vienna *	
	Threshold to the Kingdom, The British School, Rome	
1999	*Lost Horizon*, Museum für Gegenwartskunst, Basel *	
	Ecce Homo, The Fourth Plinth, Trafalgar Square, London	
	Prometheus, Portikus, Frankfurt / Main *	
	Mark Wallinger Is Innocent, Palais des Beaux-Arts, Brussels *	
1998	*The Four Corners of the Earth*, Delfina, London	
1997	Dolly Fiterman Fine Arts, Minneapolis *	
	The Importance of Being Earnest in Esperanto, Jiri Svestka Gallery, Prague	
	God, Anthony Reynolds Gallery, London	
1995	Serpentine Gallery, London *	
	Ikon Gallery, Birmingham *	
1994	*The Full English*, Anthony Reynolds Gallery, London	
	Deweer Art Gallery, Otegem, Belgium *	
1993	Daniel Newburg Gallery, New York	
1992	*Fountain*, Anthony Reynolds Gallery, London	
1991	*Capital*, Institute of Contemporary Art, London	
	Daniel Newburg Gallery, New York	
	Capital, Grey Art Gallery, New York	
1990	*Stranger2*, Anthony Reynolds Gallery, London	
1988	Anthony Reynolds Gallery, London *	
	Passport Control, Riverside Studios, London *	
1986	*Hearts of Oak*, Anthony Reynolds Gallery, London	
1983	The Minories Art Gallery, Colchester, UK	

* publication / Publikation

GROUP EXHIBITIONS 2000–2008 (SELECTION)

for group exhibitions before 2000 see
Mark Wallinger, *Credo*, Tate Liverpool, 2000

GRUPPENAUSSTELLUNGEN 2000–2008 (AUSWAHL)

für Gruppenausstellungen vor 2000 vgl.
Mark Wallinger, *Credo*, Tate Liverpool, 2000

2008 *Tales of Time and Space*, Folkestone Triennial, Folkestone
 Comme des bêtes, Musée Cantonal des Beaux-Arts, Lausanne *
 On Time: The East Wing Collection VIII, The Courtauld Institute
 of Art, London
 Collection Videos & Films | Isabelle & Jean-Conrad Lemaître,
 Kunsthalle zu Kiel *
2007 *The Turner Prize*, Tate Liverpool *
 Musée national d'art moderne – Centre Pompidou, Paris
 Skulptur Projekte, Munster *
 Schmerz, Hamburger Bahnhof, Berlin *
 Stardust ou la dernière frontière, MAC/VAL Musée d'art
 contemporain du Val-de-Marne, Vitry-sur-Seine *
2006 *Belief*, Singapore Biennale, Singapore *
 *Une vision du monde. La collection vidéo d'Isabelle et
 Jean-Conrad Lemaître*, Maison Rouge, Paris *
 Protections, Kunsthaus Landesmuseum Graz
 Choosing my Religion, Kunstmuseum Thun
 How to Improve the World, Hayward Gallery, London
 Aftershock - Contemporary British Art 1990-2006, China Art
 Gallery, Beijing and tour
2005 *Rundlederwelten*, Martin-Gropius-Bau, Berlin
 When Humour Becomes Painful, Migros Museum für Gegenwarts-
 kunst, Zurich *
 The Experience of Art, Italian Pavilion, Biennale di Venezia, Venice
 The World Is a Stage, Mori Art Museum, Tokyo
2004 *The Human Condition. The Image of Man in Art*, The City History
 Museum of Barcelona *
2003 *Contemporary Art in the Traditional Museum*, Russian Museum,
 St. Petersburg
 Warum! Ebenbild - Abbild - Selbstbild, Martin-Gropius-Bau,
 Berlin *
 nation, Frankfurter Kunstverein, Frankfurt/Main
 Rituals, Akademie der Künste, Berlin
 Sanctuary, Gallery of Modern Art, Glasgow *
 Micro/Macro - British Art 1996-2002, Mücsarnok Kunsthalle,
 Budapest
 Body Matters, The National Museum of Contemporary Art, Oslo
2002 *Sphere. Loans from the Invisible Museum*, Sir John Soane's
 Museum, London
 The Anatomy of the Horse - Mark Wallinger and George Stubbs,
 Harewood House, Leeds
 Faux/Real, Borusan Kültèr ve Sanat, Istanbul *
 The Gap Show - Junge zeitkritische Kunst aus Grossbritannien,
 Museum am Ostwall, Dortmund *
 Sidewinder, The Centre of International Modern Art, Calcutta
 and tour
2001 *Looking at You - Kunst Provokation Unterhaltung Video*,
 Kunsthalle Fridericianum, Kassel
 Century City: Art and Culture in the Modern Metropolis, Tate
 Modern, London
 Heads and Hands – A WPA\C, Project at Decatur House Museum,
 Washington
 City Racing 1988-1998: a partial account, Institute of Contempo-
 rary Arts, London
2000 *Seeing Salvation*, National Gallery, London *
 Vision-Machine, Musée des Beaux-Arts de Nantes, Nantes *

* publication / Publikation

BIBLIOGRAPHY

BIBLIOGRAFIE

Monographs
Monografien

2007 *Mark Wallinger. State Britain*, Tate Britain, London (text: Clarrie Wallis)
2001 *Mark Wallinger*, British Pavilion, The 49th Venice Biennale, The British Council, London (text: Ralph Rugoff)
Time and Relative Dimensions in Space, University Museum of Natural History, Ruskin School of Drawing and Fine Art, Oxford (text: Marco Livingstone)
2000 Mark Wallinger, *Prometheus*, Portikus, Frankfurt/Main
Mark Wallinger, *Credo*, Tate Liverpool (texts: Lewis Biggs, Ian Hunt, David Burrows)
Mark Wallinger, *Ecce Homo*, Secession, Vienna (texts: Michail Bulgakov, Adrian Searle)
1999 *Mark Wallinger Is Innocent*, Société des Expositions du Palais des Beaux-Arts de Bruxelles (text: Pier Luigi Tazzi)
Mark Wallinger - Lost Horizon, Museum für Gegenwartskunst, Basel (interview with Mark Wallinger: Theodora Vischer, text: Andrew Wilson)
1997 *Mark Wallinger*, Dolly Fiterman Fine Arts, Minneapolis (text: Donald Kuspit)
1995 *Mark Wallinger*, Ikon Gallery, Birmingham, Serpentine Gallery, London (text: Jon Thompson)
1994 *Mark Wallinger*, Deweer Art Gallery, Otegem (text: Jo Coucke)
1988 *Mark Wallinger*, Riverside Studios, London; Anthony Reynolds Gallery, London

Publications with essays about Mark Wallinger 2000–2008 (selection)
For publications before 2000 see Mark Wallinger, *Credo*, Tate Liverpool 2000
Publikationen mit Beiträgen zu Mark Wallinger 2000–2008 (Auswahl)
Für Publikationen vor 2000 vgl. *Mark Wallinger. Credo*, Tate Liverpool 2000

2008 *Collection Videos & Films, Isabelle & Jean-Conrad Lemaître*, Kunsthalle zu Kiel (text: Katharina Fricke)
Eleanor Heartney, *Art & Today*, Phaidon, London
2007 *Stardust ou la dernière frontière*, MAC/VAL Musée d'art contemporain du Val-de-Marne, Vitry-sur-Seine
2006 Sheila McGregor, *New Art on View*, Southampton City Art Gallery (texts: Gill Hedley, Nicholas Serota, Stephen Snoddy)
Belief, Singapore Biennale, Singapore (text: Eliza Tan)
Une vision du monde. La collection vidéo d'Isabelle et Jean-Conrad Lemaître, Maison Rouge, Paris (texts: Mark Nash, Chantal Pontbriand, Christine Van Assche)
2004 Marco Delogu, Massimo Reale (ed.), *Photofinish*, Rome (text: Manlio Cancogni)
Albano Silva Pereira, Miguel Amado (ed.), *On Side*, Centro de Artes Visuais, Coimbra
The human condition. The dream of a shadow, Barcelona Forum, Institut de Cultura de Barcelona, Museu d'Historia de la Ciutate de Barcelona (MHCB) (texts: Pedro Azara, Marta Llorente, Eugenio Trias)
2003 *Warum! Bilder diesseits und jenseits des Menschen*, Martin-Gropius-Bau, Berlin (text: Michael Diers)
Sanctuary - Contemporary Art and Human Rights, Gallery of Modern Art, Glasgow (text: Mark Wallinger)
Micro/macro - British Art 1996-2001, Mücsarnok Kunsthalle, Budapest (text: Alex Farquharson)
2002 *The Gap Show - Young Critical Art from Great Britain*, Museum am Ostwall, Dortmund
Faux/Real, Borusan Kültèr ve Sanat, Istanbul

2000 *Seeing Salvation*, BBC Publishing, London (texts: Neil MacGregor, Erika Langmuir)
Louisa Buck, *Moving Targets 2, A User's Guide to British Art Now*, Tate Gallery Publishing, London (text: Louisa Buck)
Locus Solus, Locus, Newcastle-upon-Tyne (text: Paul Bonaventura)

Articles 2000–2008 (selection)
For articles before 2000 see Mark Wallinger, *Credo*, Tate Liverpool 2000
Artikel 2000–2008 (Auswahl)
Für Artikel vor 2000 vgl. *Mark Wallinger. Credo*, Tate Liverpool 2000

2008 Yve-Alain Bois, Guy Brett, Margaret Iversen, Julian Stallabrass, 'An Interview with Mark Wallinger', in *October*, Cambridge (MA), no.123, Winter
2007 Grahame Swanson, 'You ask the questions ... How did it feel to walk around in a bearskin?', in *The Independent*, London, 10 December
Charlotte Higgins, 'It's a good day for bears', in *The Guardian*, London, 5 December
Dalya Alberge, 'Bearly believable? The Turner prizewinner', in *The Times*, London, 4 December
Arifa Akbar, 'Praise for Turner jury as prize goes to war protest', in *The Independent*, London, 4 December
Charlotte Higgins, 'Wallinger takes Turner prize with re-creation of parliament protest', in *The Guardian*, London, 4 December
Adrian Searle, 'Accessible, funny, and serious', critics view, in *The Guardian*, London, 4 December
Marcus Field, 'Films for People Who Don't Like Video Art', in *The Independent on Sunday*, London, 1 October
Lillian Davies, 'Critic's choice "Mark Wallinger"', in *Artforum*, New York, October
Matthew Higgs, 'Mark Wallinger', in *Artforum*, New York, September
Adrian Searle, 'Peek-a-boo!', in *The Guardian*, London, 26 June
Paul Bonaventura, 'Mark Wallinger: State Britain', in *Parkett*, Zurich, no. 79
Tom Morton, 'Back – Mark Wallinger', in *Frieze*, London, May
Yve-Alain Bois, 'Piece Movement', in *Artforum*, New York, April
Simon Webb, 'Crivelli's Nail', in *AN Magazine*, Newcastle upon Tyne, April
Jackie Wullschlager, 'Off the Wall', in *Financial Times*, London, April
Richard Grayson, 'Mark Wallinger', in *Art Monthly*, London, March
Adrian Searle, 'Bears against bombs', in *The Guardian*, London, 16 January
Tim Teeman, 'Protest loses its potency off the street', in *The Times*, London, 16 January
2006 Gilda Williams, 'Mark Wallinger', in *Artforum*, New York, December
Charlotte Bonham-Carter, 'Mark Wallinger', in *Flash Art*, Milan, November–December
Lillian Davies, 'Critic's Choice 'Mark Wallinger'', in *Artforum*, New York, October
2005 Matt Saunders, 'Berlin', best of 2005, in *Artforum*, New York, December
Rainer Metzger, 'Das Prinzip Intelligenz', in *Artmagazine*, Vienna, 25 November
Markus Mittringer, 'Im Niemandsland', in *Der Standard*, Vienna, 25 November
Francesca Bonazzoli, 'Credenti oppure no la mia arte e per tutti', in *Corriere Della Sera*, Milan, 22 September
Alessandra Mammi, 'Christo si è fermato a Londra', in *L'espresso*, Rome, 22 September
Mark Wallinger, 'Easter', in *Corriere Della Sera*, Milan, 22 September

[Ed.], 'Mark Wallinger. Via Dolorosa', in *Exibart*, Florence, 21 September
Colin Gleadell, 'Art hunters head for their prey', in *The Daily Telegraph*, London, 20 June
Lynn Barber, 'Anyone for Venice?', in *The Observer*, London, 18 June
Sally O'Reilly, 'Things that go bump in the night: Mark Wallinger bears all', in *Modern Painters*, New York, June
Adrian Searle, 'Filth, blasphemy and big stars', in *The Guardian*, London, June
Mark Wallinger, 'Sleeper', in *Frieze*, London, issue 91, May
Tom Lubbock, 'Eye Contact', in *Art Review*, London, April
2004 Sacha Craddock, 'Embedded', in *Contemporary*, London, issue 69
Paul Glinkowski, 'Losing it in translation', in *AN Magazine*, Newcastle upon Tyne, December
Oliver Bennett, 'Hellish Vision', in *The Observer*, London, 9 May
Rachel Withers, 'Mark Wallinger', in *Artforum*, New York, May
Sally O'Reilly, 'Mark Wallinger', in *Frieze*, London, April
Catherine Parker, 'Mark Wallinger', in *Art Press*, Paris, April
Norbert Bolz, 'Kunst und Sport – Sport als Ästhetik der Zukunft', in *Kunstforum International*, Cologne, vol. 169, March–April
Oliver Zybok, 'Kunst und Sport – Die Inszenierung von Körperlichkeit und Bewegung', in *Kunstforum International*, Cologne, vol. 169, March–April
Jane Watts, 'In Memorium', in *AN Magazine*, Newcastle, March
Louisa Buck, 'Three degrees of separation', in *The Art Newspaper*, London, February
Rowan Williams, 'Imitations of Christ', in *The Guardian*, London, 31 January
Adrian Searle, 'Mark Wallinger', in *The Guardian*, London, 21 January
Tom Lubbock, 'Pitch-black perfect', in *The Independent*, London, 20 January
Laura Cumming, 'Family favourites', in *The Observer Review*, London, 18 January
Charles Darwent, 'At home in the kingdom of the strangely familiar', in *The Independent on Sunday*, London, 18 January
Fisun Güner, 'Mark Wallinger: The artist ascending', in *The Independent Review*, Covington (LA), 14 January
2003 Dalya Alberge, 'Tate tree gives rosary reminder', in *The Times*, London, 13 December
Maev Kennedy, 'Traditional trappings, Artist trims Tate Tree', in *The Guardian*, London, 13 December
Nigel Reynolds, 'Christ's birth inspired me, says creator of Tate's tree', in *The Daily Telegraph*, London, 13 December
Luke Leitch, 'Has the Tate finally lost its baubles?', in *Evening Standard*, London, 12 December
Eliza Williams, 'Thatcher', in *Contemporary*, London, issue 53/54
Michael Binyon, 'Deface of the Nation', in *The Times*, London, 18 April
[Ed.], 'I wanted to invade her privacy (Thatcher)', in *The Guardian*, London, 16 April
[Ed.], 'Hungary for British art', *Art Review*, London, April
Gary Young, 'Much Ado About Nothing', in *Art Papers*, Atlanta (GA), January/February
2002 Sophie Allgårdh, 'Wallinger ger oss en glimt av det förlovade landet', in *Konst*, Stockholm, 24 November
Cristina Karlstam, 'På tröskeln till riket', in *Kultur*, Stockholm, 26 October
Carol Kino, 'Seeing and Believing', in *Art in America*, New York, October
Kate Mikhail, 'What's The Big Idea', in *The Observer Magazine*, London, 22 September

Helen Hague, 'A classy, sexy two-horse race', in *The Independent*, London, 30 August

Martin Gayford, 'George Stubbs and Mark Wallinger', in *The Sunday Telegraph*, London, 11 August

Adrian Searle, 'Sculpture gives life to Christian symbolism', in *The Western Mail*, Cardiff, 4 May

2001 Chiara Leoni, 'Ready to Rumble', in *Flash Art Italia*, Milan, December 2001–January 2002

Martin Gayford, 'Ordinary and Sublime', in *The Daily Telegraph*, London, 28 November

Laura Cumming, 'A Matter of Life and Death', in *The Observer Review*, London, 25 November

Richard Cork, 'Readings from Mark', in *The Times*, London, 21 November

Jonathan Jones, 'God's-eye views', in *The Guardian*, London, 20 November

Tom Lubbock, 'It's a hit and myth affair', in *The Independent*, London, 20 November

Charles Darwent, 'Visual Art: A poetic moment in the electric chair', in *The Independent*, London, 18 November

Richard Dorment, 'Pick of the week – Mark Wallinger', in *The Daily Telegraph*, London, 10 November

Nigel Farndale, 'Seeing the Light', in *The Sunday Telegraph Magazine*, London, 4 November

[Ed.], 'Mark Wallinger on Whistlejacket', in *Private Passions - The Times*, London, 3 October

Axel Lapp, 'It Ain't! Is It Not? Mark Wallinger and Robert Gober at the 49th Venice Biennale', in *The Sculpture Journal*, Oxford, vol. VI

Tom Lubbock, 'Wallinger and Religion', in *Modern Painters*, New York, Autumn

Michael Archer, 'Mark Wallinger', in *Artforum*, New York, September

Marcia E. Vetrocq, 'Biennale Babylon', in *Art in America*, New York, September

Heinz-Norbert Jocks, 'Die Austellung im Innern des Kopfes', in *Kunstforum International*, Cologne, August–October

Rainer Metzger, 'The Englishness of English Art', in *Frame*, Amsterdam, August–September

[Ed.], 'Biennale Venedig', in *Frame*, Amsterdam, August–September

Andrew Wilson, 'The Zones of Venice', in *Art Monthly*, London, July–August

Martin Gayford, 'States of bemusement', in *The Spectator*, London, 23 June

Michael Kimmelman, 'Arty, Artful, Artless', in *The New York Times*, New York, 20 June

Waldemar Januszczak, 'A curious beast', in *The Sunday Times*, London, 17 June

John McEwen, 'Pushy culture vultures', in *The Sunday Telegraph*, London, 17 June

William Packer, 'Wallinger marks the spot', in *Financial Times*, London, 16 June

Adrian Searle, 'Lagoon Show', in *The Guardian*, London, 16 June

Arthur Smith, 'Watery Rave', in *The Guardian*, London, 14 June

Richard Cork, 'Too many tours spoil the broth', in *The Times*, London, 13 June

Richard Dorment, 'Wallinger's act of faith pays off', in *The Daily Telegraph*, London, 13 June

Charles Darwent, 'Flying the flag at the Eurovision art contest', in *The Independent on Sunday*, London, 10 June

Dalya Alberge, 'Best of British misses the art of diplomacy', in *The Times*, London, 7 June

Mark Irving, 'Briton is the big draw as Venice Biennale opens', in *The Independent*, London, 7 June

Nigel Reynolds, 'British artist flies the flag of controversy at Biennale', in *The Daily Telegraph*, London, 7 June

Rachel Campbell-Johnston, 'The art before the horse', in *The Times*, London, 4 June

Oliver Bennett, 'Taking a Tardis to the Venice Biennale', in *The Independent on Sunday*, London, 3 June

Rose Aidin, 'Profile: Mark Wallinger – Race, class and sex', in *The Independent*, London, 2 June

Régis Durand, 'La tradition non conformiste', in *Art Press*, Paris, June

Hans Pietsch, 'Der blinde Narr', in *Art. Das Kunstmagazin*, Hamburg, June

Craig Burnett, 'Fools Walk In ...', in *Modern Painters*, New York, Summer

Rachel Withers, 'Customs Man: Mark Wallinger', in *Artforum*, New York, Summer

Paul Bonaventura, 'The Culture of Command', in *Modern Painters*, New York, Spring

Stella Santacatterina, in *Flash Art*, Milan, March–April

Martin Gayford, 'Artists on art – Mark Wallinger', in *The Daily Telegraph*, London, 3 March

Laura Cumming, 'An odds-on favourite', in *The Observer Review*, London, 28 January

Tony Godfrey, in *The Burlington Magazine*, London, January

2000 Mark Wallinger, 'Fool Britannia', in *The Guardian*, London, 12 December

Anna Moszynska, 'Breeding and Healing', in *Art Review*, London, December 2000–January 2001

Sean Dodson, 'Artists who paint by digits', in *The Guardian*, London, 30 November

Richard Ingleby, in *The Independent*, London, 11–17 November

Jonathan Jones, 'The Magical Mystery Tour', in *The Guardian*, London, 28 October

Tom Lubbock, 'In the sweet hereafter', in *The Independent*, London, 24 October

Martin Gayford, 'An Angel Underground', in *The Sunday Telegraph*, London, 22 October

RC, in *The Guardian Guide*, London, 21–27 October

Colin Gleadall, 'Contemporary Market', in *The Daily Telegraph*, London, 16 October

Simon Grant, 'From Jesus on a plinth to an angel on Merseyside', in *The Independent on Sunday*, London, 15 October

Nick Crowe, 'Football, The Lords Prayer and Heavy Metal – a peculiar kind of nationhood', in *Flux Magazine*, [London], October–November

[Ed.], 'Mostre', in *Vogue-Italia*, Milan, September

Marcus Mittringer, 'Sehet, welch ein Mensch!', in *Der Standard*, Vienna, 3 August

Colin Gleadall, 'Edge of meaning and nonsense', in *The Daily Telegraph*, London, 22 July

Daniele Perra, in *Tema Celeste*, Milan, July–September

James Hall, 'Another Time, Another Place', in *Art Review*, London, July–August

Simon Grant, 'Soul Searching', in *Tate Magazine*, London, Summer

Ann Treneman, 'Art, farce, politics and pigeons', in *The Times*, London, 11 February

Lynn Barber, 'For Christ's sake', in *The Observer*, London, 9 January

AUTHORS' BIOGRAPHIES

AUTORENBIOGRAFIEN

Michael Diers is an art historian, and Professor of the History of Art and Images at the Hochschule für Bildende Künste in Hamburg and at Humboldt University in Berlin. The main focuses of his research are the Renaissance, Modernism and contemporary art, photography and new media, political iconography and the history of science. He has recently published *Fotografie, Film, Video. Eine kritische Theorie des Bildes.* Hamburg 2006.

Richard Grayson is an artist, curator and writer. He was artistic director of the 2002 Sydney Biennale, *(The World May Be) Fantastic*, and of *A Secret Service (art compulsion concealment)*, a Hayward Gallery London touring exhibition 2006–2007. He is a regular contributor to *Art Monthly* UK and *Broadsheet Australia*. Solo exhibitions include *Messiah*, Matts Gallery, London, 2004; *Intelligence*, Matts Gallery, London, 2005; and *Suspicious Fires*, Yuill/Crowley Gallery Sydney 2006. He is currently a researcher in Fine Art at Newcastle University, UK.

Madeleine Schuppli has been Director of the Aargauer Kunsthaus in Aarau since 2007. She studied art history at the universities of Geneva, Hamburg and Zurich. Between 1996 and 2000 she was curator of the Kunsthalle Basel; and from 2000 to 2007, was the director of the Kunstmuseum Thun. She has curated solo exhibitions with Pierre Bismuth, Christoph Büchel, Maurizio Cattelan, Simon Dybbroe Møller, Vidya Gastaldon, Mark Grotjahn, Mona Hatoum and Christian Marclay, and themed exhibitions such as *Choosing my Religion*, *Swiss Pop* and *Gesellschaftsbilder*.

Janneke de Vries studied art history and recent German literature in Marburg and Hamburg. After working as an editor, a freelance critic, a freelance curator and a scientific assistant in Frankfurt/Main and Hamburg, she was director of the Kunstverein Braunschweig until 2007. While there, as well as the exhibition with Mark Wallinger and presentations with Claire Barclay, Tobias Buche and Till Krause, she curated the group exhibition *Um-Kehrungen* and set up a guest curator programme. Since January 2008 she has been responsible as director for the programme of the GAK (Gesellschaft für Aktuelle Kunst) in Bremen.

Michael Diers, Kunsthistoriker, Professor für Kunst- und Bildgeschichte an der Hochschule für Bildende Künste in Hamburg und an der Humboldt-Universität zu Berlin; Forschungsschwerpunkte: Renaissance, Moderne und Gegenwart, Fotografie und Neue Medien, politische Ikonographie und Wissenschaftsgeschichte; zuletzt erschienen: *Fotografie, Film, Video. Beiträge zu einer kritischen Theorie des Bildes*, Hamburg 2006.

Richard Grayson ist Künstler, Kurator und Autor. Er war Künstlerischer Leiter der Sydney Biennale 2002 *(The World May Be) Fantastic*, und der Wanderausstellung der Hayward Gallery London *A Secret Service (art compulsion concealment)*, 2006/07. Er schreibt Artikel für *Art Monthly* und *Broadsheet Australia*. Einzelausstellungen: *Messiah*, Matts Gallery, London 2004; *Intelligence*, Matts Gallery, London 2005; *Suspicious Fires*, Yuill/Crowley Gallery, Sydney 2006. Derzeit ist er Researcher in Fine Art an der Newcastle University.

Madeleine Schuppli ist seit 2007 Direktorin des Aargauer Kunsthauses in Aarau. Studium der Kunstgeschichte an den Universitäten Genf, Hamburg und Zürich, 1996–2000 Kuratorin Kunsthalle Basel, 2000–2007 Direktorin Kunstmuseum Thun. Kuratorin von Einzelausstellungen mit Pierre Bismuth, Christoph Büchel, Maurizio Cattelan, Simon Dybbroe Møller, Vidya Gastaldon, Mark Grotjahn, Mona Hatoum und Christian Marclay, und von thematischen Ausstellungen wie *Choosing my Religion*, *Swiss Pop* und *Gesellschaftsbilder*.

Janneke de Vries studierte Kunstgeschichte und Neuere Deutsche Literatur in Marburg und Hamburg. Nach Tätigkeiten als Redakteurin, freie Kritikerin, freie Kuratorin und wissenschaftliche Mitarbeiterin in Frankfurt/Main und Hamburg war sie bis 2007 Direktorin des Kunstvereins Braunschweig. Dort hat sie neben der Ausstellung mit Mark Wallinger Präsentationen mit Claire Barclay, Tobias Buche und Till Krause, die Gruppenausstellung *Um-Kehrungen* und ein Gastkuratorenprogramm realisiert. Seit Januar 2008 verantwortet sie als Direktorin das Programm der GAK Gesellschaft für Aktuelle Kunst in Bremen.

This book was published on the occasion of the exhibition
Mark Wallinger, Kunstverein Braunschweig, 1 September – 11 November
2007, and Aargauer Kunsthaus Aarau, 31 August – 16 November 2008.

Diese Publikation erscheint anlässlich der Ausstellung *Mark Wallinger*,
Kunstverein Braunschweig, 1. September – 11. November 2007, und
Aargauer Kunsthaus Aarau, 31. August – 16. November 2008.

Exhibition / Ausstellung Aarau

Director / Direktorin
Madeleine Schuppli

Idea and Conception / Idee und Konzept
Madeleine Schuppli, Mark Wallinger

Assistance / Assistenz
Barbara von Flüe, Katrin Weilenmann

Exhibitions Office / Ausstellungssekretariat
Verena Reisinger

Communication and Press / Kommunikation und Presse
Filomena Colecchia

Education Department / Museumspädagogik
Franziska Dürr Reinhard, Katrin Naef Felber

Conservation / Restaurierung
Willy Stebler, Véronique Mathieu

Installation / Ausstellungsaufbau
David Blazquez (Head / Leitung), Matthias Berger, Daniel Desborough,
Stefan Lenz, Brigitte Plüss

Building Services / Haustechnik
Arnold Glatthard

Aargauer Kunsthaus
Postfach
CH–5001 Aarau
T +41 (0) 62 835 23 30
F +41 (0) 62 835 23 29
kunsthaus@ag.ch
www.aargauerkunsthaus.ch

The Aargauer Kunsthaus would like to thank the Neue Aargauer Bank
NAB, principle sponsor of the Aargauer Kunsthaus, for the generous
support of the exhibition in Aarau.
Das Aargauer Kunsthaus dankt der Neuen Aargauer Bank NAB,
Hauptsponsor vom Aargauer Kunsthaus, für die grosszügige Unterstüt-
zung der Ausstellung in Aarau.

Exhibition/Ausstellung Braunschweig

Director/Direktorin
Janneke de Vries

Idea and Conception/Idee und Konzept
Janneke de Vries, Mark Wallinger

Artistic Assistance/Künstlerische Assistenz
Ursula Schöndeling

Freelance/Freie Mitarbeit
Sina Deister

Exhibitions Office/Ausstellungssekretariat
Christine Gröning

Reception/Empfang
Elisabeth Schuchardt

Installation/Ausstellungsaufbau
Andreas Eschment (Head/Leitung), Rainer Bullrich, Axel Loytved,
Eduardo Mayorga, Franziska Nast, Yotaro Niwa, Iris Schneider, Malte
Struck

Guidings/Führungen
Melanie Mayr, Ursula Schöndeling

Kunstverein Braunschweig
Lessingplatz 12
38100 Braunschweig
T +49 (0) 531 495 56
F +49 (0) 531 12 47 37
info@kunstverein-bs.de
www.kunstverein-bs.de

Board/Vorstand
Dr. Bernd Huck, Chairman/Vorsitzender des Vorstandes
Tobias Hoffmann, Vice Chairman/2. Vorsitzender
Christian Böke, Treasurer/Schatzmeister
Uta-Marie Hügin, Oliver Ruth, Isolde Saalmann, Prof. Dr. Michael Schwarz

Director/Leitung (since/seit 2008)
Hilke Wagner

The exhibition in Braunschweig received generous support from the
Volkswagen Bank and the Henry Moore Foundation.
Die Ausstellung in Braunschweig wurde grosszügig unterstützt von der
Volkswagen Bank und der Henry Moore Foundation.

VOLKSWAGEN BANK The Henry Moore
GMBH Foundation

Publication/Publikation

Editors/Herausgeberinnen
Madeleine Schuppli, Janneke de Vries

Copy Editing/Redaktion und Lektorat
Barbara von Flüe

Editing and Proofreading English/Verlagslektorat Englisch
Clare Manchester

Editing and Proofreading German/Verlagslektorat Deutsch
Salome Schnetz

Translation/Übersetzung
Judith Hayward (DeVries, Diers, Schuppli into English/ins Englische)
Clemens Krümmel (Grayson into German/ins Deutsche)

Design/Gestaltung
Gavillet & Rust

Assistance/Assistenz
Tobias Rechsteiner

Cover/Umschlag
White Horse, 2008
33 times life-size
Artwork Proposal for the Ebbsfleet Landmark Project
Courtesy Anthony Reynolds Gallery

Typeface/Schrift
NewJohnston

Production/Herstellung
Musumeci S.p.A., Quart (Aosta)

Photographs/Fotografien
Claudio Abate; Martin Bühler; Peter Day; Fred Dott; Matthias Herrmann;
Moritz Hoffmann; Galerie Susanna Kulli, Zürich; Roman Mensing,
Skulptur Projekte Münster 07/LWL-Landesmuseum für Kunst und
Kulturgeschichte; Dave Morgan; Sue Ormerod; John Riddy; Stefan Maria
Rother; Roger Senet; Staatliches Russisches Museum, St. Petersburg;
Colin Streater; Tom Van Eynde; Peter White; Gareth Winters; Edward
Woodman

Mark Wallinger would like to thank/Mark Wallinger dankt
Anna Barriball, Ursula Wallinger, Louise Wallinger, Maria Stathi, Anthony
Reynolds.
And all at/Und allen bei Donald Young Gallery, Chicago;
carlier | gebauer, Berlin; Galerie Krinzinger, Wien; Kunstverein
Braunschweig; Aargauer Kunsthaus, Aarau.

Produced in Europe/Hergestellt in Europa.

Published by / Herausgegeben von

JRP | Ringier
Letzigraben 134
CH-8047 Zurich
T +41 (0) 43 311 27 50
F +41 (0) 43 311 27 51
info@jrp-ringier.com
www.jrp-ringier.com

ISBN 978-3-905829-78-5

JRP | Ringier books are available internationally at selected
bookstores and from the following distribution partners:

Bücher von JRP | Ringier sind weltweit in spezialisierten
Buchhandlungen erhältlich und werden von den unten
aufgeführten Partnern vertrieben:

Switzerland / Schweiz
Buch 2000, AVA Verlagsauslieferung AG, Centralweg 16,
CH–8910 Affoltern a.A., buch2000@ava.ch, www.ava.ch

France / Frankreich
Les Presses du réel, 16 rue Quentin, F–21000 Dijon,
info@lespressesdureel.com, www.lespressesdureel.com

Germany and Austria / Deutschland und Oesterreich
Vice Versa Vertrieb, Immanuelkirchstrasse 12, D–10405 Berlin,
info@vice-versa-vertrieb.de, www.vice-versa-vertrieb.de

UK and other European countries / Grossbritannien und andere
europäische Länder
Cornerhouse Publications, 70 Oxford Street, UK–Manchester M1 5NH,
publications@cornerhouse.org, www.cornerhouse.org/books

USA, Canada, Asia, and Australia / USA, Kanada, Asien und Australien
D.A.P./Distributed Art Publishers, l55 Sixth Avenue, 2nd Floor, USA–New
York, NY 10013, dap@dapinc.com, www.artbook.com

For a list of our partner bookshops or for any general questions, please
contact JRP | Ringier directly at info@jrp-ringier.com, or visit our
homepage www.jrp-ringier.com for further information about our
programme.

Für eine Liste unserer Partnerbuchhandlungen und allgemeine Fragen
kontaktieren Sie bitte JRP | Ringier direkt unter info@jrp-ringier.com,
und besuchen Sie unsere Webseite www.jrp-ringier.com für Informatio-
nen über unser Programm.